HOW TO cheat IN PHOTOSHOP®
Elements 11

Release your imagination

David Asch

Routledge
Taylor & Francis Group

LONDON AND NEW YORK

First published 2013
by Focal Press

Published 2018 by Routledge
2 Park Square, Milton Park, Abingdon, Oxon OX14 4RN
711 Third Avenue, New York, NY 10017, USA

First issued in hardback 2018

Routledge is an imprint of the Taylor & Francis Group, an informa business

Library of Congress Cataloging-in-Publication Data
Asch, David.
How to cheat in Photoshop elements 11 : release your imagination / David Asch. -- Sixth editon.
pages cm
ISBN 978-0-415-66330-4 (pbk.)
1. Adobe Photoshop elements. 2. Photography--Digital techniques. 3. Image processing--Digital techniques. I. Title.
TR267.5.A33A84 2013
006.6'86--dc23
2012045737

ISBN 13: 978-1-138-37227-6 (hbk)
ISBN 13: 978-0-415-66330-4 (pbk)

Contents

How to cheat and why

The truth about cheating

I've used the word 'cheating' in the title of this book in two ways. The most obvious is that I'm describing how to make images look like photographs when they're not. In this sense, it simply means creating photographic work without the need for a dedicated studio.

The other sense of 'cheating' is finding shortcuts to help you work more quickly and more economically. Wherever possible, I've used the quickest solutions we can find to achieve the results.

The work-throughs in the book vary from a single effect or technique to more complex projects comprising several individual techniques; these can be taken and used individually enabling you to pluck out a particular section to use with your own images.

At the end of each chapter you'll find an interlude in which I discuss an issue of relevance to the Elements artist. Some cover essential information about file sizes and types, color mode, and so on; others take a broader view. Think of them as light relief, and read them to save eye strain from staring at the screen for too long.

Who is the book for?

As the 'baby brother' to the full Photoshop CS6, Photoshop Elements has long suffered the stigma of being a cheap, unprofessional product. Cheap it may be, but it is certainly not lacking in features; well over 70% of those found in the full version of Photoshop and, as we've seen from user-created artwork, it's anything but unprofessional.

It's true that Elements is rarely used in a graphics studio or publishing company. But this is mainly because it doesn't include the high-end prepress features found in Photoshop; using Elements doesn't mean that you're working with a substandard application.

Some Elements users simply want to enhance their digital captures, perhaps adding a caption or two. But there are also those who want to take their work further: to explore the field of photomontage, and to make reality from the dreams locked in their heads. It's for these users that *How to Cheat in Photoshop Elements 11* will be of most benefit, helping them to release that potential and get their ideas out of their heads and onto the screen. As a montage application, Elements is only

as limited as your imagination. It can realize any montage you can conceive, as long as you have the technical skill required. I aim to provide you with that skill set, enabling you to unleash your creativity. Whether you're montaging missing family members into a group portrait, or creating a complex work of art, Elements can help you achieve your goal.

Where do I access the images and other files?

All the photographic images from the work-throughs in this book are available to download from the book's website:

http://www.howtocheatinphotoshopelements.com

So after reading about them you can open up the original files and experiment with them for yourself. There are also a number of Quicktime movies showing specific techniques in action.

The online content also includes a set of layer styles and custom shapes and actions that I've created in Photoshop. Although you can't create these effects in Elements, you can import them and apply them to your own artwork – and modify them to quite a large degree.

Going further

As well as the downloadable content on the website, you'll find the Readers' Forum. This is where you can post questions or problems, and exchange ideas with other readers: I'll also do my best to solve any Elements-related issues that may be troubling you. If you get stuck, either on a tutorial in the book or elsewhere in Elements, this is your first place to look for a solution.

David Asch
Brighton, 2012

How to use this book

I doubt if any readers of this book are going to start at the beginning and work their way diligently through to the end. In fact, you're probably only reading this section because your computer's just crashed and you can't follow any more of the work-throughs until it's booted up again. This is the kind of book you should be able to just dip into and extract the information you need.

But I'd like to make a couple of recommendations. The first four chapters deal with the basics of photomontage: making selections, working with layers, masks and distortion techniques. There are many Elements users who have never learnt how to make layer masks, or picked up the essential keyboard shortcuts. because I talk about these techniques throughout the book, I need to bring everyone up to speed before we get to the harder stuff.

Although the book is designed for users of Elements 11, most of the tutorials will apply to those who have earlier versions of the program as well. Despite its new look, the majority of Elements 11's tools have remained the same.

The techniques in each chapter build up as you progress through the work-throughs. Frequently, we'll use a technique that's been discussed in more detail earlier in the same chapter, so it may be worth going through the pages in each chapter in order, even if you don't read every chapter in the book.

The downloadable content icon on each tutorial page indicates that the source material for the project is on the website, so you can download it and follow the tutorial for yourself.

If you get stuck anywhere in the book, or in elements generally, visit the reader forum, accessed through the main website or directly via this address:

http://www.howtocheatinphotoshopelements.com/forum

This is where you can post queries and suggestions. I visit the forum every day, and will always respond directly to questions from readers.

Using keyboard shortcuts

Throughout the book I use the built-in keyboard shortcuts in Elements and it's really worth learning at least the most frequently used ones; they are there to help you work more efficiently. Not only is it far quicker to press a key to choose a particular tool or function, it also helps to save your aching wrists by avoiding the need for unnecessary mouse or pen movement. You can switch from tool to tool without leaving the area of the image you're currently working on, which also keeps your workflow more streamlined.

The Toolbox items all use a single letter for the shortcut, some correspond to the initial letter of their names, for example: T selects the Type tool, M selects the Marquee Selection tools; others are a little more obscure – J, for instance, selects the Healing Brush tools and F gives us the Smart Brush.

Given that we only have a relatively small amount of keys on the keyboard compared with the vast amount of commands in Elements, many features are accessed by adding what is known as a modifier key (or keys); these are pressed in conjunction with the letter or symbol key, giving each one the potential to have up to four different functions. Because the book is designed for users of both Windows and Mac and the modifier keys are slightly different on each platform, we list them color-coded: blue for Windows, red for Mac, in that order, along with their names: **ctrl** (control) and **alt** (alt), or in the case of the Mac, their symbols: **⌘** (command or Apple) and **⌥** (option or alt).

So to demonstrate: if we want to open the Levels dialog we would first hold down **ctrl** or **⌘** then press the L key. We show this in the book as follows: **ctrl L ⌘ L**. There are also combinations of modifier keys: the shortcut for Remove Color, for example, is **Shift ctrl U Shift ⌘ U** and for the Magic Extractor it's the finger-twisting **alt Shift ctrl V ⌥ Shift ⌘ V**!

Although the Shift key is the same for both Mac and Windows, we keep it in the relevant color when it's part of a multiple sequence, as in the above example, to avoid confusion. On their own, keys like this and also the Toolbox shortcuts are shown in black: **Shift**, **Enter**, **T**, **M**, **J**, **F** and so on.

What's new in Elements 11

THE PAST FEW RELEASES OF ELEMENTS, whilst boasting many new features in each, have been subtle upgrades with little in the way of obvious changes. With Elements 11, however, comes a major overhaul to the program. Here, we'll take a look at the most significant changes in the Editor. If you're new to Elements, this will all be fresh, of course!

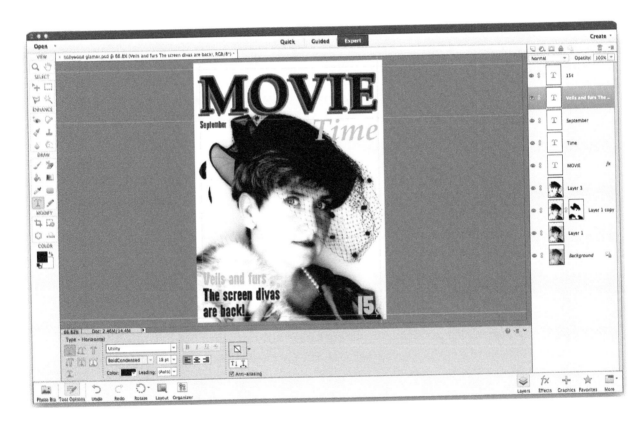

The user interface

The most prominent change is the program layout itself. It now has a fresh lighter color; replacing the much frowned-upon darker interface of the last five versions. On the whole the layout has stayed consistent, although there are a few important changes: Full Edit mode is now Expert mode; everything we do in the book takes place here. The Tool Options bar is now the Tool Options panel and is found at the bottom of the screen, sharing its space with the Photo Bin. Both can be hidden away to gain more space. The Toolbox is fixed to two columns and can no longer be floated into the workspace. Similarly, the Panel Bin on the right is now fixed; the different panels are now viewed individually by clicking their icons along the bottom of the screen. It is possible to switch back to the old floating style by switching to Custom Workspace from the More icon; this is highly recommended.

2

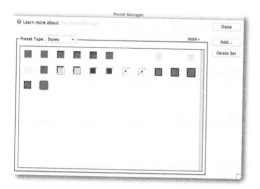

The Preset Manager

It's now possible to add Layer Styles using the Preset Manager. Although this is a relatively small change, it's an extremely welcome one. In the past the only way to do this required you to delve deep into the bowels of the computer's file system to copy in the styles, write arcane text files and delete databases; all so we could add some more inner shadows and a neon effect to our text!

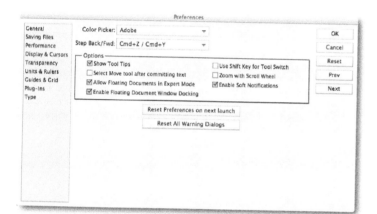

Program Preferences

We now have the option to enable floating window docking. Previously it was only possible to dock, that is to create tabs of different documents, in the main workspace. Floating windows can also contain multiple tabbed images.

Elements now has soft notifications. These display the last undo or redo action we performed. They can be helpful but if they become irritating we have the option to turn them off.

One other useful addition is *Reset Preferences on next launch*. Every now and then Elements can start behaving erratically; tools doing strange things, layer masks not working, and so on. This is usually due to the preferences becoming corrupt. Previously, the only way to fix this was to hold down ctrl alt Shift ⌘ ⌥ Shift, known as the three finger salute, as Elements was launching. This was a little tricky to perform. Now we can simply click the button and the preferences will be reset the next time we start Elements. Remember that this will take everything back to their defaults.

The Actions panel

Another noteable addition is the Actions panel. Previously, actions were only present in Elements in the guise of Effects. If you're unfamiliar with the concept, actions can be used to automate a particular process; usually one that performs a repetitive task.

Adding them in earlier versions required the same amount of technical know-how as adding layer styles. There was also the problem of some actions not working properly; particularly those written for Photoshop, which access commands that Elements does not have. We still can't record our own actions but installing them is now a whole lot easier.

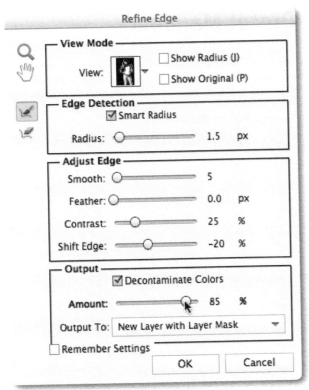

Refine Edge

Possibly the best addition to Elements' toolset in this release is an update to Refine Edge. Although we have had this since version 6, its feature set was really nothing more than a collection of the curently available tools, combined into one dialog.

With this release, we get the full functionality found in Photoshop CS6. We're no longer restricted to the standard selection refining tools, we now have smart edge detection. This analyzes the outline of the selected area to determine if it should be a hard or soft edge. We can adjust the size of the detection area to control its effect. What really makes it special is the Refine Edge tool. With this we can paint over an area to further expand the refinement area. Where this really comes into its own is when it's used with complex parts of an image such as hair and fur. Extracting images of people and animals from their background has never been quicker or easier!

Once the initial alterations have been made, we can fine-tune the selection further to give us near-perfect cutouts every time. Something that Elements has fallen down on up to now.

We also have the option to remove color contamination. This is where the colors of surround areas of the background have affected the edges of the subject; if they were standing next to a bright green sign, for example, it may reflect onto the skin. Finally, we have several methods to output the refined edge; a new layer, a layer with a mask defined from the selection, or just the selection itself.

We explore this amazing feature at length in Chapter 1.

The Lens Blur filter

Another feature that's finally made the leap from Photoshop to Elements is the Lens Blur filter. This differs from the other blur filters, which work in a very two-dimensional way, as it attempts to mimic the way a camera's lens sees the image. We can adjust not just the amount of blur but also use selections and masks to define the focal length of the lens. This gives us a far greater amount of realism and is great for salvaging images with busy, distracting backgrounds. We can also create depth of field effects that may have escaped us when we were taking the original photo. We'll be looking at this filter in more detail in Chapter 5.

New sketch filters

Elements has had sketch filters since version 1 and they haven't changed since then. The effects they produce are OK but nothing with a wow factor. Up until now, that is. Elements 11 has three new filters; Comic, Graphic Novel and Pen and Ink. Whilst Pen and Ink gives so-so results, it's the other two effects that give really excel, Graphic Novel in particular.

The filters are based on new technologies found in Photoshop CS6 and go beyond simple pattern effects. The image is analyzed for its tone and contrast; the filters extract the information on which they base the output. As a result the outlines have diminishing strokes, giving them the appearance of been drawn with a pen or brush. The colors are blended to give them an inked-in look.

Each filter comes with a set of presets; some better than others. They can all be fine-tuned manually, however, so we can tweak the image until we're completely happy with the results; which, on the whole, are astonishingly good!

Guided edit

Although this book encourages a hands-on approach to creating effects and montages, it's well worth mentioning the new effects in the Guided Edit module. Four new effects have been added; Vignette, High key, Low key and Tilt-shift. The results are often brash but the interesting point is their output.

After running through the steps and clicking done, you'd think you would end up with a single flattened image. This isn't the case; if we go straight into Expert mode, we have an image with each part on a separate layer. Not only can we make further edits, we also get to see how the effect was created and learn from it.

Getting up to speed

Regardless of your skill level it's always useful to have a refresher on the basics. I've used these two pages to not only document some of Elements' standard features but also to illustrate how they are used and referred to throughout the book.

The Layers panel

We use the Layers panel all the time when we're editing images in Elements. It displays all sorts of information about how layers interact with each other. It's worth taking the time to get to know how it works, and how to use the icons and settings to make our layers behave as we want them to.

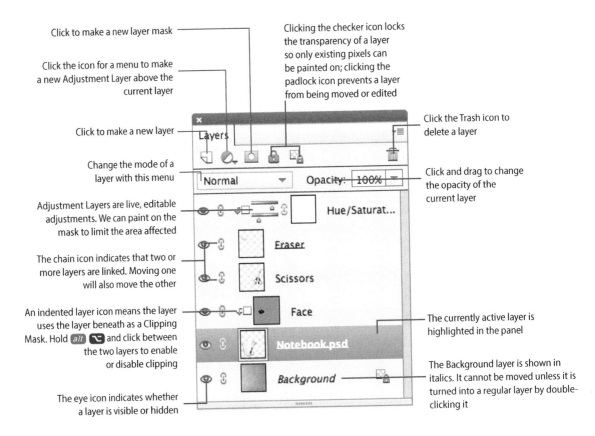

Click to make a new layer mask

Click the icon for a menu to make a new Adjustment Layer above the current layer

Clicking the checker icon locks the transparency of a layer so only existing pixels can be painted on; clicking the padlock icon prevents a layer from being moved or edited

Click to make a new layer

Click the Trash icon to delete a layer

Change the mode of a layer with this menu

Click and drag to change the opacity of the current layer

Adjustment Layers are live, editable adjustments. We can paint on the mask to limit the area affected

The chain icon indicates that two or more layers are linked. Moving one will also move the other

An indented layer icon means the layer uses the layer beneath as a Clipping Mask. Hold *alt* and click between the two layers to enable or disable clipping

The currently active layer is highlighted in the panel

The Background layer is shown in italics. It cannot be moved unless it is turned into a regular layer by double-clicking it

The eye icon indicates whether a layer is visible or hidden

The Toolbox

The Toolbox is the most important part of the Elements editor. Tools can be selected by either clicking their icons or pressing their corresponding keyboard shortcut.

In Elements 11 the Toolbox is fixed in the two column display. The different types of tool are now shown in distinct category sections.

Many of the tools have two or more options, denoted by a small arrow in the top-right corner of the tool's icon when you hover over their section. The associated tools can be switched between by selecting them in the Tool Options panel at the bottom of the workspace, pressing their associated keyboard shortcut repeatedly to cycle through them, or by holding *alt* ⌥ and clicking the tool in the toolbox to cycle through them.

The various settings for each tool are also found in the Tool Options panel.

Here is a list of the tools along with their shortcuts. These are mainly the same for both the Windows and Mac versions – differences are shown in color.

Zoom **Z** (or hold down *ctrl* ⌘ and the Spacebar to access it temporarily)

Hand **H** (or hold down the Spacebar to access it temporarliy)

Move **V** (or hold down *ctrl* ⌘ to access it temporarily)

Elliptical/Rectangular Marquee tools **M**

Freehand/Polygonal/Magnetic Lasso **L**

Magic Wand/Quick Selection Tool/Selection Brush **A**

Red-Eye Removal Tool **Y**

Spot Healing Brush/Healing Brush **J**

Smart Brush/Detail Smart Brush **F**

Clone Stamp/Pattern Stamp **S**

Smudge/Blur/Sharpen **R**

Burn/Dodge/Sponge **O**

Brush/Impressionist Brush/Color Replacement Tool **B**

Eraser/Background Eraser/Magic Eraser **E**

Paint Bucket **K**

Gradient Tool **G**

Color Picker Tool **I**

Custom Shape/Rectangle/Rounded Rectangle/Ellipse/Polygon/Star/Line/Shape Selection tool **U**

Horizontal Type/Vertical Type/Horizontal Type Mask/Vertical Type Mask/Text On Path Tools **T**

Pencil **N**

Crop **C**

Recompose **W**

Straighten **P**

Swap foreground & background colors **X**

Foreground color

Background color

Set default foreground & background colors **D**

1

Selection techniques

WORKING IN PHOTOSHOP ELEMENTS almost always involves making selections. Whether you're combining images from several sources into a single montage, or simply replacing an overcast sky with a bright sunny one, you need to make selections within your image.

Elements offers a range of tools for the purpose. Some are automatic, and will find areas of similar color; some involve tracing around an object's edge; some combine the two methods, making complex selections easy to do.

Whether you're new to Elements, or an old hand, it's worth your while going through this chapter to make sure you're up to speed on the selection methods that are available to you.

1 Selection techniques
Basic selections

IMAGE: **CLOCK – CEZARY GRESZKO (SXC.HU)**

THE MOST BASIC SELECTION TOOLS in Elements are the Rectangular and Elliptical Marquee tools. With them we can quickly select objects or areas in an image by simply clicking and dragging out the tools' boundaries on the image.

In this lesson we'll use the Marquee tools to select some objects on a wall. We'll see how we can create selections using the tools' unconstrained drawing modes and also their constrained modes, for drawing perfect squares and circles.

DOWNLOADS

Basic selections.jpg

WHAT YOU'LL LEARN

- Creating basic selections with the Marquee tools
- Using modifier keys to alter the tools' drawing mode

1 We'll begin by selecting the rectangular picture on the left of the image. Select the Rectangular Marquee tool **M**. Place the cursor on the top-left corner of the frame. Now click and drag down to the bottom-right corner, keeping the mouse button held down. When the whole frame is selected, we can release the mouse button to make the selection.

2 Next, we'll make a selection around the square picture. Press *ctrl* D ⌘ D to deselect the first frame. Position the cursor at the top-left and drag down. Keeping the mouse held down, press and hold the *Shift* key. The outline will snap to a square shape; usually referred to as constraining the proportions. Release the mouse first, then release *Shift*. If we don't do it in that order, the selection area will snap back to its original freeform shape.

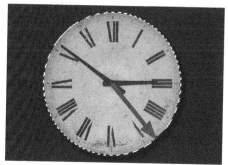

3 Deselect again. Switch to the Elliptical Marquee tool; we can do this by pressing **M** again, or by selecting its icon in the Tool Options panel. When we start to draw the selection from the edge of the clock face, however, we have a problem. Rather than keeping to the edge of the clock, the boundary begins to shift inside. This is because it's still based on a rectangular guide, so we would have to start from an imaginary corner, which is not at all easy to do!

4 We'll use a different method instead. Press *ctrl* D ⌘ D to deselect. Now position the cursor in the very center of the clock face; we can use the pin of the clock's hands as a guide.

5 We'll begin to draw out the selection. We want a perfect circle, of course, so we'll hold down the *Shift* key to constrain the proportions. Now, as well as *Shift*, we'll also hold down the *alt* ⌥ keys. This forces the selection to draw out from the center, around the original cursor position. We can now select the clock perfectly. Rememeber to release the mouse first, then release the keys.

HOT TIP

You don't need to use the Deselect command when you're drawing individual selections; by default, the drawing mode is set to new, which will automatically clear the previous selection. It is worth getting into the habit, however, as it can prevent unwanted mishaps when using different tools.

Combining selections

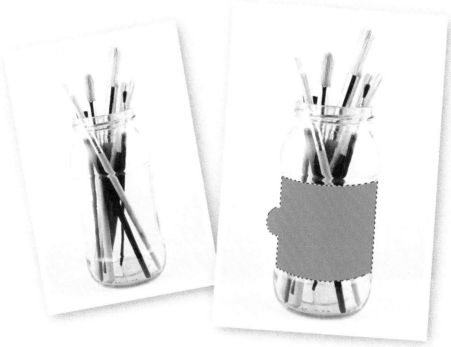

A S WELL AS CREATING individual selections of objects, we can also have them interact with each other to create more complex and irregular shapes.

There are three selection modes that we can use:

Add: Any area of the new selection that extends outside the original selection will be included.

Subtract: Removes the area of the original selection where the new selection overlaps.

Intersect: Anything within the area of the new selection is kept. All areas outside of this are removed.

These can be initiated in one of two ways: we can either use keyboard modifiers, or select the appropriate icon from the Tool Options panel; we'll refer to both throughout.

WHAT YOU'LL LEARN

- Using the different selection drawing modes to create more complex shapes.
- Quickly changing drawing modes using modifier keys

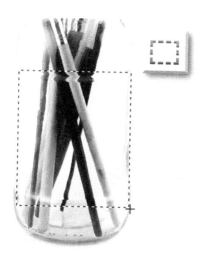

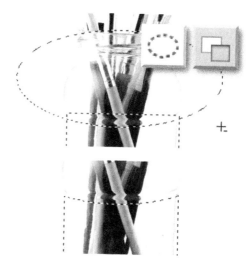

1 We'll begin by using the Rectangular Marquee **M** to draw out a rough outline of the label. Make sure the area extends further above and below where we want the label to appear on the jar, as we need space for the trim; we can use the jar's moulding as our guide.

2 Next, we'll trim away the top of the label. Switch to the Elliptical Marquee by pressing **M** again. Hold down *alt* *⌥*. This puts the selection in Subtract mode. Now draw out an ellipse so the bottom follows the curve of the jar; again, using the moulding as a guide. When we release the mouse, the top of the label is trimmed to the curve.

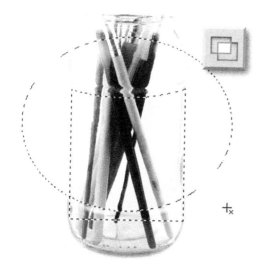

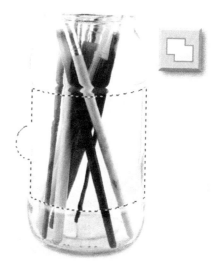

3 Now for the bottom of the label. Hold *alt* *Shift* *⌥* *Shift* to switch to Intersect mode. Draw out another ellipse, this time following the bottom moulding of the jar. Make sure the entire label above is inside the selection; if we don't do this, those areas will be removed as well.

4 Here's the result: Everything within the area of the ellipse has been retained. The section of the label at the bottom, that was outside the selection area has been trimmed away. To demonstrate Add mode, we've drawn a small tab on the side by holding *Shift* before drawing another ellipse.

HOT TIP

When drawing selections that need to be precisely positioned, as with the ellipse in step 2, we can move the selection area by holding down the Spacebar. Instead of changing size or shape when you move the mouse, it will move the boundary around.

Selection techniques

The Lasso tools: part 1

IMAGE: **AMMINOPURR (SXC.HU)**

SO FAR WE'VE SEEN how to make selections where the objects are two-dimensional with perfectly straight edges, or circular. This isn't always the case, of course; more often than not the subject will be at an angle or irregularly shaped. Fortunately for us, Elements has a range of far more versatile selection tools. We'll be exploring these over the next few pages.

We'll begin with the Lasso tool. In this lesson we'll cover two of its three modes: freehand and polygonal. Freehand is, as you'd expect, completely unrestrained; you draw, it follows. It's a little clumsy to use, however, even with a graphics tablet. It is better for making relatively small selections, and for making repairs to existing ones. The Polygonal Lasso is far more useful. In this mode you click to set a point, when you move the cursor, a straight line follows to the next point, and so on. This is great for making quick selections of edges that aren't at precise right angles.

WHAT YOU'LL LEARN

- Creating selections with the Freehand and Polygonal Lasso tools.
- Using modifier keys to temporarily switch between the two tools while you draw.
- Constraining the selection path to a right-angle

1 We'll start our selection on the yellow pencil. Choose the Polygonal Lasso tool *L*. Click once at the bottom of the pencil to set the first anchor point. As this is a vertical edge, we can hold down *Shift* as we drag the cursor up to constrain the tool to a straight line (we've enhanced the path here to make it clearer). Pause when you reach the edge of the shaved wooden area but keep *Shift* held down for now to ensure the path stays straight.

2 Click the mouse once again to set a new anchor point. We can release *Shift* now. Drag the cursor up to where the point of the pencil changes direction. Click the mouse again to set a new anchor point. The point of this pencil is fairly angular, so we can carry on clicking around it with the Polygonal Lasso tool to select it.

3 Carry on to the pink pencil, clicking to set points as before. When we reach the the tip, we can see its a more rounded. We'll switch to the Freehand Lasso. Click and hold the mouse. Now, holding *alt*, trace round the top of the pencil. As we do the cursor changes and creates a path that follows the mouse movement. When we reach the straight edge, release the key to return to the Polygonal lasso again.

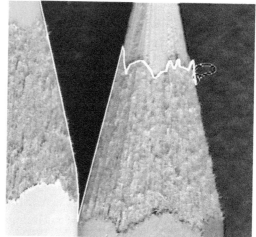

4 Continue selecting the other pencils, alternating between the two tools where necessary. Here, we've used the Freehand tool to select the rough shaved area instead of the point. Complete the selection by clicking and dragging from the base of the blue pencil, back to the yellow pencil.

HOT TIP

It can be fiddly switching between the two Lasso tools on the fly. A simple alternative would be to square off the selection to begin with. Once the selection is complete, you can go back and add or subtract from the selection using the other tool.

The Lasso tools: part 2

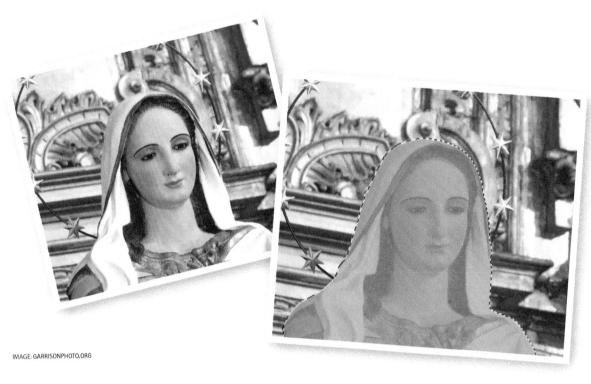

IMAGE: GARRISONPHOTO.ORG

ON THE PREVIOUS PAGES we saw how the Freehand and Polygonal Lasso tools can be used together to select more complicated shapes; particularly where there are a lot of straight edges but what if the object you need to select has large areas of curves? You could try the Freehand lasso but you'll need a lot of patience and a steady hand to draw the outline. There is another method: the Magnetic Lasso is a variant. As its name implies, this tool sticks to the edges of shapes as you draw around them, making the process of cutting objects or people from their backgrounds very much simpler.

The tool isn't perfect, by any means; it's almost impossible for any computer program to figure out the difference between foreground and background objects with any degree of accuracy. But it's a real time-saver, and can be used to make quick selections with ease.

DOWNLOADS

Madonna Statue.jpg

WHAT YOU'LL LEARN

- Using the Magnetic Lasso to make assisted selections
- How to correct mistakes in the selection

1 Start in one corner of the statue and trace along the edge of the object, sticking as close as you can to it. We've zoomed in here and enhanced the Magnetic Lasso edge to show it more clearly. The tool places square 'anchor points' each time it marks a change in direction.

2 Right away, we hit a problem: when we get to the shoulder, the Magnetic Lasso wants to follow the gold bar, rather than the paler white cloth. No need to start again; simply press *Backspace* to remove the last placed points; backtracking until we reach the place where it branched off.

3 We can now force the tool to go in the direction we want. Drag a little way up the perimeter, and before Elements places another point, get in first by clicking the mouse button to place one of your own. Continue doing this until the tool recognizes the direction in which you're going.

4 We'll hit a few more of these snags as we work our way around the figure; they occur each time Elements finds a strong line to follow. Once again, it's not a problem; simply delete the misplaced points, and then click the mouse button to add your own.

5 To make it easier to trace the outline, press the *Caps Lock* key on your keyboard. This will change the Magnetic Lasso cursor to a circle, which shows the perimeter of the area in which it searches for boundaries.

6 When you get to the end of the object – in this case, the bottom right corner, hold *alt* ⌥ and click once. This switches to the Polygonal Lasso tool; you can now move the cursor straight across to the starting point. Click once again to close the selection with a straight line.

HOT TIP

There are several options that can be adjusted to affect how the tool behaves. In most situations it's usually OK to leave them at their defaults; it's likely to take more time to refine the settings than it would to make quick repairs afterward.

Selection techniques

The Magic Wand

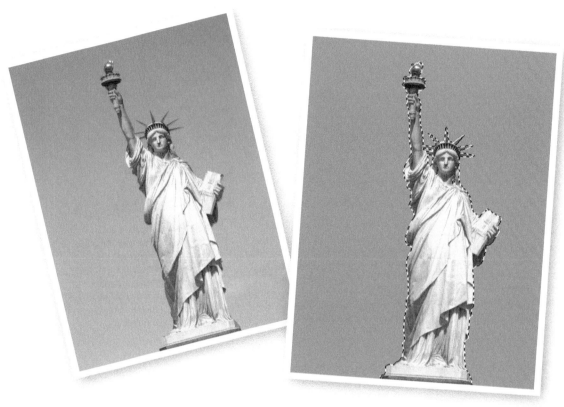

IMAGE: **TOMAS LARA (SXC.HU)**

CONTINUING ON from the previous pages, we'll now look at the Magic Wand tool and the Selection Brush. The Magic Wand has been around for many years and is often maligned for its clumsiness. It is, however, perfect for selecting large areas of an image with a minimum of fuss.

The Selection Brush, as its name implies, lets us paint with a selection, just as we would with the regular paint brush tool. It would be a bit of a chore to make large selections solely with this tool but, as we'll see here, it is particularly useful for tidying up and repairing stray areas of a selection.

WHAT YOU'LL LEARN

- Making selections with the Magic Wand
- Adding to selections
- Using the Selection Brush to tidy stray areas

1 Begin by selecting the Magic Wand **A**. We'll start the selection by clicking on an area of the sky. It's done a reasonably good job already.

2 To add in more areas we hold the down the *Shift* key whilst clicking. We now have most of the sky, leaving only a small area of cloud to take care of; again, we can hold *Shift* to add it in.

3 Adding the section of cloud has also included part of Liberty's robes. This often happens where the contrast in tone between areas is low. We'll fix this later.

4 There are a couple of areas missing inside the crown and between the neck and hair. Again, we simply need to hold *Shift* and click inside those areas.

5 Let's sort out the area where the selection has bled into the robes. Choose the Selection Brush **A**. We can change the brush size by tapping **[** to reduce it and **]** to increase it.

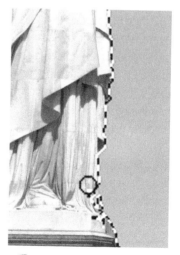

6 As we selected the area around Liberty, we need to subtract from the selection. Holding *alt* ⌥ paint over the affected area inside and up to the edge of the robes to remove it.

HOT TIP

As with all of the selection tools in Elements, you can subtract from a selection by holding down *alt* ⌥ as you paint. If, however, you have the tool set to Subtract in the Options panel, holding *alt* ⌥ temporarily switches it back to Add mode.

The Quick Selection tool

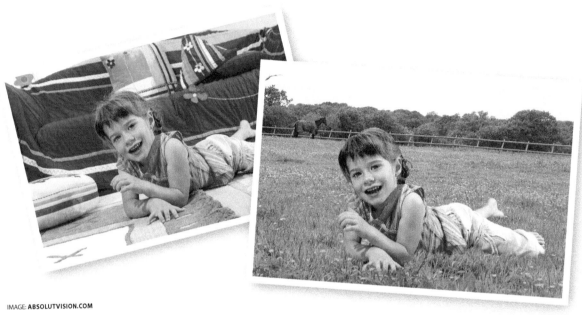

IMAGE: **ABSOLUTVISION.COM**

THE QUICK SELECTION TOOL may well be the fastest method yet for cutting a person or object away from the background.

We've seen several selection methods already in this chapter, but they all involve a fair amount of work on the part of the user. The Quick Selection tool can help the process of lifting a complex subject from a complex background, quickly and painlessly.

The image we'll work with here is of a girl in her bedroom. It's a tricky selection to make: both the girl and her surroundings have a similar range of colors and tones, making it harder for automatic selection to take place. But even in cases like this, we can perform the function with ease, with only a small amount of manual adjustment needed.

DOWNLOADS

Girl in Pink.jpg

WHAT YOU'LL LEARN

- Using the Quick Selection tool
- Changing the drawing mode to add and subtract areas of the selection
- Using the Selection Brush to fix more difficult sections

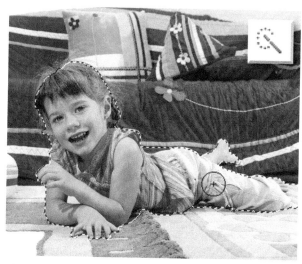

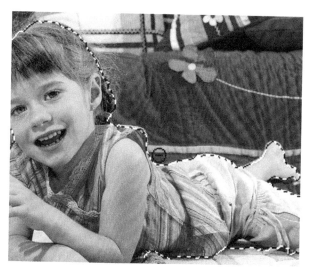

1 Start by choosing the Quick Selection tool **A**. Make sure Auto-Enhance is enabled in the Tool Options panel. This gives us a better selection, with only a slight expense of some perfomance. Start to paint over the girl. As we do, the selection spreads out automatically. It's made short work of this. There are a few areas where the selection spills out onto the background; this is due to the close similarities in color.

2 To fix the areas where the selection went too far, we'll switch to Subtract mode. We can do this by holding down **alt** ⌥, or setting it in the Tool Options panel. Decrease the size of the brush a little using the left square bracket key **[**. Now we'll paint along the outside edge of the affected area. As we do the selection will start to snap back to the girl's outline.

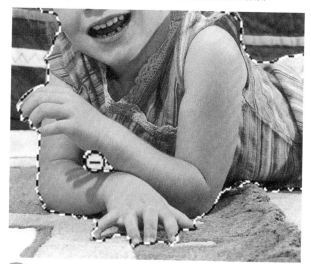

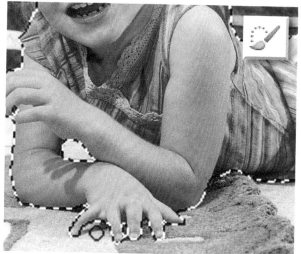

3 There's an area between the girl's arms that was missed; again because the tones are very similar. This is easily fixed with a single click inside. There are still some areas, such as the fingers, that need to be cleaned up. Although we could attempt to do this with the Quick Selection tool, it can be a little hit-and-miss; we'll address them next.

4 To finish off, we'll switch to the Selection Brush **A**. For adjusting the areas that spill outside, we need to use Subtract mode. For those areas inside that don't go up to the edge, we'll use Add mode. We can adjust the size of the brush using the square bracket keys **[** **]**. It's also a good idea to zoom in **Z**, to make sure we get the selection right.

HOT TIP

We can improve the tool's accuracy by first making a small selection inside our subject. Then, holding **alt** ⌥ to switch to Subtract mode, we trace the outline of the subject with a smaller brush, being careful not to touch the edges. This helps the tool to determine what not to include in the selection.

Selection techniques
Working with Refine Edge

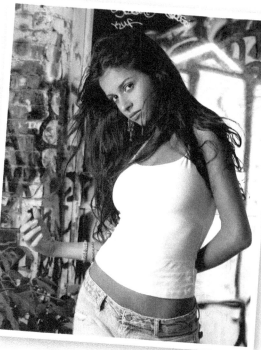

IMAGE: **ABSOLUTVISION.COM**

R EFINE EDGE MADE ITS DEBUT in Elements 6. Back then it was fairly basic and was really just a unified dialog for the existing selection modifying commands, along with the ability to view the selection in a number of different modes. It's remained almost the same up until now.

With Elements 11 we get the very latest version, the same as Photoshop CS6 in fact. This is far removed from its predecessor, with many more features; the most outstanding of which being the edge detection tools. These make light work of previously complex and time-consuming tasks such as extracting hair, fur and other similarly complicated items from their backgrounds.

In this lesson we'll extract a photo of a woman from a plain gray background and place her onto a another photo, blending seamlessly into the image.

WHAT YOU'LL LEARN

- Using the Refine Edge dialog to create perfect cutouts
- Editing selections of hair to blend into the background
- Tidying up rough selection edges and halos

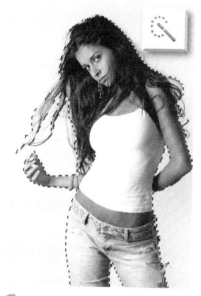

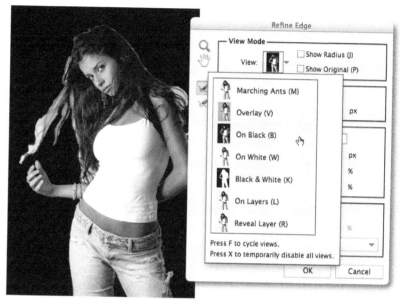

1 We've begun by making a selection of the girl using the Quick Selection tool. We've cleaned up the selection as much as possible using the techniques from the previous pages in this chapter.

2 Open the Refine Edge dialog, either from the Tool Options panel, or from the Select menu. We can choose to view the cutout on a variety of backgrounds using the View Modes. We'll choose black as the original background is light; the problem areas will be more visible. The most obvious problem is the hair. There are large chunks of grey and the edges are far too harsh. This would look dreadful and unrealistic if we pasted it into another image.

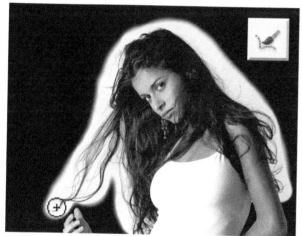

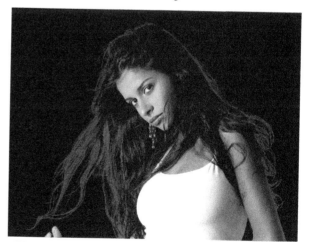

3 Here's where Refine Edge really comes into its own. Grab the Refine Radius tool from the left of the dialog box (or press **E**). We'll begin to paint over the area around her hair. As we do, the gray starts to return. This won't show up in the final image, it's just telling the tool to rethink the boundary areas of the selection.

4 When we release the mouse we can see a vast improvement. The solid gray background has almost disappeared completely. We can also see that the edge of the hair is much softer and we've also brought back the wispier areas that were previously omitted. It's not perfect yet, we'll be looking at fine-tuning the effect on the next page.

HOT TIP

The view mode that you choose depends greatly on the image you are working on. Black works best for this image as the original background was much lighter; so the trouble spots are much clearer. You can cycle through the modes by pressing **F**. Pressing **X** will toggle the effects on and off.

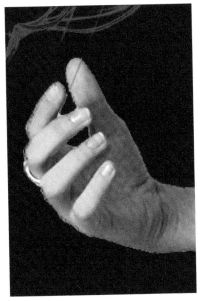

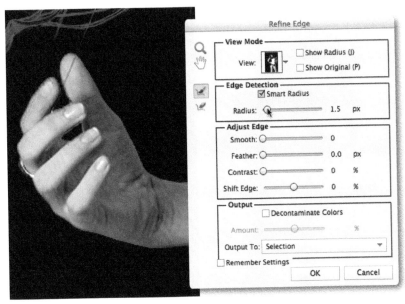

5 We'll move away from the hair for now. Looking at other areas of the image we can see it's a little jagged in places. This often happens when using the automatic selection tools. We'll work on them next.

6 We can modify the outline of the image using the Edge Detection control. First, click the Smart Radius checkbox. This helps Elements to distinguish between existing hard and soft edges in the image. Now we'll increase the Radius slider. Refine Edge will now examine a wider boundary around the edges of the subject. This only needs to be a slight increase, 1.5 pixels here. We can see the edge is a lot smoother now.

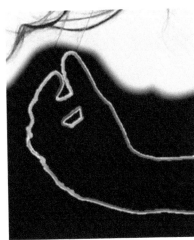

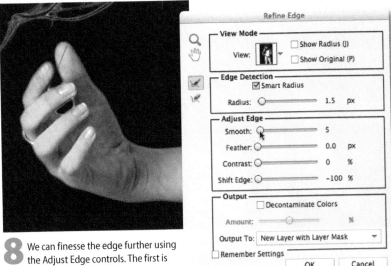

7 We can see how the edge detection works by clicking Show Radius (**J**). The outline displays the area it covers, both inside the hand and outside. Elements analyzes the area to determine where the borders are.

8 We can finesse the edge further using the Adjust Edge controls. The first is Smooth. This further softens the sawtooth effect. Again, we only need to increase it a little to get a good effect; 5 pixels works well in this instance, we don't want to overdo it.

HOT TIP

The Edge Detection control is useful when we need to correct the outline of the whole object. It's more controllable than the Refine Radius tool, which is better suited for softer areas such as hair, and for making localized spot repairs.

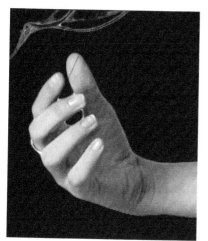

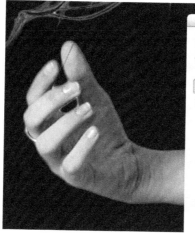

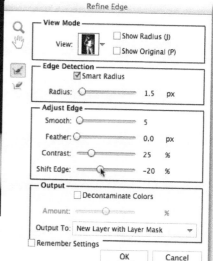

9 Smoothing the edge has cleaned up the jagged appearance but has also made it a little fuzzy. Go down to the Contrast slider and increase it to around 25%. This tightens the selection boundary.

10 There's still a halo around the edge. We can fix this by dragging the Shift Edge slider to the left. This pulls the selection back towards the subject. We don't want to decrease it too much, as it will start to cut away too much. Around -20 works well here.

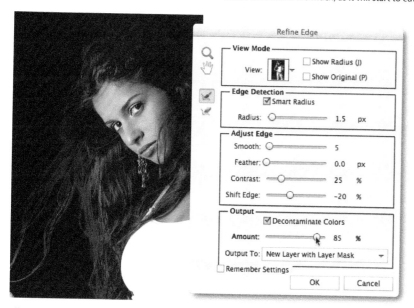

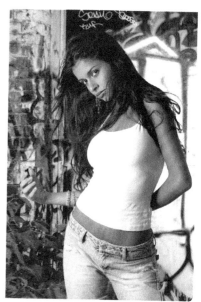

11 Going back to the hair, we can still see a small amount of gray around the edges. This is a combination of the selection boundary and also some natural reflection when the photograph was taken. For this we'll use the Decontaminate Colors control. Check its box to enable it. Now push the slider to the right. As we do so, the gray in her hair starts to disappear. We'll leave it at around 85%. We're almost finished.

12 Finally, we can choose how to output the image. The best method is New Layer with Layer Mask. This option lets us make further edits at a later stage. We'll learn more about masks later in the book.

HOT TIP

When you're working with a solid color background within the Refine Edge dialog, the edges around hair and other softer areas can still look unrealistic. Once the image is placed against a more complex photo, the fringes will blend away.

25

Protecting with selections

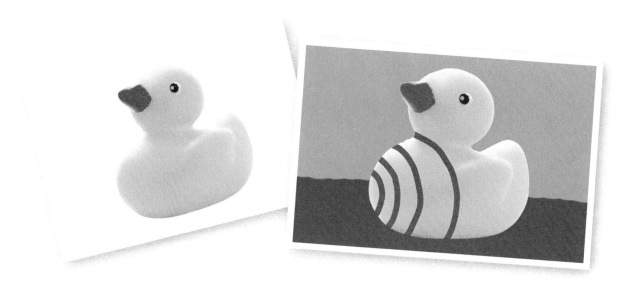

IMAGE: **ABSOLUTVISION.COM**

S O FAR IN THIS CHAPTER we've looked at how to make selections using a variety of methods. Here, we'll look at what we can do with those selections when we've made them.

As well as being used to extract areas of an image from their background, selections can be used to contain, isolate and protect an area; for painting and filling localized parts of the image with color, for example. They can also be used in conjunction with filters and other effects. We'll be exploring these throughout the book.

Here, we'll see how to use a selection as a protective boundary around an object. We'll see how we can freely paint over the background without worrying about painting over the subject. We'll then inverse the selection, allowing us to paint the object but protect the background.

DOWNLOADS

Plastic Duck.jpg

WHAT YOU'LL LEARN

- Using a selection to protect an area of an image
- Inversing the selection to reverse the protected areas

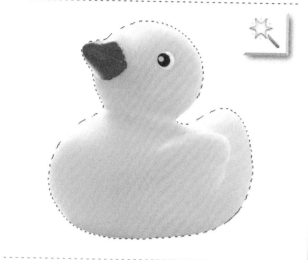

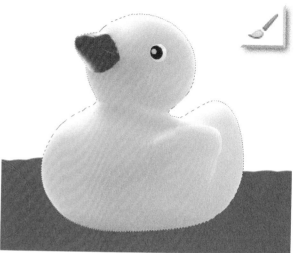

1 We'll begin by using the Magic Wand **A** to select the area around this plastic duck. As it's on a white background we can do this with a single click.

2 Grab the Brush tool **B**. Select a foreground color by clicking the chip in the Toolbox; we'll use a dark blue for the water. When we paint over the image, only the area outside of the duck is affected.

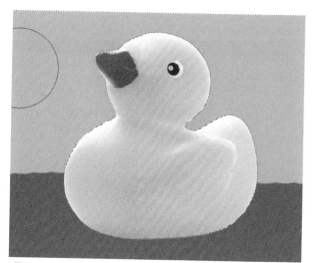

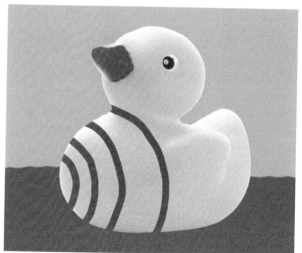

3 Select a lighter blue as the foreground. Now paint the sky in. We can overlap the water we painted before but we still can't paint over the duck.

4 Invert the selection by pressing _ctrl_ _Shift_ _I_ _⌘_ _Shift_ _I_. Choose a new foreground color; red is good. Choose a smaller brush. Now draw some circles on the duck. This time, it's the background that's protected. We only see the part of the circle inside the selection.

HOT TIP

You can toggle the visibility of the selection boundary by pressing _ctrl_ _H_ _⌘_ _H_ or by choosing Selection from the View menu. This is useful if you find it distracting when working on fine details within a selection.

Filling and replicating

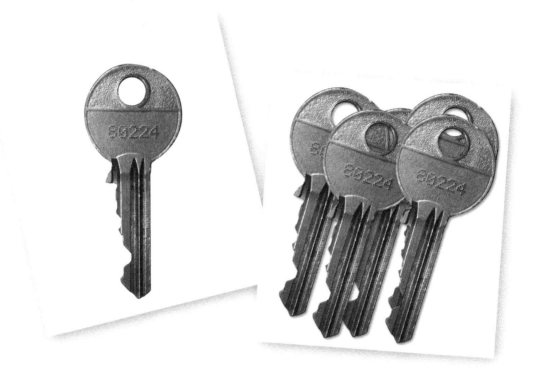

CONTINUING THE THEME of the previous lesson, we'll now take a look at some advanced ways we can use a selection to isolate parts of an image. Here we'll be looking at how we can use selections along with the Fill dialog to create more complex effects; we'll be making a shadow for key in this example.

We'll also see how we can quickly create multiple copies of an object. This can be used to make repeating patterns for a background image.

WHAT YOU'LL LEARN

- Recalling the selection area of an object
- Moving a selection around
- Applying a soft edge to a selection
- Using different modes of the Fill dialog to create a shadow
- Replicating a selected object using the Move tool

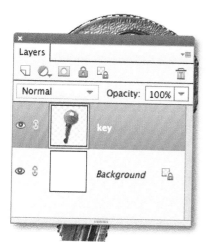

1 Make sure the Key layer is highlighted by clicking its entry in the Layers panel. As the key is on a separate layer, we can recall its selection by holding *ctrl* ⌘ and clicking its layer thumbnail. This is often referred to as 'loading up' the selection.

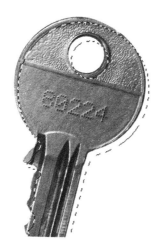

2 Grab one of the selection tools. We've picked the Lasso tool but it doesn't matter which one you use. Now tap the cursor (arrow) keys to nudge the selection. This will mark our shadow area. Around 5 pixels to the right and 5 pixels down should be enough.

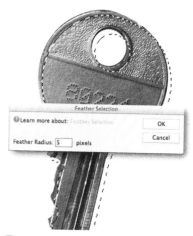

3 We need to soften the selection, otherwise the shadow will be too harsh. Go to the Select menu and choose Feather. Set the Feather Radius to 5 pixels. Click OK to apply. We don't see much difference as Elements can't display the feathered edge as a border.

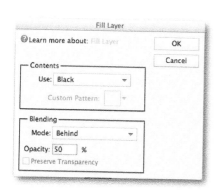

4 Open the Fill dialog from the Edit menu or by pressing *Shift Backspace*. Set the Contents to black. Choose Behind for the Blending mode; this only fills the empty area of the selection, leaving the rest intact. Set the Opacity to around 60%. Now click OK to apply.

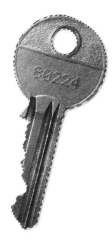

5 We have a soft shadow. This is a permanent part of the object now. We need to reload the selection before we make our copies, otherwise we'll lose part of the left side where we nudged it. This is done simply by *ctrl* ⌘ clicking the thumbnail again.

6 Switch to the Move tool *V*. Holding down *alt* ⌥, click and drag the key. As we do, a duplicate will be made. We can do this as many times as we want to quickly create repeating patterns.

Sometimes you may find that using the cursor keys doesn't nudge the selection. This is due to a bug in Elements. Most times, clicking onto another tool and back to the selection tool will clear this. Alternatively, you can click and drag the selection into place; as long as you have a selection tool active.

Setting up Elements

WHEN YOU BUY MOST APPLICATIONS, you can just install them and run them straight out of the box. (Or out of the zip archive in which you downloaded them, if you prefer.) And so, to some extent, you can with Elements; but there are a few tricks you can do to make the experience more comfortable.

It isn't that Elements is a particularly awkward program, but that since it involves working with images, it's memory hungry. It will happily gobble up all the RAM (memory) you allocate to it, and then sit panting for more. If it can't find any more real memory, it will settle for virtual memory, using vast chunks of your hard disk to store temporary files while you're working. These 'scratch' files, as they're called, are slotted in around the other files on your hard disk, and are then deleted when you quit Elements. The more fragmented your hard disk, the more pieces these files will end up in, and the slower Elements will run. In the Interlude following Chapter 2, we'll look at the best way of coping with scratch files.

The Elements interface can be customized in a number of ways. Normally, you probably wouldn't bother to mess around with the interface of your applications – after all, the people who designed the program probably know it better than you do, so why not just trust their judgment and leave things as they are? Well, believe it or not, the people who designed Elements don't seem to spend that much time actually working in it. If they did, they wouldn't have the Project Bin turned on by default. Sure, it gives you access to all your currently open files, but it uses up an inch or more of valuable real estate. And that's an inch you could be using to view your pictures that much larger. Turn it off; you don't need to have it permanently on view. You can always pop it open when you need it. The same is true of the new Tool options panel; by default, this appears whenever you choose a new tool, even when it's hidden! Fortunately, we have the ability to stop this behaviour; there's a setting in its fly-out menu.

When you first install Elements the Panel Bin, down the right-hand side of the screen, is fixed; you can't add, remove or even resize the panels. This means you end up with floating panels for everything else. Again, this can be changed: click

Tabbed windows give extra space for the image

Tabbed Panel Bin lets you stack your most used panels for quick access

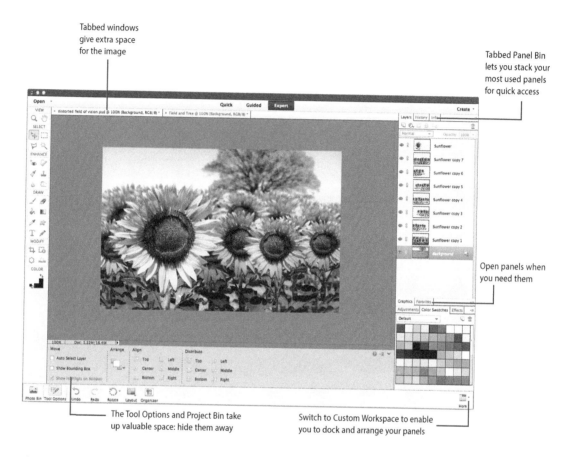

Open panels when you need them

The Tool Options and Project Bin take up valuable space: hide them away

Switch to Custom Workspace to enable you to dock and arrange your panels

the arrow next to More in the bottom-right corner and select Custom Workspace; you can now add and rearrange your favorite panels. Remember to collapse them to just their title bars when you're not using them: they take up a lot of space, and you want to give the maximum amount of space to the Layers panel. When you have a document with a lot of layers in it, consider reducing the size of the thumbnails (using the pop-up menu at the top of the panel) to fit more in.

The tabbed window view is a great space-saver, giving you as much viewing area as possible. If, however, you prefer to work with the classic floating window setup, you will need to initially enable it in Preferences. This is found under General > Allow Floating Documents in Full Edit Mode.

Unfortunately, there's no way to save your custom layout other than Elements remembering it when you close the program. This means if you have to reinstall, reset the program's preferences, it will all be undone. Luckily it's not something you have to do frequently – just watch out for that Reset Panels button!

2

Working with layers

WHEN CREATING A MONTAGE, layers are probably the most important part of the process. Aside from the design itself, of course. Without them, creating complex composite images would be a slow and difficult process. Think of layers as individual celluloid sheets: each one can be laid on top of (or beneath) another to build up the artwork. These can be manipulated independently without affecting the rest of the picture. There are many different types of layer, too, as we'll see.

We'll be exploring techniques that demonstrate the many functions and abilities of the main layer types. Beginning with the basics and on through to more advanced concepts, we'll see how layers are created, controlled and can be made to interact with each other in a variety of different ways.

Introducing layers

IMAGE: **SANDWICH – ABSOLUTVISION.COM; BREAD SLICE – PASCAL THAUVIN (SXC.HU); TOMATOES – WIKIMEDIA COMMONS**

THE CONCEPT OF LAYERS can be a tricky thing to get to grips with; we are, after all, used to creating artwork on the more traditional mediums of paper or canvas, where everything takes place on a single surface. This is unforgiving when it comes to versatility, however. If we make a mistake it's usually irrevocable and we either have to start again, or cover up the error in some other way.

Layers give us much more freedom in our work. We can build up our designs on different levels; it's like using pieces of tracing paper placed on top of one another. Each sheet can contain a part of the final image but is independent of the rest. There are numerous benefits to making images in this way. Each part can be freely repositioned, edited or hidden at will. We can also apply filters and effects that only affect certain parts of the image. If we make a mistake or decide we're not happy with the result, it's far easier to correct if it's on a layer.

DOWNLOADS

Layer Sandwich.psd

WHAT YOU'LL LEARN

- The basic concept of layers
- Changing the visibility of layers
- Building up an image in stages

1 When we first open the image file all we have is a plain white background. If we look at the Layers panel, however, we can see five stacked thumbnails above the background. These are all additional parts of the document but they're currently not visible. We can tell if a layer is hidden by the state of the eyeball icon to the left of its thumbnail. If there is a line through it, the contents of the layer won't be visible.

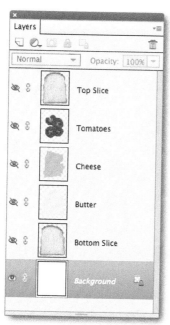

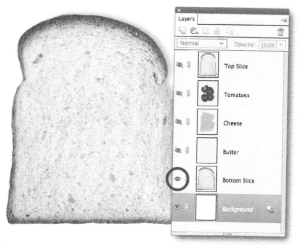

2 If we click the eyeball icon of the Bottom Slice layer the line through it disappears and it becomes visible. This is sitting directly above the background layer. We can still see the background beneath it because the area around the slice of bread contains no pixels; this is denoted by the gray checkerboard pattern.

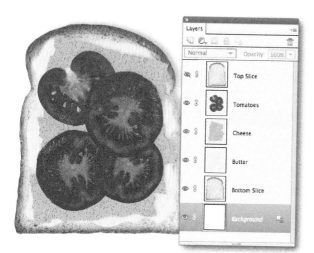

3 When we make the rest of the layers visible, continuing with the Butter layer, the different components of the image start to build up. Each part sits above the last in the same order that they appear in the Layers panel. We've left the last layer – the top slice of bread – hidden here as it would obscure the rest of the image.

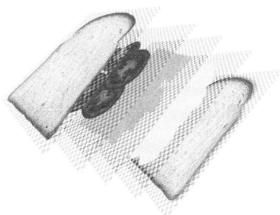

4 If we could see the layers of our completed image laid out in three dimensions, they would appear as something like this. We've included the checkerboard pattern of the transparency in the illustration to show the overall layer dimensions and how they relate to the dimensions of the document; it will never show up in your images.

HOT TIP

Rather than clicking each eyeball in turn, if you keep the mouse button held while moving up the panel, they will all be hidden in turn. If you just want to see a layer on its own, press *alt* ⌥ while clicking its eyeball. This will turn the rest of the layers off. Repeat the action to make them visible again.

Repositioning layers

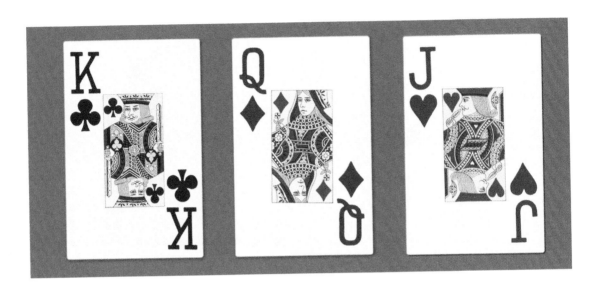

O N THE PREVOUS pages we looked at how a layered image is constructed. We saw how layers can be turned on and off to change the appearance of the design.

The positions of the layers within a document aren't rigid, of course. We can change the order in which the layers appear, so they can be placed in front and behind one another. They can also be moved around the document to place them exactly where they are required in the artwork.

WHAT YOU'LL LEARN

- The differences in basic layer types
- Changing the order of layers within a document
- Repositioning the layers with the Move tool

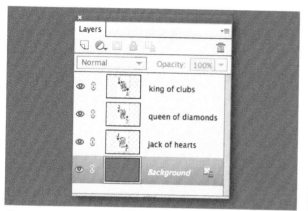

1 Before we begin, it's worth talking about the Background layer. Although it behaves in many of the same ways as the other layers in the document, it differs in a couple of ways. It is always at the bottom of the layer stack. By default it is locked in position (denoted by the lock symbol); if we try to move it, we will get an error. Think of it as your base canvas; a single color, a pattern, or a photograph to build upon.

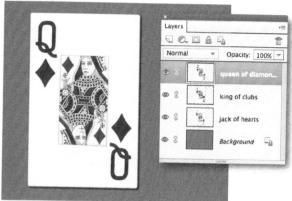

2 We start with the king of clubs at the top of the layer stack. We'll change the order in which the cards appear. Go to the Layers panel. Click and hold the mouse on the queen of diamonds' thumbnail. Now drag it up over the king's thumbnail. A solid line will appear above it to indicate the new position. When we release the mouse, the queen will be dropped at the top and become the frontmost layer.

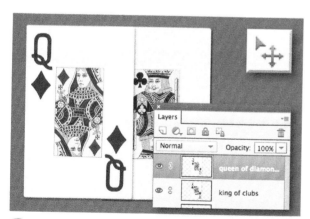

3 Currently we can only see one of the three cards, as they are stacked directly obove each other. Grab the Move tool **V**. Go over to the document. Now click and hold the mouse. When we drag the mouse, the queen will move around the image. If we also hold **Shift** while we drag, the movement is restricted to 45° angles. Notice how the queen's position has changed in the layer thumbnail.

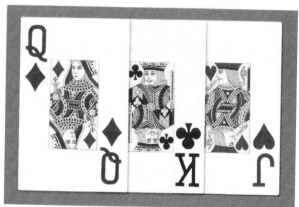

4 We don't need to be working with the topmost layer to be able to alter the positions. If we click on the jack of hearts' thumbnail in the Layers panel it will be highlighted; becoming the active layer. If we click and drag with the Move tool as before, we'll see the jack appear from beneath the king. Again, if we hold **Shift** we can constrain the layer's movement horizontally.

HOT TIP

If you find that the wrong layer is being selected when you click and drag on the document, it's likely that you have the Move tool's Auto Select Layer option enabled. You can turn it off in the Options panel.

Grouping and linking

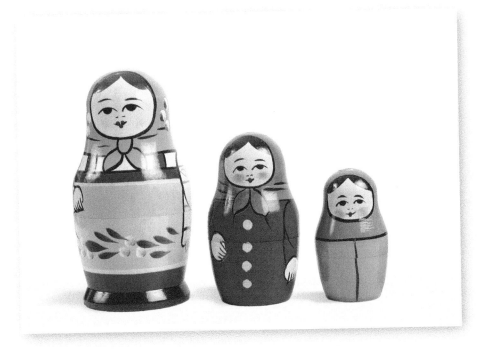

IMAGE: **ABSOLUTVISION.COM**

PREVIOUSLY, WE LOOKED at using the Move tool to reposition layers in a document. We did this with individual layers but it is also possible to move two or more layers at the same time by grouping them together.

There are two ways to do this in Elements. The first is a temporary grouping: the association is lost as soon as we select a different layer. This is useful if we need to move several elements around together but only need to do it the once. The second allows us to leave the layers linked together indefinitely, even after saving and closing the file. We'd generally use this if we have two or more elements that need to be kept together; a fish in a bowl, for example. We'll be looking at both methods in this lesson.

DOWNLOADS

Russian Dolls.psd

WHAT YOU'LL LEARN

- Creating a temporary group
- Linking layers together

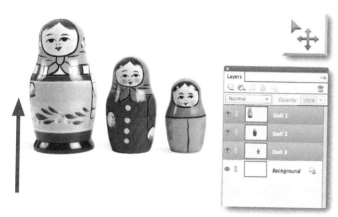

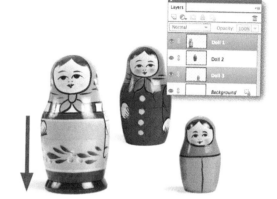

1 We'll begin by creating a temporary group of layers. Go to the Layers panel. Click on Doll1. Now hold *Shift* and click on Doll3. All three layers will be highlighted. Grab the Move tool **V**. Now click and drag up on the image itself; remember to hold *Shift* to constrain the movement vertically. The three dolls we grouped together will all move in unison.

2 If we want remove layers from a group we go back to the Layers panel. Hold *ctrl* **⌘**. Click on the layer or layers we want to exclude; Doll 2 here. Don't click the thumbnail, that will load the layer's selection. Anywhere on the label is fine. Now when we move the layers down, Doll 2 stays put.

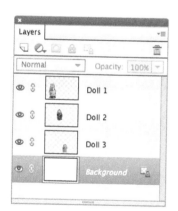

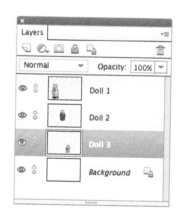

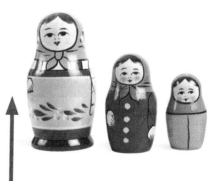

3 If we want to clear the group, we simply need to click on one of the individual layers in the Layers panel. We could also hold *ctrl* **⌘** as before and click the other layers we wanted to remove from the group.

4 For a more permanent grouping, we can link layers together. To do this, highlight one of the layers by clicking its entry in the Layers panel. Now click the chain icon to the left of the layer you want to group with.

5 Once the layers are linked together, we no longer have to highlight them both to move them together. Whichever of the layers in the group we choose, the other layer will always move with it. This link will remain active until we choose to remove it; we do this simply by clicking one of the chain icons again.

HOT TIP

To quickly unlink all the layers in a document, open the fly-out menu from the Layers panel and choose Select Linked Layers; this highlights all the linked layers in the document. Then go back to the menu and choose Unlink Layers. This is useful when working on large, multi-layered documents.

2 Working with layers
Layers from selections

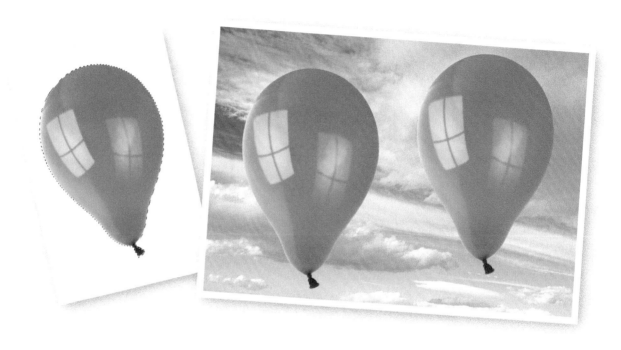

IMAGE: **ABSOLUTVISION.COM**

I N CHAPTER 1 we used a selection to create a duplicate of an object. In that instance all the copies were on a single layer. That's OK if we want to make a quick image, a background design, for example. The problem is the elements are flattened and cannot be edited individually.

In this lesson, we'll make a selection of our image then create copies on separate layers. These can be moved and edited individually. As we'll see, there are two ways to do this, one duplicates the original image, the other creates a new layer but removes the original. Both have their uses but we'd generally want to make copies of the original to leave intact, in case we wanted to use it again.

WHAT YOU'LL LEARN

- Inverting a selection
- Copying the contents of a selection to a new layer
- Reloading a layer's selection
- Cutting the contents of a layer to create a new instance

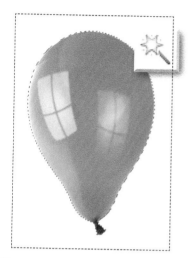

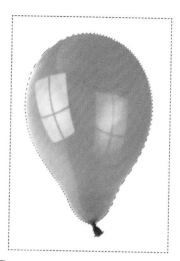

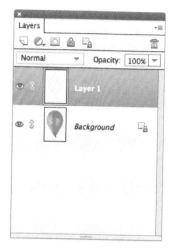

1 We'll begin by making our selection. As the balloon is on a white background, the Magic Wand **A** is the best method. Click anywhere on the background. The whole object is selected in one go.

2 The first method of creating a new layer from a selection is from the Layer menu: select New > New Layer Via Copy. We can also use its keyboard shortcut `ctrl` `J` `⌘` `J`; we'll be using this throughout the book.

3 If we look at the Layers panel we see a problem. Instead of creating a copy of the balloon, we've copied the background. That's because we selected everything around the balloon. Press `ctrl` `Z` `⌘` `Z` to undo.

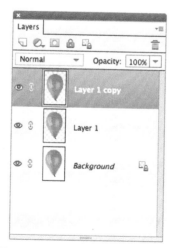

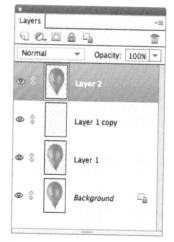

4 This time, before we create the new layer, we'll invert the selection. Press `ctrl` `Shift` `I` `⌘` `Shift` `I`. The marching ants border will now only show around the outline of the balloon and not the edge of the document as it did before.

5 Press `ctrl` `J` `⌘` `J` again to to make a copy, Now, when we examine the Layers panel, we see that just the balloon has been copied, the area around it is clear. We can press `ctrl` `J` `⌘` `J` again to make a further copy, based on this new layer.

6 We can also create a layer by cutting the contents of a selection. Hold `ctrl` `⌘`. Click the second balloon's thumbnail to reload its selection. Press `ctrl` `Shift` `J` `⌘` `Shift` `J`. Another layer appears, this time by removing the previous layer's contents.

HOT TIP

We only need to create the selection once to make the initial copy, as we needed to extract the object from its background. We can make as many duplicates from the copy as we want, as it's already on a transparency. We do, however, need the selection to cut the object to a new layer.

Divide and multiply

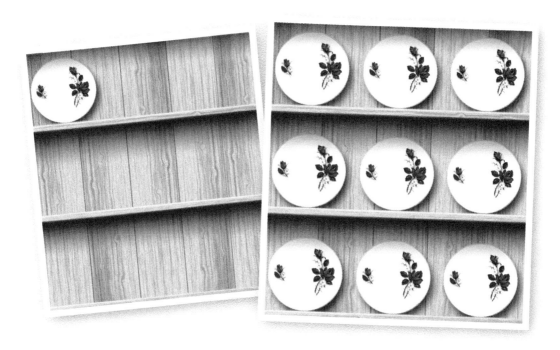

I N THE PREVIOUS LESSON we saw how to duplicate the content of a selection onto a new layer using the New Layer Via Copy command. In this tutorial we'll be looking at another method of duplicating layers using the Move tool and one of its keyboard modifiers. This lets us create the copies on-the-fly as we are moving items around the artwork.

Here we'll first learn how to duplicate a single layer. We'll then group the layers together in order to make multiple copies. This is useful if we need to quickly populate an image with a particular design element; a plate on a shelf in this example. We'll also see how we can merge layers together in order to reduce the amount of layers in the document once we've completed the image.

WHAT YOU'LL LEARN

- Duplicating a single layer
- Grouping layers to create multiple copies
- Merging layers together

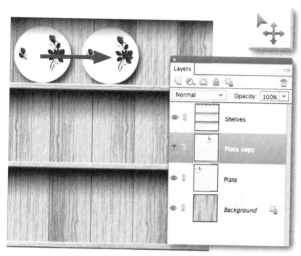

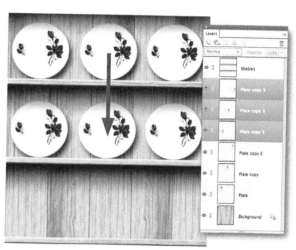

1 When we open the image, we have a single plate on the shelf. Make sure the Plate layer is highlighted by clicking its thumbnail. Grab the Move tool **V**. Hold down *alt* ⌥. Now click and drag on the plate. As we do so, rather than just moving it, we create a copy. If we also hold *Shift* as we move, the copy will be constrained and follow the shelf. Move it to the middle and release the mouse.

2 Repeat the previous step to create a third plate. We now have three separate layers. Hold *Shift*, now click on the original plate layer's thumbnail. All three layers are now selected as a group. Go back to the image. Hold *alt* ⌥ as before. Now drag down towards the second shelf. As we do so we have created three new layers containing copies of our plates. Remember to press and hold to constrain the movement.

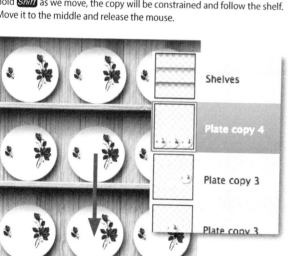

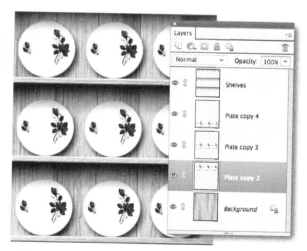

3 Our duplicate group remains selected, so we can make another copy from it. That completes our image but if we look at the Layers panel, we have nine layers plus the two parts of the shelf; it's a little cluttered. We can tidy it up a little by merging sets of layers together. Keeping the current group highlighted, press *ctrl* *E* ⌘ *E*. The three separate layers are now one single layer, containing all three plates.

4 Click one of the layers named Plate copy 3. Now add the other two layers into a group. Press *ctrl* *E* ⌘ *E* to merge them together. Finally, select the remaining three plate layers and merge them as well. The Layers panel is now much tidier. Generally we would avoid merging layers, in case we need to make further adjustments. Sometimes it's necessary, though, especially if your document contains dozens of layers.

HOT TIP

Once a copy of the layer has been made you can release *alt* ⌥. This isn't absolutely necessary but it will prevent additional copies being made by accidentally bouncing the mouse button. It will also save a little strain on your finger, of course!

Align and distribute

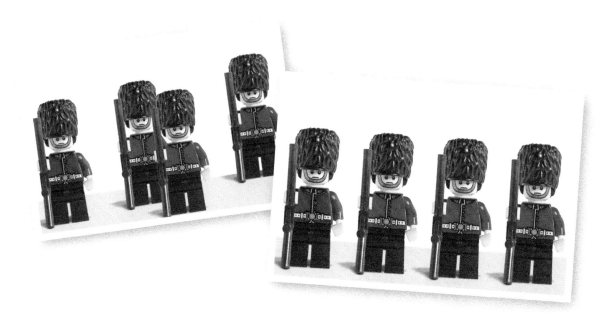

KEEPING ON THE SUBJECT of layer groups, in this lesson we'll be looking at how we can use them to align and distribute the layers in an image; it's a similar principle to aligning content in a word processing application. In Elements these tools are very useful for design graphic layouts, especially where we are working with repeating elements and blocks of text.

The alignment and distributon tools are available as options of the Move tool. Alignment is based on the position of the layers in relation to top and bottom of the document. We can also align the layers to a selection; this is a useful trick for restricting the alignment to a specific area. Distribution is used for spacing layers equally. We'll be using both tools here to sort out some wayward soldiers.

DOWNLOADS

Guardsmen.psd

WHAT YOU'LL LEARN

- Aligning layers to a selection
- Using groups to selectively space out layers

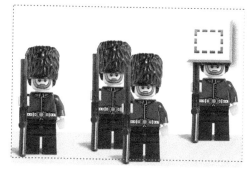

1 To begin, grab the Rectangular Marquee tool **M**. Starting in the top-left of the image, draw a selection across to the far right. Don't go right to the bottom, however, leave it just below the blue soldier's feet. This will be the basis for lining up the layers.

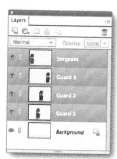

2 We need to group the soldier layers together. Go to the Layers panel. Click the Sergeant layer's entry to select it. Now holding **Shift**, click the Guard 1 layer.

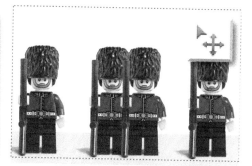

3 Select the Move tool **V**. Now go to the Tool Options panel. Under the Align section click on the button marked Bottom. All the layers will snap down to the bottom edge of the selection we made. If we hadn't created the selection to begin with, the layers would have aligned to the bottom of the document instead.

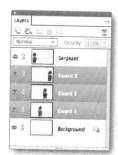

4 Next we'll space the soldiers out evenly. Go to the Layers panel. Hold **ctrl** **⌘**. Click the sergeant layer's label to remove it from the group.

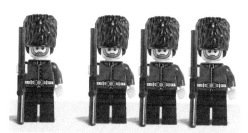

5 Go back to the Tool Options panel. This time, go to the Distribute section. Click the item labelled Middle. As we removed the sergeant from the group, only the troops are adjusted. Notice that the two outer guards stayed in the same position. The guard in the middle is positioned perfectly beween them.

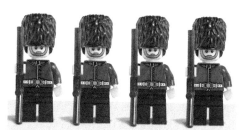

6 In the spirit of equality, let's make all the soldiers evenly spaced out across the image. Hold **ctrl** **⌘** and click the sergeant's layer label in the Layers panel again. He's now back in the group with the others. If we click the Distribute Middle icon again, the second and third guards have now been adjusted to fit.

HOT TIP

The distribute tools work by averaging the distance between the first and last layer in the group; these layers will always remain in the same place. The layers in between are then equally spaced to fit inside. If you want the spacing to be wider or narrower, move the outer layers closer or further apart.

2 Working with layers
Creating a simple montage

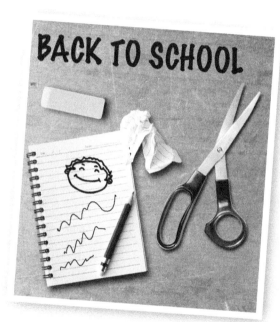

IMAGE: **NOTEBOOK – ABSOLUTVISION.COM**

U P TO NOW, we've looked at how layers can hidden, moved and duplicated. All the necessary layers were already included in the lesson files. Before we can begin creating multi-layered designs ourselves, of course, we need to know how to add and create our own layers.

Over the next few pages we'll build up a basic montage. We'll be looking at different ways to add images into a document and also how to create the various different types of layer Elements has to offer. Our final image will comprise images, text, shapes and also blank layers that we can paint on.

Although fairly basic, the steps we'll take here are the fundamentals of any photomontage, all of which we will be using and looking at in more detail throughout the chapters in the book.

WHAT YOU'LL LEARN

- Arranging the workspace for multiple images (page 47)
- Importing images as layers (pages 47–48)
- Creating empty layers (page 49)
- Using Shape layers (page 49)
- Adding text with the Type tool (page 49)

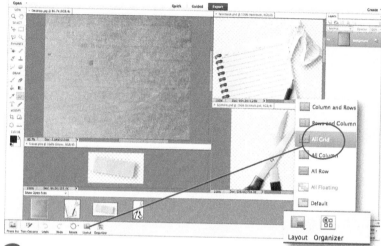

1 We'll begin by opening the files required for the project. Go to File > Open. The File Open dialog will appear. Browse to the place you downloaded the images. Select them all by holding *ctrl* ⌘ and clicking each in turn. Click Open to open them up into the Editor.

2 By default, Elements will open all the images as tabs along the top of the workspace; each image fills the entire screen as you click its tab. This is usually the best way to view them as it avoids clutter. In this project we need to be able to see all the images at once; for the first stage, at least. Click the Layout icon at the bottom of the workspace. Select All Grid. This will display all the images at once. We can adjust the size of the individual windows by clicking and dragging the dividing lines.

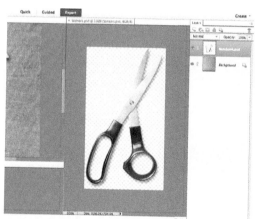

3 The simplest method of adding an image into a document is directly from the Photo Bin. Make sure the bin is visible by clicking its icon at the bottom of the workspace. Make sure the Desktop image is the active document by double-clicking its thumbnail or by clicking its tab label at the top of the window. A blue border will appear around its thumbnail. We'll add the notebook first. To do this, click and drag its thumbnail onto the image.

4 Once we've added the notebook, we can close its original document. To do this, click the cross next to its label in the window tab. You can also use the shortcut *ctrl* *W* ⌘ *W*; just make sure the correct document is active at the time. Once the document is closed, Elements will fill the space with the remaining documents.

HOT TIP

If you want the documents in their own windows you'll need to enable floating windows. To do this, open the Preferences dialog *ctrl* *K* ⌘ *K*. In the general settings area, click to enable Allow Floating Windows in Expert Mode. Now windows can be taken off the dock to be resized and repositioned.

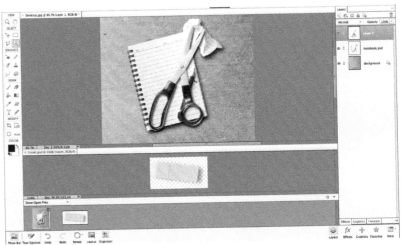

5 Another way to create a layer is to copy and paste from one document to another. Make sure the Scissors image is active. First press ⌘A ⌘A to make a selection of the entire image. Now press *ctrl*C ⌘C to send a copy to the clipboard.

6 Make the Desktop image active again. Press *ctrl*V ⌘V to paste the copy of the scissors into the document. Elements automatically centers the image. We won't worry about the positions of the layers at the moment; we'll work on the composition when we've finished importing the layers. As before, we can close the original scissors document. If you get a dialog asking if you want to save the changes, say no; it will be because we didn't drop the selection we made, which counts as an edit.

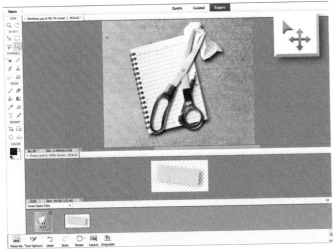

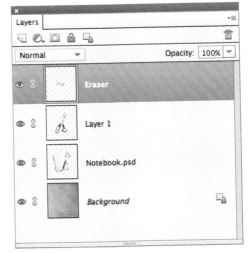

7 The last image layer we are going to import is the eraser. Grab the Move Tool **V**. Click on the eraser's window to make it active. Now click and drag the eraser itself onto the Desktop document. All we see is an outline as we do this. When we release the mouse, a copy of the image will be placed in the center of the desktop image. Close the original eraser document.

8 If we look at the layers we've added so far, notice how the layer we imported from the Photo Bin bears its filename. The Layer we copied and pasted in has just been named Layer 1. The eraser layer we added with the move tool keeps its name from the original document.

HOT TIP

We don't have to keep the default names of the layers, of course. To change them, double-click the current name in the Layers panel and type in a new one. To set it, just press *Enter*, or click onto another layer. It's good practice to give your layers meaningful names; it makes finding them much easier.

9 Before we move on, let's arrange the layers. We already have the Move tool selected. Start with the notebook; it sits nicely in the bottom left corner. Move the scissors to the right. The eraser can go just above the notebook. Leave some space at the top for the text, which we'll add later.

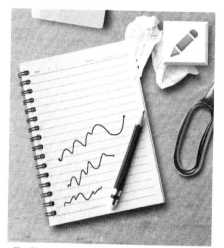

10 Let's continue by adding a new layer to our montage. We can do this by clicking the New Layer icon at the top of the Layers panel or by pressing *ctrl* *alt* *Shift* *N* ⌘ ⌥ *Shift* *N*.

11 Now that we have our blank layer, let's do something with it. Select the Pencil tool *N*. Draw a few scribbles on the notepad. They're not actually on the notebook, of course; being on their own layer we can still reposition them or turn the visibility off to hide them from the image.

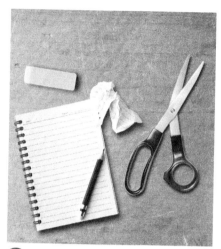

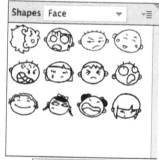

12 Another type of layer is the Shape layer. We'll use a the Custom Shape tool here. Press *U* to select it. Go to the Tool Options panel. From the tool's preset picker, choose Faces. Now click on a face to use.

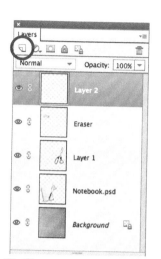

13 Hold down *Shift* to constrain the size. Now click and drag out the shape onto the notebook. It doesn't look right to begin with. That's because we see its path outline as well as the image itself. If we click off it to another layer the path will disappear and we can see the shape properly.

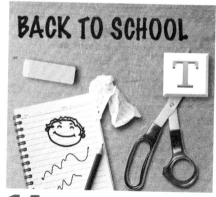

14 The last layer we'll use is a Type layer. Press *T* to select the Horizontal Type tool. Go to the Tool Options. Select Marker Felt from the font menu. Set the size to 24pt. Click the cursor at the left of the image, around half-way between the eraser and the top of the document. Now type some text; Back to School seems fitting! To set the text press *ctrl* *Enter* ⌘ *Enter*. We can always reposition the text with the Move tool, if required.

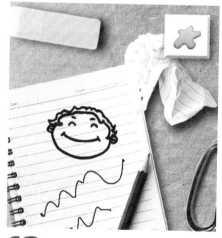

HOT TIP

Both Shape and Type layers use vectors to create their content; a mathematical method of drawing between points. This means they can be scaled up and down without ever losing quality. Unlike other types of layer, they cannot be painted on directly but can still have effects and adjustments applied.

2 Working with layers
Layer blend modes

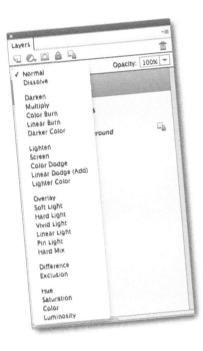

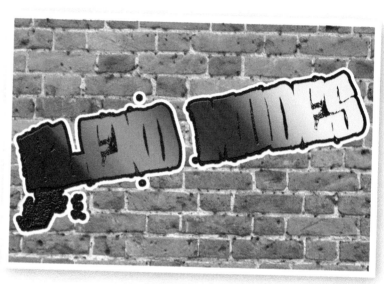

EVEN IF YOU'VE NEVER USED THEM you will no doubt be familiar with the term 'blend modes'. These determine how the target layer interacts with the layer or layers beneath it. In our example, we'll change the graffiti layer's mode, which will affect the way it blends with the wall, our background layer.

Elements has 24 blend modes, 25 if you count Normal, which, although appearing in the list, isn't technically a blend mode at all, as it doesn't actually blend anything. We're not going to go through them all here; instead, we'll look at the modes we'll be using most throughout the book.

A lot of the time, deciding which mode to use is simply a matter of trial and error; whilst one image will look good with a particular mode, applying it to another might look awful. It gets more complex still when we start combining multiple layers and multiple blend modes!

WHAT YOU'LL LEARN

• Using blend modes to change the appearance of a layer

50

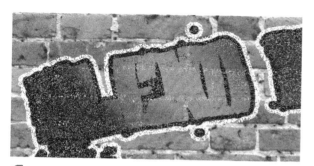

1 Dissolve: At first glance there seem little point to this mode. When we apply it, the edges become slightly speckled. If we start to lower the layer's opacity, more of the image begins to disappear. This is useful for creating effects of sand, snow and other particle-based substances.

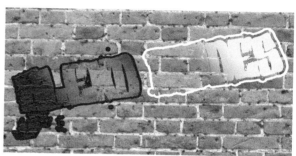

2 Darken (left) and Lighten (right): Darken blends pixels that are lighter than the wall: white becomes transparent. There's little change in the color. Its counterpart, Lighten, has the opposite effect, only blending where the wall is darker. The color is a little washed out.

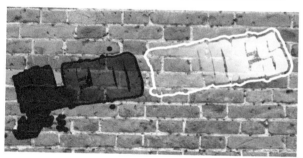

3 Multiply (left) and Screen (right): Multiply produces rich, darker tones; great for adding more contrast. Black is opaque. Any white in the layer is cancelled out. Screen is the opposite, giving a much brighter blend. White is completely opaque. Any black in the layer is removed.

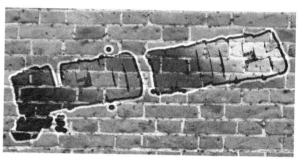

4 Overlay: A combination of Multiply and Screen. It darkens lighter pixels and vice versa. In areas of midtones there is little or no effect, 50% gray being completely invisible. The highlight and shadows are retained, giving it a slightly blown-out appearance.

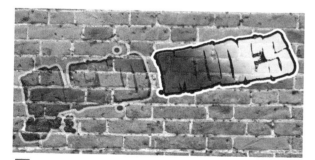

5 Soft Light (left) and Hard Light (right): Soft Light operates in a similar way to Overlay. The difference being it combines Darken and Lighten. It's useful for haze effects and reflections. Hard Light gives us a much harsher effect, adding more contrast to the image.

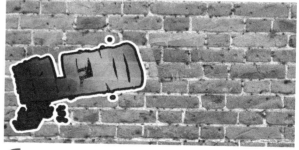

6 Luminosity (left) and Color (right). Luminosity discards any color information to blend based purely on the tones of the layer. This is useful for effects that corrupt colors. Color ignores the tones of the layer and blends only its colors. This is great for tinting black and white images.

HOT TIP

We can cycle through the modes by pressing *Shift* ➕ to go down the list and *Shift* ➖ to go up. Make sure you have a tool such as the Move tool selected when you do this; some drawing tools have their own mode settings, and you'll be changing them instead of the the layer's mode.

2 Working with layers
Using layer styles

Layer styles are a great way to add effects to your artwork. They are quick to apply and, more importantly, they are non-destructive; they never affect the image pixels directly, instead they behave like overlays. This means they are just as easy to remove.

In this lesson we'll use styles to add effects to a watermark on a photo. We'll add a bevel and drop shadow to allow it to stand out. We'll also use another type of style to hide the pixels of the watermark, leaving only the effect of the style visible. This lets us cover a large amount of the photo to deter people from stealing it but still leave it clear enough to see.

DOWNLOADS

Beefeater.psd

WHAT YOU'LL LEARN

- Applying layer styles to an image
- Adjusting the style settings
- Changing the visibility of the layer's pixels

1 Here's our photo. We've turned the watermark layer on. The problem we have is the text is obscuring too much of the image behind. It is doing its job as a theft deterrant but it's also overpowering the image.

2 We can reduce the boldness of the watermark by lowering the layer's opacity; we've reduced it to 25% here. This doesn't look too bad but it's a little indistinct. Bring the opacity back up to 100%.

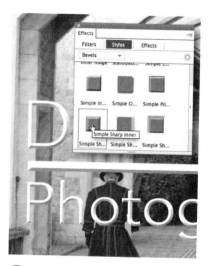

3 Go to the Effects panel. Click on the Styles heading. Select Bevels from the menu. We'll use the Simple Sharp Inner preset. Double-click its icon to apply it. The layer's label now has a small *fx* icon to denote a layer style.

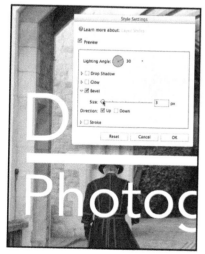

4 The default size of the bevel is too large for our text. Open up the Style Settings window by clicking the cog icon in the corner of the Effects panel. Under the Bevel heading, lower the size to around 4 pixels.

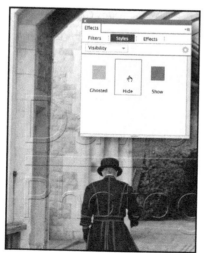

5 Go back to the Effects panel. Select Visibilty from the menu. Double-click on Hide. Our text has turned transparent but the bevel is still visible. Ghosted would have made the text semi-opaque. Show makes it visible.

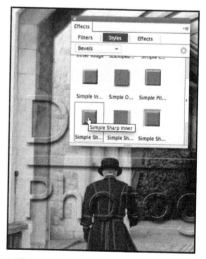

6 As a final step, let's add a small shadow to have the text stand out a little. Select Drop Shadows from the Effects panel. Double-click the Low preset. We can still see the photo, whilst still making it difficult to steal.

HOT TIP

Individual styles can be disabled in the Style Settings, but there's no way of turning them all off at once. Here's a workaround: create a duplicate of the target layer. Apply the styles to the copy. Use the Hide mode to leave all but the styles visible. We can then toggle the overall layer visibilty to hide them.

Keep up, no slacking!

THERE'S ONLY ONE THING FASTER than the speed of light: the computer industry. It seems that no sooner do you remove the shrink-wrap from your software or prise the new PC from its snug Styrofoam packaging, than you expect to see a little fortune cookie-style note congratulating you on your purchase being out of date. That groaning, creaking sound you hear becoming progressively louder is not your antiquated computer about to keel over in a spectacular shower of sparks, but the heavy cogs of the corporate machine trundling toward you, decimating all but the newest of technologies in its path.

As with the fashion industry, it seems you're nobody unless you're first in line for this season's must-have accessory. As the glossy adverts in magazines will imply and the even glossier salespeople in computer stores will tell you (the prospect of a sales commission instantly makes you an expert, of course), your current system is already halfway to the scrap heap and not fit for anything other than being the basis for a retro art statement.

You should not be too despairing of the seemingly decrepit piece of hardware chugging away beneath your desk, or that your copy of Whizz-Bang 3000 Professional Gold Edition SP5 is now 'so last Tuesday'. Before you rush out to part with a month's salary, you have to ask yourself: is it good enough for my purposes and, if it lacks a certain area of functionality, can I achieve the same thing in a different way? Unless the latest hardware or software is offering something completely revolutionary, the answer will almost certainly be yes.

There will, of course, come the time where an upgrade is necessary. Perhaps support for your current operating system is being dropped and its replacement will not run efficiently on your computer. It may also be that certain components, such as graphics cards, need replacing. This doesn't involve replacing the whole system.

Ask anybody in the world of digital imaging – unless they're trying to sell you a completely new computer – what, above all, are the most important system components and you'll generally get the same answer: memory and hard disk

space. Even if you have the latest AMTEL liquid-cooled, 50 megagiga-googleplex processor, it is still very much at the mercy of these two commodities. The computer needs memory to run the graphics program itself and store the image(s) you are currently working on, not to mention everything else that's going on in the background. Adobe recommends 1Gb+ for the current version of Elements to run smoothly. The more complex the document becomes, however, the more memory it needs to use to hold that information. Images can often bloat out to hundreds of megabytes in size, especially when you start creating multiple layers. Add to that the history (undo) states and the space used by copying and pasting to the clipboard and you'll soon be pushing the resources to their limits.

Presently the average PC comes with around 2–4 Gb of RAM (physical memory), which is ample for most tasks. When the system starts running low on physical memory, it starts to free it up by using virtual memory, referred to as 'scratch' space in Elements. This is a temporary area on the hard disk set aside for storing the overflow. Think of it as writing things down on a scrap of paper when you begin to become overwhelmed with information. This is where you need to make sure you have a large enough hard disk. Remember, the operating system, programs and your data all share this space. If it's full to bursting, trying to cram in this transient file will at best slow things down to a crawl; at worst it can cause the program (or the entire system) to crash, taking whatever you are working on with it.

Enhancing your system needn't be expensive. A large external hard drive will set you back around $100–200; you just plug them in and they're ready to go with no fuss. An internal drive could be half that amount. You can add an extra gigabyte of memory for less than $50. If you're not technically minded and unwilling to delve into the arcane world that is the inside of your computer, there will usually be someone you know who can help. If not, there will be no shortage of people advertising in the classified section of the newspaper who will be able to do the work – usually for a reasonable price, too. If it keeps you up and running for a year or two more, it's certainly money well spent.

3

Transformation and distortion

COMPOSING MULTIPLE IMAGES into a single montage almost always involves scaling, rotating and moving the elements around. In this chapter, we'll look at the basics of using that most powerful tool, Free Transform: with its multiple keyboard modifiers, it's capable of producing good results.

There's more to distortion than simply scaling and rotation, though. We'll also be exploring other methods of bending and twisting images to meet our needs; including how to magnify a section of an image, straighten the Leaning Tower of Pisa, place a photo onto a computer screen and much more.

3 Scaling with Free Transform

IMAGE: **HEMERA PHOTO OBJECTS**

WHEN WE'RE CREATING a photo-montage, it's rare that all the elements of the design are going to be the correct size. We'll invariably need to change the size of one or more of the layers to fit. For this we need to make use of Elements' Free Transform tool. The tool comprises four modes; scale, distort, skew and perspective and with them, we can alter a design element to fit almost any image.

We'll be looking at all the different ways of using Free Transform over the next few pages. In this lesson we'll be looking at the scaling features. We'll apply the Alice in Wonderland effect to our unsuspecting model to demonstrate the ways we can resize an image.

WHAT YOU'LL LEARN

- Scaling proportionally to maintain the image shape
- Free scaling to change both the size and shape

1 This little girl hasn't paid heed to Alice's plight and has sipped from the Drink Me bottle. Let's begin her transformation. Press *ctrl T* / *⌘ T*. A bounding box appears to tell us we're now in Free Transform mode.

2 By default Free Transform is set to constrain the proportions of the layer. If we click and drag the top-left handle down towards the bottom-right, the girl starts to shrink down and keeps her original shape.

3 If we hold down *Shift* while we drag the corner we temporarily disable contrained proportions. Now when we drag the mouse, she starts to stretch out in the direction we move the bounding box.

4 The middle handles are different; they only scale vertically and horizontally and do not maintain the proportions, regardless of whether or not the option is enabled. Here we've dragged the top-middle handle down. She's now looking a little squashed.

5 Normally when we drag the handles the transformation follows the cursor, expanding or contracting out in one direction. If we hold *alt* / *⌥* as we drag, the layer will be scaled in or out from the center of the bounding box.

6 We'll adjust her out a little to get her proportions back but keep her small; she won't fit down the rabbit hole otherwise! Once we're happy with the adjustments we've made we can apply them. To do this either click the green check at the bottom or press *Enter*.

HOT TIP

You can also access Free Transform from the Move tool. If you have its bounding box enabled in the options, as soon as you click on one of the handles Elements will switch modes. This is indicated by the apply and cancel icons appearing at the bottom of the bounding box.

Correcting images with skew

IMAGE: **DIANE ROBERTSON (SXC.HU)**

I N THE PREVIOUS LESSON we used the Transform tool to scale an element of an image. We'll continue to look at its features; here we'll see how an image can be distorted by skewing; pushing the pixels on one side of an image up and down or left and right.

Skewing an image has many uses, we can use it to fit elements into scene's perspective, distort text and many more. We can also use skew as a correction tool for photos. We can correct perspective distortion and a number of other problems. To demonstrate, we'll be using the tool to straighten up one of the World's best known architectural faux pas, the Leaning Tower of Pisa.

DOWNLOADS

Leaning Tower.psd

WHAT YOU'LL LEARN

- Using the skew transform mode
- Straightening the angle of an image

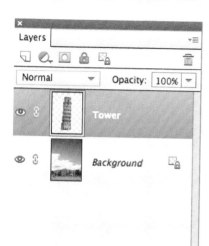

1 Open the image. We've placed the tower on its own layer, otherwise the whole image would be distorted. We had to remove the original from the background, of course; our apologies for reshaping bits of Tuscany.

2 Go to the Image menu. Choose Transform > Skew. We still get the bounding box but if we hover over the handles the cursor changes to a double-headed arrow, rather than the standard cursor of Free Transform.

3 We'll begin by adjusting the vertical angle. We do this by dragging the top-middle handle; to the left in this case. We can use the flag to gauge when we have the tower more or less straight vertically.

4 Now we'll adjust the horizontal angle. Click and drag the left-middle handle down a little. Use the horiontal section at the base of the tower as the guide. It's looking good so far.

5 There's still some distortion as we look up the tower. We'll adjust the vertical angle some more; this time from the bottom. Click and drag the bottom-middle handle to the right. Again, it just needs to be subtle.

6 All that remains is to apply the transformation by clicking the green check at the bottom of the bounding box, or by hitting *Enter*. There's a bit of tidying to do on the ground but otherwise, it's not bad.

HOT TIP

Although we invoked skew from the Image menu here, we can also select it by clicking its icon in the Tool Options panel or by right clicking inside the Transform bounding box. We can also temporarily switch whilst in Free Transform by holding down *ctrl* *Shift* *⌘* *Shift*.

3 Transformation and distortion
Unlocking rotation

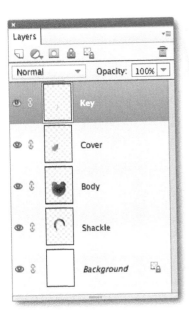

IMAGE: **HEMERA PHOTO OBJECTS**

A S WELL AS SCALING and distorting our images with the Transform tools, we can also rotate parts of our designs. This is essential, of course; our artwork would look decidedly plain if all its elements were rigidly straight.

In this lesson we'll see how we can rotate individual layers around their centers and also, by changing the pivot point, we can rotate a layer around a different axis. This is a really useful trick, as it means we can change the angle of an object precisely, based on the rest of the design.

DOWNLOADS

Lock and Key.psd

WHAT YOU'LL LEARN

- Using transform to rotate objects
- Altering the pivot point of the transformation

1 We'll use the rotate feature to unlock this padlock. Firstly, make sure the key layer is highlighted by clicking its thumbnail in the Layers panel. Press *ctrl* **T** **⌘** **T** to enter Free Transform mode.

2 Move the cursor outside of the bounding box. It's image will change to a curved double arrow. When we move the mouse down, the key rotates clockwise. Will make a quarter turn. Press *Enter* to apply the changes.

3 Now select the shackle layer in the Layers panel. Press *ctrl* **T** **⌘** **T**. When we start rotating, there's a problem; the shackle just spins round. This is because it's pivoting around the center. Press *esc* to cancel.

4 Enter Free Transform again. Hold down *alt* **⌥**. Now click on the crosshair in the center of the bounding box. Drag it across to the pin on the face of the lock that makes the real pivot point of the shackle.

5 Now when we rotate the layer, because we have redefined the pivot point, the lock opens as we'd expect it to. Once we've opened it up sufficiently we can press *Enter* to apply the changes.

6 Because we're working with layers, everything is reversible. Close the shackle again. Hide the key by turning its layer off. Now select the lock cover layer and close it. Remember to move the pivot point first.

HOT TIP

The position of the cursor in relation to the object you are working with greatly affects the rotation. If the cursor is near to the item, the object will rotate quickly. If you want to use more precision, move the cursor further away; the same amount of mouse movement will rotate it much more slowly.

3 Transformation and distortion
Simple perspective distortion

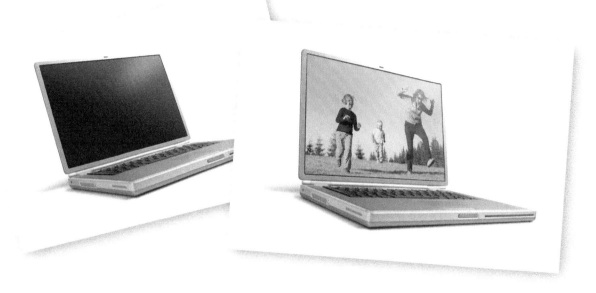

IMAGE: **ABSOLUTVISION.COM**

ONE OF THE MOST USED distortion techniques in photomontage is to add or replace an image where it will be viewed in perspective. This could be anything from a photo lying on a table to a billboard in a street scene, or in this example, a photo placed onto the screen of a laptop.

As we'll discover in the following tutorial, this effect can be achieved quickly and simply using the distort mode of the Free Transform tool. The task is made easier still if we already have a basis for our distortion: the laptop's screen in our example. We'll also see how the effect can be made more realistic by blending the images to retain the original highlights of the screen.

DOWNLOADS

Laptop.psd

WHAT YOU'LL LEARN

- Using Free Transform to distort an image
- Using layer opacity
- Using Zoom tool whilst using another tool.
- Using blend modes to alter the appearance of a layer

64

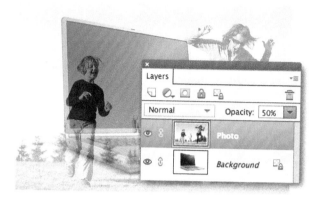

1 Open the project image. Now make the photo layer visible by clicking its eyeball in the Layers panel. We have a bit of a problem. The layer has obscured the image of the laptop. This will make it difficult to see when we go to fit the image onto the screen. We can fix this by making the photo layer slightly transparent. Use the slider at the top of the Layers panel to lower the opacity; around 50% is sufficient.

2 Press *ctrl* *T* *⌘* *T* to enter Free Transform. In order to distort the photo to fit the screen, we need to be in Distort mode. We can do this by holding *ctrl* *⌘* as we drag the corner handles of the bounding box. Start with the top-left handle; drag it across to meet the corresponding corner of the laptop's screen. Now do the same for the rest of the image. Don't apply the changes yet.

3 We'll zoom in and check the corners are in place. Press and hold *ctrl* *⌘* . Now press the spacebar. This temporarily swaps to the Zoom tool. Click on the top-left corner of the laptop a few times to zoom in. Release the keys. Make any necessary adjustments. Do this for the rest of the image. Now press *ctrl* *0* *⌘* *0* to zoom out so we can see the whole image once more. Press *Enter* to apply the changes.

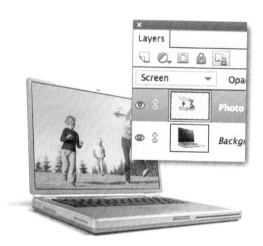

4 Bring the opacity back up to 100%. The photo doesn't look like it's part of the image, however; it just seems to be in front of the screen. To fix this, go to the blend mode menu at the top of the Layers panel. Change the mode from Normal to Screen. This lets the highlights show through from the original laptop screen. We can also drop the opacity a fraction; around 80% works well.

HOT TIP

Rather than zooming out and moving to the next area each time. If you press and hold the spacebar it switches to the Hand tool. While active you can pan the image around. When you release the spacebar, you'll go back to the tool you were previously using.

Close-ups with Spherize

IMAGE: **POSTAGE STAMPS – WIKIPEDIA COMMONS; MAGNIFYING GLASS – DAVIDE GUGLIELMO (SXC.HU)**

FILTERS OFTEN SUFFER from abuse and consequently can quickly achieve cliché status. Even though their effects can be gradually increased, there is too much of a temptation to take it straight to the extreme. Spherize is one such casualty. Because of its potential for caricature, it rarely sees anything between -100% and 100%. It can, however, be used for much more subtle duties.

The following example uses the filter in moderation to create the illusion of an image being enlarged through a magnifying glass, in this instance on a collection of postage stamps. This is a great effect for drawing attention to something in your artwork or simply as a realistic component.

DOWNLOADS

Magnifier.psd

WHAT YOU'LL LEARN

- Duplicating layers
- Containing the effect of a filter within a selection
- Using the Spherize filter
- Reapplying a filter with its previous settings

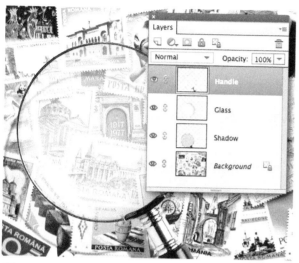

1 Open the project image. If we look at the Layers panel we see that the magnifier's handle, glass and shadow are on separate layers. They are linked together, however (denoted by the gold chain icons); we can move them around as a whole and also access the individual components. We'll see why later in the lesson.

2 Select the Move tool **V**. Make sure one of the parts of the magnifying glass is highlighted in the Layers panel. Now move the magnifier to the position on the background that you want to apply the effect; the stamp with the flag is good. Now click on the Background layer in the Layers panel. Press *ctrl* *J* ⌘ *J* to duplicate it.

3 Stay on the copy of the background layer. Hold *ctrl* ⌘. Now click on the Glass layer's thumbnail to load its selection. This will keep the effect within the confines of the glass.

4 Go to Filter > Distort > Spherize. Dial in an amount of around 70%; we don't want the distortion to be too strong; we can see a wireframe representation of the effect. Make sure the Mode is set to Normal. Click OK to apply the changes.

5 The shadow should also be magnified. Ensure the glass selection is still active. Click on the Shadow layer in the Layers panel. Now press *ctrl* *F* ⌘ *F*. This repeats the last filter and its settings. Press *ctrl* *D* ⌘ *D* to deselect.

HOT TIP

In the final step we didn't bother to duplicate the shadow layer before applying the distortion. Although it is generally good practise to make copies of all elements before editing them, sometimes you have to weigh up the inconvenience of having to recreate the item over tidyness and speed.

Transformation and distortion

Keep your composure

SOMETIMES, WE HAVE the perfect image but it's been shot at the wrong aspect. Our example would be great for a promotional flyer or magazine cover but it's a landscape image and we would need it in portrait. We'd want to keep the four people in the image too, so cropping isn't possible.

Elements has a secret weapon: the Recompose tool. This behaves very much like Transform but with one important difference: it analyzes the image on the fly, working out what it thinks is important detail and what's not; this is referred to as Content Aware. In our case this is the grass and hills. The people remain untouched.

WHAT YOU'LL LEARN

- The problems with regular transformations
- Using the Recompose tool
- Restricting the area of effect with a selection

1 Here's our image with the magazine cover overlay. First we'll try scaling it down using Free Transform `ctrl` `T` `⌘` `T`. If we drag the right-middle handle to the left we can immediately see the problem. Although the four hikers now fit the space, they've been squashed up. We couldn't use the image like this. Press `esc` to cancel the transform.

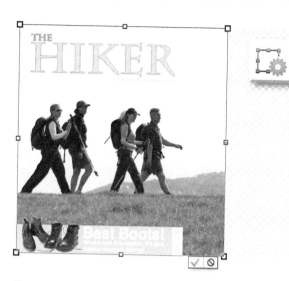

2 Select the Recompose tool `W`. We get the same bounding box as the Transform tool. Click the right-middle handle. Start to drag it across to the left as we did before. Now we get a very different result. Instead of the whole image being squashed, the people stay in shape and the larger expanses of the grass and background are compressed down.

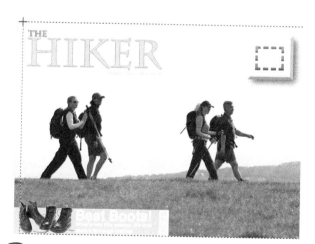

3 Because the tool looks at the areas with less detail, it has pushed the person at the back up against the left edge of the image. Press `esc` to cancel the transform. Grab the Rectangular Marquee tool `M`. Draw a selection around the whole image, leaving a small vertical border on the left hand side; we can use the edge of the boot as a marker.

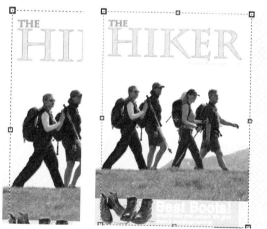

4 Select the Recompose tool again. As we scale the image, the area we left out of the selection is ignored. This gives us a less cramped design and we still have enough space to fit the people in comfortably. Butt the image up to the right edge of the magazine overlay. Press `Enter` to apply the changes. All we need to do now is crop the blank space.

HOT TIP

If we need to maintain a particular size of image, we can select one of the presets from the Tool Options panel. This contains many standard photographic sizes. When one is selected the image is automatically sized to those proportions. The results aren't always perfect but it can save a lot of time.

3 Transformation and distortion
Think Smart!

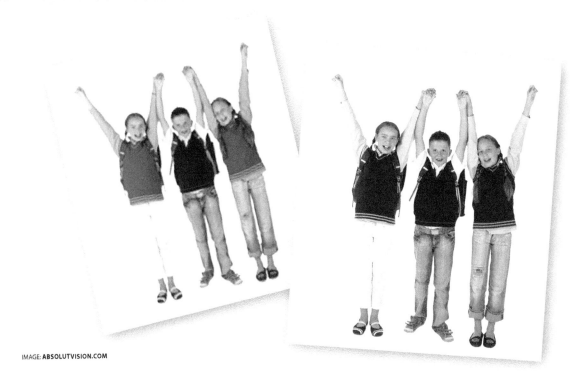

IMAGE: **ABSOLUTVISION.COM**

WE'VE SEEN HOW LAYERS can be scaled and distorted to enable them to fit into another image. This versatility can come at a price, though. Scaling the image much larger or smaller than its original size, or repeatedly distorting it, will eventually result in its quality degrading, as Elements has to stretch or remove the pixels each time. This can be a problem if we're trying different layouts in our montage.

There is an answer to this problem. There are special types of layers called Smart Objects. These are created when you import an image file into a document using the Place command. Outwardly, they are no different. They do have one special feature, however: they can be scaled and distorted indefinitely without them ever losing their original image quality.

I've also included an action to create a Smart Object without using the Place command. This can be applied to any layer.

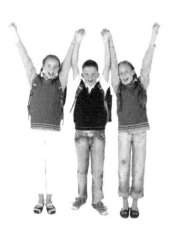

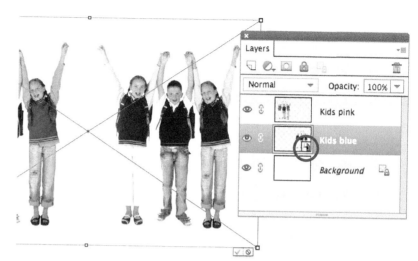

1 Begin by opening the Kids pink image. This is a normal image containing the photo of the kids on a regular layer. We've saved it as double the width to accommodate the copy we're going to insert.

2 Go to File > Place. Select the file named Kids blue.psd. Click Open. A new photo appears with what looks like the Free Transform bounding box; apart from it has a cross division. We saved the file with the same dimensions so it would open with the second layer in the correct position. Press *Enter* to set the layer down. If we look at the Layers panel, the only difference we can see is a small icon in the corner of the Kids blue layer's thumbnail; this denotes a Smart Object layer.

3 Click the Kids pink layer in the Layers panel to make it active. Now use Free Transform *ctrl T* *⌘ T* to scale the image right down. Press *Enter* to apply the transform. Now select the Kids blue layer. Do the same with this image. Notice how the bounding box kept its dimensions; the previous size and shape is recalled each time you transform.

4 Use Free Transform to scale both layers back up to their original size. If we start with the Smart Object we can use its bounding box to restore the exact dimensions. Now let's compare quality of the two photos. On the left the image is horribly blurred. The image on the right, however, has remained exactly the same as when we first opened it.

HOT TIP

It's always best to use the largest available version when opening an image as a Smart Object, even if it's many times larger than the document you're working on. Scaling an image larger than its original size always results in some loss of quality, even if it is reversible.

Transformation and distortion

Tricky selections

EVEN WITH ELEMENTS' well-stocked arsenal of selection tools, there will be times when it seems we have been defeated. The locket in this example is a case in point: it's been photographed at an angle but the Elliptical Marquee cannot be tilted to match, so try as we might, we cannot make a selection of the window inside.

Although we could use the Quick Selection tool, there is still some tidying up to be done afterward. Instead, we have the Transform Selection tool that allows us to distort a selection in the same way that we would an image layer; making short work of this irregular shape.

We'll also look at saving selections. In this instance we'll save our distorted selection then use it again for the second window of the locket. It's good practise to save selections, especially if they are complex and took time to complete.

WHAT YOU'LL LEARN

- Modifying selections with the Transform Selection tool
- Saving selections for later use

1 Here we're using the Elliptical Marquee **M** to select the window of the locket. We cannot match its shape because of its irregular angle; the marquee tools only stretch horizontally or vertically. We'll get it as close as possible.

2 Go to the Select menu and choose Transform Selection. Hold *ctrl* **⌘** to switch to Distort mode. When we drag out the corner handles, however, instead of affecting the image, we are reshaping the selection. Adjust it to fit the window. Press *Enter* to apply the changes.

3 Unfortunately, we can't duplicate selections, so let's save this one. We'll then be able to use it again for the second window. Go to Select > Save Selection. Leave the Selection box set to New. We need to name it; Window 1 is a logical choice. Click OK to save.

4 Invoke Transform Selection again. We can click inside the bounding box and drag it over to the second window. Adjust it to fit. Press *Enter* to apply. Save this selection as Window 2. If we save the image as a Photoshop or TIF file, the selections will be saved for later use.

HOT TIP

When we save a selection we have the option to create a completely fresh one. If there is already a saved selection, we can choose to have them interact, as we would if we were creating them with any of the selection tools. The same applies when we load a selection if we already have one on screen.

3 Transformation and distortion
A flag for all nations

IMAGE: **HEMERA PHOTO OBJECTS**

I N THIS LESSON we'll be using the Displace and Shear filters to transform a two-dimensional graphic of the Stars and Stripes into a realistic looking flag. To achieve the billowing, rippled effect, we're going use an image of a hanging sheet

The filter works by pushing the image's pixels horizontally and vertically, based on the tones of the displacement map – a grayscale image the filter uses as its reference – anything lighter than mid-gray is pushed up and right, anything darker is pushed in the opposite direction; based on the scale values we set. This results in the target image following the contours of the sheet perfectly.

The technique is versatile too. As well as fabrics, it can be used with many other types of texture; almost anything which has a raised pattern such as rock, tiles or even the bark of a tree.

WHAT YOU'LL LEARN

- Changing the appearance of an image with blend modes
- Using the Displace filter to distort an image
- Creating a wave effect using the Shear filter

1 Open the image file. Click on the sheet layer in the Layers panel to highlight it. Click its eyeball to make it visible. If we change the sheet's blend mode to Multiply we get this effect. It's not bad but we can make it more realistic.

2 The problem here is, although the ripples of the sheet blend well with flag, the lines are still straight, where they should be following the contours. Hide the sheet layer for now. Click back to the flag layer to make it active.

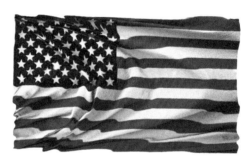

3 Select Filter > Distort > Displace. The filter's dialog box will appear. Leave the settings at their default values. Click OK. Another dialog will open prompting for a file. Browse to where you saved the files and select Displace.psd.

4 The result looks a little odd. If we turn the sheet layer back on we can see the effect. There's a problem, though: the sheet layer no longer fits with the flag. Make its layer active. Press *ctrl* *F* ⌘ *F* to reapply the filter.

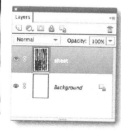

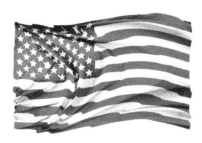

5 We'll add a wave to the flag using the Shear filter. Before we do this we must rotate the image. Go to Image > Rotate > 90° Left. Now group the flag and sheet layers together. Press *ctrl* *E* ⌘ *E* to merge them.

6 Go to Filter > Distort > Shear. Create a smooth S shape by clicking and draging on the line in the top-left window. Click OK.

7 Go to Image > Rotate > 90° Right to restore the orientation. We can brighten the flag up. Press *ctrl* *J* ⌘ *J* to duplicate the layer. Now set its blend mode to Screen.

Mimicking long exposure

TAKING A LONG EXPOSURE photo in bright daylight requires the use of a neutral denisty filter; a little like putting sunglasses on the lens. This prevents the shot being over-exposed. These filters are only available for SLR cameras, so it's not usually possible to do with point and shoot cameras.

We can mimic the effect these types of shots produce in Elements with almost any photo and from any camera. We'll be using the Radial Blur filter to create the whispy, zoomed appearance of the clouds; typical of the long-exposure technique.

DOWNLOADS

Landscape.jpg

WHAT YOU'LL LEARN

- Selecting areas with the Quick Selection tool
- Changing the order of layers to hide problem areas
- Using the Radial Blur filter

1 We'll start by making a selection of the sky. The Quick Selection tool **A** is perfect for this job. Make sure the whole area is captured. Now press *ctrl* **J** *⌘* **J** to create a layer from the selection.

2 Now we'll make a copy of the ground. Hold *ctrl* *⌘* and click the cloud layer's thumbnail. Press *ctrl* *Shift* **I** *⌘* *Shift* **I** to invert the selection. Click the background layer in the layers panel. Press *ctrl* **J** *⌘* **J** to create a copy.

3 Click the sky layer in the layers panel to make it active. Enter Free Transform *ctrl* **T** *⌘* **T**. Holding *alt* **⟲** to scale around the cener, drag one of the corner handles out to stretch the layer. We only need to expand it by a few pixels.

4 Click the ground layer in the layers panel. Drag it above the sky layer. In the last step we expanded the sky layer. This is because the blur may pick up some stray pixels from the horizon edge that were caught in the selection; moving the ground layer in front will hide this.

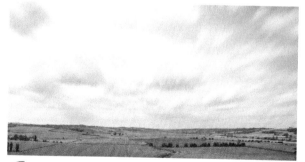

5 Click the sky layer in the layers panel. Go to Filter > Blur > Radial Blur. Set a fairly low amount; around 20 here. Click Zoom for the method. Next we'll set the angle of the blur. Click and drag the window so the horizontal section roughly matches the horizon. Click OK.

6 Here's the result. It may take a little while to render, depending on the size of the image you're working on. If the effect is not strong enough, we can always run it again by pressing *ctrl* **F** *⌘* **F**. This is the reason we started off with a low value for the effect to begin with.

HOT TIP

The ground is fairly flat in this image. This makes it easy to hide the extra pixels. If you're working on an image with obstructions in the foreground, it might be best to use a different image for the sky. Otherwise you would need to spend time cloning the areas out of the original sky layer.

Drawing comparisons

ONE OF THE QUESTIONS MOST FREQUENTLY asked by newcomers to digital imaging is which program should they choose: Photoshop Elements or the full Photoshop product. There is no definitive answer; each has its merits. The basis for the decision should be one of individual requirements.

A common misconception is that Elements is Photoshop's poor relation, only suitable for photography hobbyists who need a simple program to catalog their images and perform quick fixes such as removing red-eye from portraits or correcting color casts. Although there is a definite leaning toward the amateur market, Elements is more than capable of producing the same standard of artwork as its big brother. Elements still has around 70% of the features found in Photoshop; it merely lacks some of the more high-end functionality associated with professional pre-press. You'll find all the same filters and the majority of adjustments are present. Some are cut-down versions offering less in the way of fine-tuning, though not at the expense of their usefulness. There is also a degree of symbiosis between the two programs. Look under the hood of Elements and you'll find technologies from recent Photoshop releases packaged to perform a specific purpose. Similarly there are parts of Elements that have traversed the other way.

There is, of course, one distinct difference: the price. Presently, Photoshop will happily relieve your bank account of $600 upwards, depending on the version you choose. Elements, on the other hand, will cost you around $100 for the full product (less for an upgrade from previous versions). This makes it an ideal solution if you have a limited budget.

So, with all that said, what exactly are the differences between the two programs and can you survive without whatever it is that's missing? As we mentioned before, Elements does not feature some of the tools required for press-quality printing, such as comprehensive color management and the CMYK color space. This, however, does not mean it cannot be used professionally; the images in this book were all produced using it, after all. Most designers' applications, such as Adobe's InDesign, will convert the images and, to an extent, allow you to adjust the

color. The differences become less of an issue when you start comparing the tools and commands. Many of Elements' shortfalls can be overcome with a little lateral thinking. Here are the main 'extras' found in Photoshop, with workarounds:

Photoshop tool	What it does	Elements workaround
Pen tool	Draws Bézier paths	Use selections instead, and save as Alpha channels; save as .psd or TIFF file
Curves adjustment	Adjusts color and brightness	Use Levels instead
Vanishing Point filter	Places images in scene in perspective	Use Free Transform to distort layer
Layer styles	More control over layer styles	Be creative with built-in styles or import styles from Photoshop
CMYK mode	Prepares artwork for commercial printing	Use third-party software to convert to CMYK mode
Smart Filters	Allows editable filters with selective masking	Duplicate target layer and lower opacity, use a mask to hide the effect
Image Warp	Allows free distortion of layers	Use Shear or Liquify filters for similar effect

There are some features in the full Photoshop that have no Elements equivalent – such as fully-featured Smart Objects, Video and 3D Layers (Photoshop Extended edition only), and support for specialist video modes. But in the main, Elements is capable of satisfying 99% of every montage artist and photographer's requirements.

4

Hiding and showing

CREATING EFFECTIVE PHOTOMONTAGES is all about making layers interact with each other. And more often than not, this entails making layers partially hidden behind existing objects in the scene.

The standard way to do this is to erase the parts you don't want. But this is an irrevocable step; instead, we'll look at the tools that give Elements users some of the power of Photoshop CS6, with the ability to selectively hide and show regions of layers.

We'll also see how to blend layers together in a convincing manner, and how to arrange our montages so that they look that bit more convincing.

Working with layer masks 1

IMAGE: **ABSOLUTVISION.COM**

ELEMENTS ONLY RECENTLY gave us the ability to create true layer masks. This has made a huge difference to the way we can edit our images; it was a cumbersome task beforehand.

If you're not familiar with the concept, a mask allows us to selectively hide areas of a layer non-destructively as, unlike the Eraser tool, we can restore the hidden parts whenever we want. As we'll see here, and in the rest of the book, masks have many practical uses and are an essential part of the montage artist's repertoire.

WHAT YOU'LL LEARN

- Creating a mask
- Removing and restoring areas of the image with a mask
- Using levels of gray to make the image transparent
- Disabling and enabling the mask

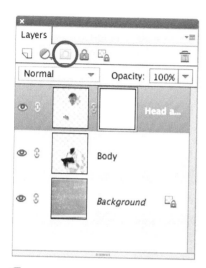

1 We can see that the image of the woman has been separated into two layers. Click on the head and hands layer in the layers panel. Now click the Add a mask icon at the top. Another thumbnail appears next to the image.

2 There's no difference to begin with. By default the mask is set to reveal all. Grab the Brush tool **B**. Set the foreground color to black. When we paint the mask over the area of the woman's head, it begins to disappear.

3 We've removed both the head and the hands. Notice that we haven't had to be precise; only areas on the current layer are affected. We wouldn't normally get to see what's behind the hidden areas, of course!

4 Switch the foreground color to white. Now start to paint over the hidden areas. As we do, the image starts to return. We could also restore the image in one operation by filling the mask with white.

5 Masks work with grayscale tones; anything in between black and white causes the image to become translucent. Press *Shift* *Backspace* to open the Fill Layer dialog. Choose 50% Gray. Click OK. We get this result.

6 We can turn a mask off at any time. This is useful for looking at the before and after states. Hold *Shift*. Now click on the mask thumbnail. A red cross will appear. Do the same to turn it back on again.

HOT TIP

As well as disabling the mask, we can perform other commands by right-clicking the mask thumbnail in the Layers panel. From there we can delete the mask; this is the more permanent version of disabling it. We can also apply it. This merges the areas of the mask with the image to take permanent effect.

Hiding and showing
Working with masks 2

IMAGES: **RABBIT – HEMERA PHOTO OBJECTS; TOP HAT – MORGUEFILE.COM**

O N THE PREVIOUS PAGES we saw how to remove areas of an image by painting onto a mask. In this lesson we'll take this a step further by using a mask to section off an area of an image. This enables us to control how objects interract with the rest of the image; in this case, the traditional rabbit in a magician's hat.

First we create the mask in the normal way but, instead of simply painting away the part of the object we don't want to see, we make a much larger mask; one that covers the portion of the part of the image we want the object to be behind.

Normally when we move an object around, its mask moves with it; the two are linked together in a similar way to linking two separate layers. If we unlink the mask, it stays put, so when we move the object itself, it can move into or away from the mask. Here, it allows us to move the rabbit in and out of the hat.

WHAT YOU'LL LEARN:

- Creating a mask from a selection
- Unlinking the mask from the image

1 Here we have a rabbit and a top hat. The rabbit should be inside the hat, not in front of it. Even if the hat was on a separate layer, we could only put the rabbit behind it.

2 Turn the rabbit layer off. Click the background layer to make it active. Make a selection of the front of the hat, including the brim. The Quick Selection tool **A** works best.

3 Turn the rabbit layer back on. Click it make it active. Go to Layer > Layer Mask > Hide Selection. A mask is created in the shape of the hat. Our rabbit is now inside.

4 Click the rabbit's thumbnail to make sure it's active; it will have a blue border. Select the Move tool **V**. Drag the rabbit up to bring it out of the hat. Not a happy bunny!

5 This happens because the rabbit and its mask are linked together. Moving the rabbit also moves the mask; the rabbit's body remains hidden. Press *ctrl* Z ⌘ Z to undo.

6 Click the link icon between the rabbit and the mask. This will unlink the two. Now when we move the rabbit, the mask stays put and the rabbit is still in one piece.

HOT TIP

We could also create the mask using the icon in the Layers panel. By default this creates a mask that reveals the selection, we don't want that, as it hides the parts of the rabbit that are outside of the hat. If you hold *alt* ⌥ when you click the icon, it creates a mask that hides the selection.

4 Hiding and showing
Gradient masking

W E'VE SEEN HOW to paint on a mask to hide or show portions of an image and also how to create a mask using a selection. Another way we can apply the mask is by creating a gradient directly onto it. This has the effect of gradually fading the visibility over part or all of the image. There are many uses for this technique, the most practical is to use it to fade out a reflection.

Here we'll look at creating the illusion of a shiny surface; the type that a certain high-profile computer manufacturer favors. In this case we give it the effect of plastic, so the reflection is slightly hazy. We could also use it as the basis of a water reflection; adding ripples to finish the effect.

WHAT YOU'LL LEARN

- Mirroring a layer
- Using a gradient with a mask to fade out the image
- Using Gaussian blur to add a hazy effect to the reflection

1 Make sure the apple layer is highlighted in the Layers panel. Press *ctrl* *J* / *⌘* *J* to create a duplicate layer. Now make the original apple layer active again. Go to Image > Rotate > Flip Layer Vertical.

2 Select the Move tool *V*. Hold *Shift* to constrain the movement. Now drag the layer straight down. We can use the shadows to align the two images. This is the basis for the reflection but it's far too solid.

3 Create a mask on the reflection layer. Grab the Gradient tool *G*. Select the Black, White preset. Choose the Linear gradient style; this simply transitions from the first color to the second in the direction it's applied..

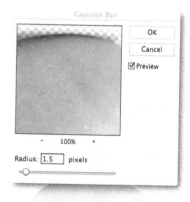

4 We want to fade the reflection as it goes down, so we need to start with black. Click at the base of the image. Hold *Shift* to keep the line straight. Click and drag up; just above the top of the shadow works well.

5 When we look at the mask's thumbnail in the Layers panel, we can see how it relates to the image. Black is completely transparent. As we move up the image it starts to fade to white, where it becomes visible.

6 The reflection is a little sharp; we would only see it like this on a mirror. Click the reflection image's thumbnail. Go to Filter > Blur > Gaussian Blur. We only want a subtle change. A radius of around 1.5 pixels should suffice.

HOT TIP

Different materials reflect images a variety of ways. Here we've simulated the effect of shiny acrylic; this is as smooth as glass but doesn't reflect back as vividly. If we wanted to produce a varnished wood finish, we would also need to take the unevenness of the surface into consideration.

4 Hiding and showing
Using Clipping Masks

IMAGE: **HEMERA PHOTO OBJECTS**

AS WELL AS THE STANDARD type of layer mask we've seen so far, we can also create a Clipping Mask. This is a special way of grouping two or more layers together; also known as a clipping group. The layer at the bottom of the group determines what is visible in the layers above. In fact, prior to Elements 9, this was the only way we could achieve masking.

In this lesson we'll create a clipping mask to add someone to the screen of a television. We can move them around to position them; they will always remain within the confines of the screen.

It's often more useful to use Clipping Masks instead of regular masks as we can quickly add more layers to the group. The clipped layers also take on the attributes of the blend mode and opacity of the base layer.

WHAT YOU'LL LEARN:

- Creating a clipping mask to hide parts of a layer
- Moving an object with a clipped group
- Changing blend modes to create different effects

1 Hide the singer's layer by clicking its eyeball icon in the Layers panel. make sure the TV's layer is active. Now make a selection of the screen. The Quick Selection tool **A** is perfect for this.

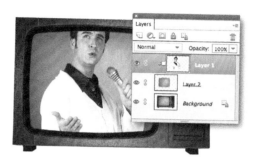

2 Press *ctrl* *J* *⌘* *J* to create a copy of the selected area to a new layer. Click the singer's layer in the Layers panel to make it active. Make it visible again. Press *ctrl* *G* *⌘* *G*. The singer is now clipped to the copied screen layer.

3 We need to reposition the singer slightly. Grab the Move tool **V**. We can move him around the screen to get him into the correct position. Notice he always stays within the screen area.

4 Clipped layers take on the base layer's blend mode. Click on the screen copy layer to make it active. Now change its blend mode to Luminosity. There's no change to the screen but our singer is now in black and white. Well it is an old TV!

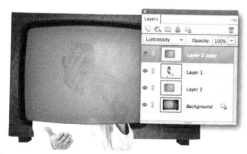

5 Because the singer's layer is above the screen, its reflections are beneath him. Press *ctrl* *J* *⌘* *J* to make another copy of the screen. If we drag the new layer above the singer in the Layers panel, we have a problem!

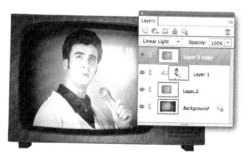

6 Moving the copy layer has broken the grouping. Select the singer's layer again. Recreate the clipping group. Highlight the screen layer above the singer. Set its blend mode to Linear Light; this gives a retro look to the picture.

HOT TIP

When we moved the duplicate layer, it caused the clipping group to be lost; Elements does not assume that you want to use the next layer down instead. Rather than dragging the new copy, if we drag the original layer instead, the group remains in place.

Smudge masking

IMAGE: **PHOTOS.COM**

EARLIER IN THE CHAPTER, we looked at creating layer masks and editing them by painting on them with the Brush tool. It works well: we can paint on a layer's mask to hide and show the object it's attached to.

But we're not restricted to painting the mask with just the Brush tool; we can use any of the painting tools. Here, we'll look at how we can use the Smudge tool to create a convincing grass effect in order to nestle the flower pot into its surroundings. As we'll see, the technique is quick and effective and far easier than painting each blade.

WHAT YOU'LL LEARN:

- Creating a mask from a selection
- Using the Smudge tool to alter the mask
- Creating a clipping mask to limit an effect
- Adding shading with the Brush tool

1 Make sure the pot is the active layer. Hold *alt* ⌥ then click the pot's thumbnail to load its selection. Click the Add layer mask icon in the Layers panel. This ensures that only the area of the pot is masked.

2 Grab the Smudge tool **R**. Open the brush picker from the Tool Options panel. Choose the largest of the Spatter brushes. Set the Strength to around 60–70%. This controls the amount affected by each brush stroke.

3 Make sure the mask is selected. Now start making short upward strokes at the base of the pot. As we do, the mask starts to hide the area of the pot, making it seem like the grass is growing up around it.

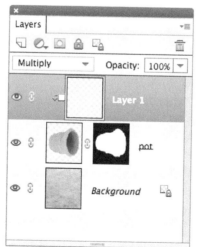

4 Here's how the finished layer's mask looks. Smudging the mask in from the edges in this way is very much easier than painting the mask, as the smudging creates a natural, fading look that matches the growth style of the grass.

5 We'll add some shading on the pot. First, create a new layer above the pot. Create a clipping mask by pressing *ctrl* **G** ⌘ **G**. This will keep the shading confined to the area of the pot. Set the layer's blend mode to Multiply.

6 Grab the Color Picker tool **I**. Sample a color from the base of the pot. Switch to the Brush tool **B**. Choose a small, soft brush. Carefully paint along the bottom of the pot, following the contours of the grass.

HOT TIP

Try changing the size of the brush with the square bracket keys **[** **]** to vary the density of the grass clumps; the effect works better if you use the very edge of the brush. If you're not happy with the way an area looks, simply reverse the stroke, using the brush to push the area back down again.

Spectacular fireworks

IMAGES: **EIFFEL TOWER – PHOTOS.COM; FIREWORKS – NINTARO (SXC.HU)**

FIREWORK DISPLAYS ARE FANTASTIC to watch but notoriously difficult to photograph, especially when there are other elements in the scene to consider; the camera has to be perfectly steady to prevent the foreground from becoming horribly blurred – not to mention the problem of timing the shot to capture the moment at its best. We can add our own pyrotechnic delights, of course.

Extracting something as complex as fireworks from their background is time-consuming and the results are, frankly, unrealistic. Instead, we'll approach the problem from a different angle. We'll use a blend mode to knock out the dark areas, allowing the background to show through, enables us to place the fireworks into the scene precisely where we want them. If we need to place the fireworks behind objects in the foreground, it's a simple masking job.

DOWNLOADS

Eiffel Tower.psd

WHAT YOU'LL LEARN

- The problems with selecting complex areas
- How to reset an image with Revert
- Using Levels to adjust the black point of an image
- Using the Screen blend mode to remove dark areas
- Using the Hue/Saturation command to boost colors

1 Make sure the fireworks layer is active. Grab the Magic Wand **A**. Uncheck the Contiguous option in the Tool Options panel; this will select all similar pixels in the image at once. Now click anywhere in the sky.

2 Press **Backspace** to clear the selected area. Deselect **ctrl D** **⌘ D**. We've removed the sky but we are left with harsh edges and patchy areas. Go to Edit > Revert to undo all the changes.

3 Let's use a different method. First, we need to make sure the sky is as close to black as possible. Press **ctrl L** **⌘ L** to open the Levels dialog. Select the Black point tool. Now click an area of the sky. Click OK to apply.

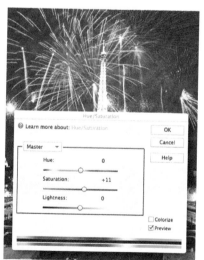

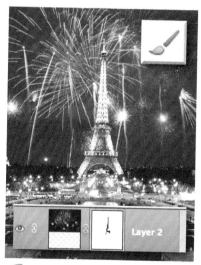

4 The change was only subtle but it will make the blending much tighter. Go to the Layers panel. Set the fireworks layer's blend mode to Screen. All the black is gone and the fireworks blend perfectly into the background.

5 The blending mode has left the fireworks a little washed out. Press **ctrl U** **⌘ U** to open the Hue/Saturation dialog. Increase the saturation slightly; enough to make the colors more vivid. Click OK to apply the changes.

6 Parts of the fireworks are visible in front of the tower. Create a mask on the fireworks layer. Grab the Brush tool **B**. Select a small, hard tip. Set the foreground color to black. Now paint the areas out.

HOT TIP

If you overdo an adjustment when using Hue/Saturation or another similar command, rather than cancelling the dialog and starting again, simply hold down **alt** **⌐** and the Cancel button will change to Reset. This takes the dialog back to its defaults.

Digital cameras

BEING AN ELEMENTS USER, it's likely that you'll already have a camera of some type, even if it's only your cell phone. You may, however, be looking to buy your first, or upgrade from your current model, and with so many different cameras on the market, choosing the right one can be a difficult decision. There are many factors to take into consideration and they are largely based on how much you intend to use it and for what purpose; you don't really want to be carrying huge amounts of equipment around with you if you're only interested in taking the occasional snapshot and similarly, if you're a keen photographer, you might be disappointed with the lack of features on a smaller model.

There are three main types of digital camera; let's begin with the compact models. Firstly, small is not necessarily a sacrifice in quality or features. Even at entry level, 3 megapixels (Mp) will give you a perfect quality 7" x 5" print and a reasonable one at Letter or A4 size. Some have a fixed lens whilst others offer a moderate amount of optical zoom – don't fall for the digital zoom gimmick, though; the results are often lower quality because the image is enlarged by the software in the camera, and not by the lens. The features vary from set point-and-shoot modes to a reasonable amount of manual control, depending on the model.

Next in line are the mid-range cameras, sometimes referred to as prosumer (from professional-consumer). These are bulkier than the compacts but are generally higher quality having larger image sensors and more manual control of the settings. The lenses are larger with a good zoom factor; again, many still include the digital zoom feature in an attempt to make the package more attractive to the buyer.

Finally, we have the DSLR (Digital Single Lens Reflex) cameras. These are the most expensive, and largest, but do give the best image definition; most producing photos that can be printed at A3 with no degradation. They have the same control features as their film-based brethren and their lenses are interchangeable. Many share the same mounts as their analog predecessors, giving you the option of using your existing ones, if you choose the same manufacturer.

It's worth noting that when it comes to the resolution of a camera, bigger isn't necessarily better, especially on the compact cameras which use a smaller sensor; the receptors need to be more tightly packed and the definition of the image can suffer as a result. For most purposes anything between 5 and 12 megapixels is sufficient. Professional DSLRs tend to start at 6Mp and can go as high as 20Mp or more, but you'll be paying out serious money at that level.

Once you've decided on the type of camera, you then need to choose the specific make and model: this can be another minefield, of course, and it's certainly a good idea to read reviews, both in magazines and online. There are two websites well worth visiting: *www.dpreview.com* and *www.stevesdigicams.com*; both offer highly in-depth information about almost every camera currently available – and sometimes advanced previews of the latest technology, as well as archives of the older models too.

From a photomontage perspective, having a good camera certainly helps when it comes to sourcing images for your artwork. We'll talk about stock libraries elsewhere in the book and whilst you're almost certain to find the image you need on at least one of the sites, there's still no substitute for taking your own; you are in full control of the pictures and can get just the right angle and distance to suit your needs. You can create your own library of images, especially if you have a camera that you can carry with you easily at all times; that way you'll always be ready to capture those interesting scenes and textures. You can also set up a small home-studio for photographing smaller objects, either by buying a dedicated light box and lamps or, if you're feeling particularly adventurous, you could build your own.

You might even consider uploading your own images to one of the many free stock libraries and add to the constantly growing resources. You may think that your contributions will be just a drop in a very large ocean, but you may just provide someone with a picture of something nobody else has. There's always the excitement of seeing one or more of your pictures in use on someone's website or in a book such as this, perhaps.

5

Image adjustments

DIGITAL CAMERAS are the best gadget the Elements user can own. But even the best camera can't produce sunny skies on an overcast day, or change the color of a car. Fortunately, we have a solution.

Elements allows us to make any changes we like to an image: literally anything we can imagine can be changed within a single image. We can turn silver into gold, remove people from a scene, and remove distracting items from an image.

But we can also enhance our images without adding anything new. Got a dull, lifeless photograph? We'll see how to liven it up in just a few steps – and how to recover apparently lost information from shadows and burnt-out highlights. We can even turn Summer into Fall.

Boosting contrast with levels

Before we start working on an image, we must first make sure its tones and colors are correct. It will make it easier to integrate it into a montage further along. Elements has many ways to fix photos, some giving better results than others.

In this lesson, and over the next few pages, we'll be looking at the most powerful tool, the Levels command. This allows us to work directly with the tones of the image, so we can fine tune it to achieve the best results. In this example we'll boost the contrast of a somewhat washed out image to make it really pop off the page.

DOWNLOADS

Squirrel.jpg

WHAT YOU'LL LEARN

- Using the Levels dialog
- Reading the histogram
- Displaying the clipped tones in the image
- Correcting the shadows, highlights and midtones

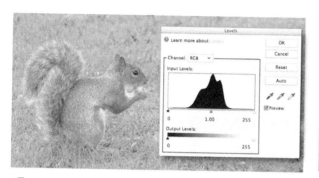

1 Open the Levels dialog *ctrl* **L** ⌘ **L**. If we look at the histogram, we see there is a lot of tonal information in the center of the image where our midtones lie but not so much either side in the highlights and shadows. This has led to our image looking flat and slightly washed out.

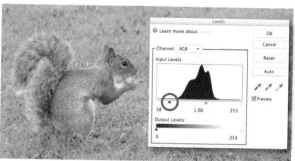

2 We'll start by bringing tone back into the shadows. Click on the arrow on the left. Start to drag it to the right. We can see the contrast starts to return. Notice how the midtone arrow moves as well, keeping it exactly centred between the shadows and highlights.

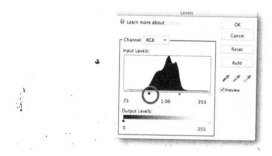

3 If we hold the *alt* ⌥ key while we drag, the screen changes. This shows us the clipping preview. Areas in blue are where we've gone too far; the shadows have become totally black.

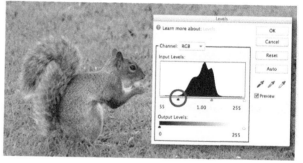

4 Pull back toward the left a little. Some clipping is OK; the squirrel's eye, for instance is almost black naturally. A general rule of thumb is to align the shadows arrow with the base of the histogram. Around 55 in this example. This will vary, depending on the image content.

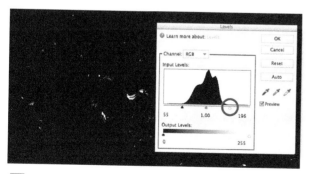

5 Now we'll switch to the highlights. If we hold *alt* ⌥ and drag the highlights slider to the left, this time the screen is black. Areas of white show the clipped highlights. Again, if we stop at the base of the histogram, we get a fairly even balance, some clipping is unavoidable.

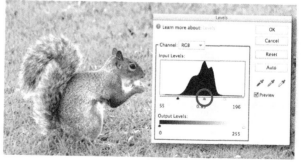

6 As a final step we'll boost the midtone contrast. Grab the midtones arrow and drag it a little to the right. This brings out the color of the image. We don't need to push it too far, just enough to give the tones a nice richness. An amount of around 85 works well here.

HOT TIP

It's always worth trying the Auto adjust button to begin with. Sometimes it's all that's needed to correct the image. Even if it doesn't do a perfect job, it can often act as a good starting point. If the result is totally wrong, we can always hit the Reset button to restore the original settings.

Fixing color problems

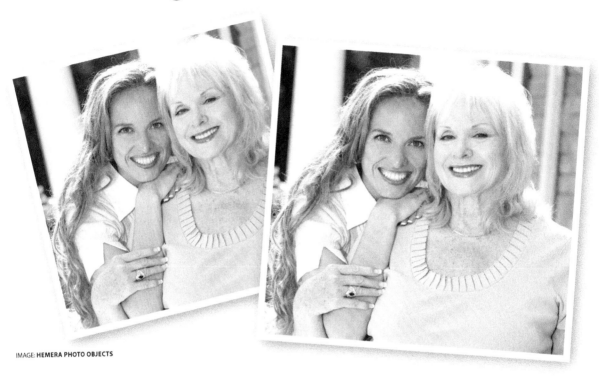

IMAGE: **HEMERA PHOTO OBJECTS**

Previously, we saw how to use the Levels command to adjust the tones of an image and restore its contrast. We can also use Levels to correct the colors. The most common problem is where we have a color cast. This can happen if the white-balance of the camera was incorrect at the time of shooting, or perhaps on old prints that have been scanned in where age and light have affected the inks.

It's straightforward to fix these problems, as we'll see here. The Levels command has three eye-dropper tools; blacks, midtones and whites. By finding these areas in our image, we can quickly get the color back to how it looked at the time the photo was taken.

WHAT YOU'LL LEARN

- Using the Levels eye-dropper tools to fix color casts

1 Our image has an obvious blue cast that makes the photo look unnatural. Open the Levels dialog *ctrl* **L** ⌘ **L**. If we use Auto correct there is almost no change. This is because the tones of the image are good but Elements has no way of knowing the color isn't correct.

2 We'll start by resetting the black point. Click the left-hand eye-dropper in the Levels dialog. Go across to the image and look for an area that should be black. The stone of the woman's ring is a good place. Click the mouse. We can see an improvement already.

3 Now we'll set the white point; this is the most important. Select the eye-dropper on the right. Don't be tempted to go for something like teeth or eyes, they are not usually pure white and will give unpredictable results. The top of the pillar on the left works well.

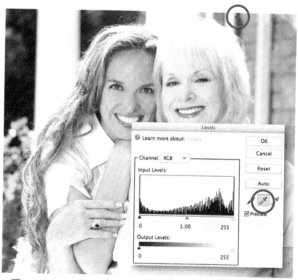

4 Finally, we'll set the midtones. This creates a balance between the highlights and shadows. This can be tricky, as we're looking for a mid-gray. In this image, the best place was the darker area of the frame just above the mother's head.

HOT TIP

It's often difficult to find the best place to set the gray point. Many images do not contain exactly the right shade. As long as the target area is fairly neutral, it should be OK to use. It's worth trying several different points around the same area to get the best results.

Image adjustments
Shadows and highlights

Exposure is the one factor that photographers worry about more than any other; unlike our eyes, which constantly adjust to normalize what we see, cameras can only balance the tones to a certain point. Professional photographers will always 'bracket' their exposures – that is, they'll take a range of exposures of the same image to make sure they've got the right one.

The real difficulty comes when we're faced with an image like this: a view through a window. In the image captured by the camera, above, we can see that the room itself is too dark (we can barely make out the blind texture among those deep shadows), while the view is so bleached out as to be wholly indistinct.

We can fix both of these problems in one go, with the Shadows/Highlights adjustment. It's a hugely powerful tool, which can rescue even the most poorly exposed photographs.

DOWNLOADS

Window exposure.psd

WHAT YOU'LL LEARN

- Balancing exposure with Shadows/Highlights

Lighten Shadows:	35	%
Darken Highlights:	0	%
Midtone Contrast:	0	%

1 Go to Enhance > Lighting > Shadows/ Highlights, and the dialog above will appear. As long as the Preview button is checked, any changes you make here will be visible immediately in the image. The default setting for this adjustment is to Lighten Shadows by a value of 35% and, as we can see here, this setting manages to rescue some of the darker areas of the image. We can already see, for example, that there's a yellow pattern in the blind.

Lighten Shadows:	80	%
Darken Highlights:	0	%
Midtone Contrast:	0	%

2 That's not enough for our purposes. Let's increase the value significantly – here, we've dragged the slider to raise it to 80%. Now, the pattern and texture in the blind can be clearly seen. In addition, we can see that the dark field outside the window has now acquired some definition: the trees on the hill are now distinct from the plowed field in front of them.

Lighten Shadows:	80	%
Darken Highlights:	70	%
Midtone Contrast:	0	%

3 Now let's turn our attention to the highlights. As the image stands, the sky is greatly over-exposed. Dragging the Darken Highlights slider addresses this problem: the further to the right we drag it, the more detail we're able to see in the sky. We've dragged it here to a value of 70%, and this means that the clouds now stand out from the sky behind them.

Lighten Shadows:	80	%
Darken Highlights:	70	%
Midtone Contrast:	–50	%

4 Although we could stop there, it's worth looking at the final slider – Midtone Contrast. Generally, we'd welcome contrast, as it provides definition within the image. Here, though, the result of tweaking both the shadows and the highlights has resulted in a window frame that's so well defined that it overpowers the view through it. By lowering the midtone contrast we take out a little of that over-defined molding, drawing the eye through the window to the view instead.

HOT TIP

Not all cases are as extreme as this one. The adjustment is also useful when a person has been photographed with side lighting; by lightening the shadows and darkening the highlights, we're able to give the impression that the lighting came directly from the front.

103

5 Image adjustments
Working with color channels

IMAGE: **ABSOLUTVISION.COM**

Every image we work on in Elements comprises three separate color channels; red, green and blue. These are known as the primary additive colors. Every other color we see on screen is made up by mixing different amounts of these three colors.

So far we've been using Levels to adjust the overall tones of an image. We can also select the color channels individually. This gives us direct control over the colors in the image.

In this lesson we'll be adjusting the colors of a silver coffee pot to change it first to gold, then to different hues, by simply decreasing the amount of midtone color in one or more of the channels.

WHAT YOU'LL LEARN

- Altering the individual color channels with Levels

1 Open the Levels dialog `ctrl` `L` `⌘` `L`. By default we start with RGB mode, also referred to as the composite view. When we adjust the tones, we are working with all the color channels together.

2 Gold is a warm color whereas silver is a colder hue, containing a lot of blue. Click the Channel menu and select Blue, or press `ctrl` `5` `⌘` `5`. Drag the midtone slider all the way over to the right; this removes the blue.

3 This is a dramatic change and is starting to get closer to gold. We still have a greenish tint to the color. Select the green channel. Now start to drag the midtones to the left. As we do, the pot becomes a richer color.

4 The color is good but it's a little dull. Let's brighten it up. Go back to RGB mode. Click and drag the highlights and midtones over to the left. This completes our gold effect.

5 If we introduce some blue back into the image, we get an effect closer to copper. Notice how the actual tones – known as the luminosity – of the image are unaffected when working with the color channels.

6 We can change the pot to any color of our choosing, of course, simply by mixing the amount of each channel in varying degrees. Here we've increased the blue and green but now reduced the amount of red.

HOT TIP

It wasn't necessary to create a new layer to work on in this instance as the background is pure white, so tonal and color changes do not affect it. The same applies for black. If the background had been gray or another color, we would need to extract the object first.

5 Image adjustments
Bee flat to bee sharp

IMAGE: **HEMERA PHOTO OBJECTS**

WE ALWAYS STRIVE to get the best possible images but sometimes, even with the best equipment, we can end up with an image that is slightly soft.

In our example the combination of the extreme close-up and the bee's movement has resulted in a less defined photo. There is, of course, no way to get a clearer image once it's been taken but we can enhance it to give the impression of it being a lot sharper.

Rather than working directly on the image, however, we'll use a grayscale copy and blend it with the original; this way we have far greater control over the final effect.

WHAT YOU'LL LEARN

- Using the Unsharp Mask filter
- Applying the effect to a duplicate layer for more control

1 The first thing to do is duplicate the background layer. Press `ctrl` `J` `⌘` `J`. The technique we'll be using requires the image to be grayscale. Press `ctrl` `Shift` `U` `⌘` `Shift` `U` to remove the color.

2 We'll use the Unsharp Mask adjustment. This can be found at the bottom of the Enhance menu. The dialog may look a little daunting but it's surprisingly straightforward.

3 Drag the Amount slider to the right. Don't be afraid to increase it higher than you would normally, it won't look as severe when we blend it with the original. In this case we raised it to 350%. We can leave the other settings at their default values.

4 With the adjustment applied we can overlay it onto our original image. Set the blend mode to Luminosity. It's looking a lot sharper whilst retaining much of its tonal qualities and color balance, something that might have been affected if we'd applied the effect directly.

HOT TIP

If the resulting image looks too over-processed we can lower the opacity of the blending layer to strike a balance. Often, however, when the image is printed, a lot of the harsh detail will appear softer. So it's worth leaving it looking a little overdone, just in case.

Introducing adjustment layers

IMAGE: **ABSOLUTEVISION.COM**

W E'VE SEEN HOW TO FIX and make changes to photos using a variety of different tools. So far these have all been applied directly to the image pixels. This is known as destructive editing; once altered, we can only restore the original using the Undo command or, if we've used a duplicate layer (of course we have!), we can delete it and start again. This is time-consuming and it can be frustrating when we're trying to perfect a particular effect.

There is a much better method: adjustment layers. They behave much the same as regular layers but instead of containing image pixels, they apply adjustments and effects to the layer below; so the image data is never directly affected.

In this lesson, we'll use two types of adjustment layer to create a summery 'light leak' style effect. Once created we can go back and change the settings of the effect without the need to start from scratch.

WHAT YOU'LL LEARN

- Creating adjustment layers
- Using Levels to flatten the tones of a photo
- Adding a light-leak effect with a gradient
- Returning to an adjustment to make alterations

1 Click on the split black and white circle icon in the Layers panel. To begin with we want to select Levels. The adjustments panel opens containing the familiar Levels dialog. A new layer has also appeared above the background layer.

2 Begin by dragging the midtone slider over to the left a little. This decreases the contrast, giving us a flatter overall tone. Now drag the left slider of the Output Levels toward the right. This increases the overall brightness.

3 Now for the light-leak effect. Go back to the Layers panel. Click the Adjustment layer icon. Choose Gradient. Open the gradient picker by clicking the arrow to the right of the gradient preview. Select Violet, Orange. Click OK to apply.

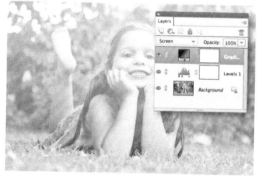

4 Because we're using adjustment layers, we can use blend modes and opacity in the same way as regular layers. For this effect, Screen mode works perfectly; the orange gives us a warm glow at the top with a slight color shift at the bottom.

5 What if we want to change the effect? No problem! First, set the foreground color to bright red. Double-click the gradient layer's thumbnail. This reopens the gradient dialog. This time select the Foreground to Transparent gradient.

6 We need to change the direction of the gradient. Change the angle to point to around the 8 o'clock position. We now have the red fading across from the top-right corner. This looks more like a traditional light-leak.

HOT TIP

With the exception of the first three options in the list, the settings of the adjustments appear in the Adjustment panel. This gives us far greater flexibility as we can still alter their blend modes, opacity and even their positions in the layer stack without having to finish making our changes.

The perfect respray

IMAGE: PEGGY S. SIMONI (MORGUEFILE.COM)

THERE ARE NUMEROUS WAYS to change the color of an object. Most, however, are designed to affect the entire image. We could, of course, use the selection tools to isolate the parts we need to work on. This is a time-consuming practice and often more trouble than it's worth.

For tricky jobs, such as this car with all that complex trim, by far the best method is to use the Replace Color tool. With this we can selectively alter the hue, saturation and lightness of an area without the need to separate it from the rest of the image.

WHAT YOU'LL LEARN

- Using Replace Color dialog to selectively alter an image
- Recovering problem areas with a mask

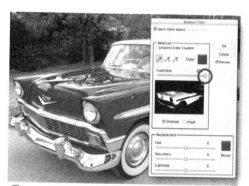

1 Press *ctrl* *J* *⌘* *J* to duplicate the background layer. Go to Enhance > Adjust Color > Replace Color. Click on an area of red on the car. The preview in the dialog shows the amount of that color we've selected. Increase the Fuzziness amount to its maximum.

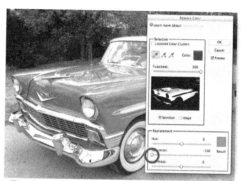

2 Instead of applying the new color straight away, we've lowered the Saturation completely; this shows up the more subtle shades of red not included initially. We can add these areas to the selection by holding *Shift* and clicking them with the Eye-dropper.

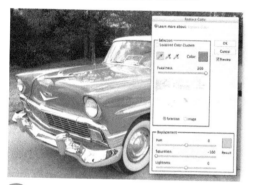

3 We've isolated all of the car's color but we now have a problem: looking at the preview, a large amount of unwanted areas have been included from the rest of the image. This is where we'll use the Fuzziness setting to fine-tune the result.

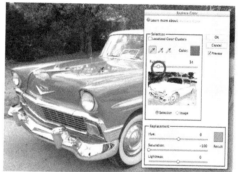

4 By lowering the Fuzziness value we can see the selection start to tighten up in the preview. Some of the previously selected color will begin to reappear. Zoom in a little and start to add these back in. Adjust the Fuzziness a little more until you have a good balance.

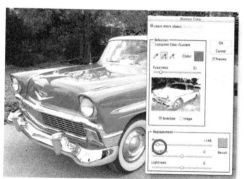

5 Now we can give our car its new color. Raise the Saturation back to 0. This generally gives the best result; increasing it too much will result in the image looking unrealistic. Now we can adjust the Hue slider until we get the desired shade.

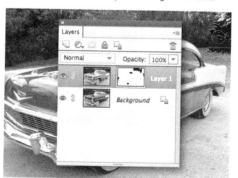

6 There are areas of the background that have still been caught up in the color change. We can fix this by adding a mask to the top layer and painting out the areas. with black. This allows the original background to show through.

HOT TIP

The Fuzziness setting of the dialog works in a similar way to the Tolerance feature of tools such as the Magic Wand. By increasing the value, Elements will select a greater tonal range of the chosen color. This can be used to avoid harsh lines where two hues meet. It's rarely possible to achieve a perfect result with no excess areas affected. If we keep refining the balance by adjusting the fuzziness and adding in small amounts to the selection, we can keep problems to a minimum.

111

5 Image adjustments
Shifting the seasons

IMAGE: **HEMERA PHOTO OBJECTS**

I N THE PREVIOUS LESSON we used the Replace Color command to change the paintwork of a car. Being a uniform color, this was a fairly easy task. We can run into problems if the image we want to alter contains several different shades, such as our example image. If we try to change the hue in one step, we can end up with unpredictable results, as there is too much of a variance in color.

In situations like this we need to take a slightly different approach. We'll select smaller areas of the trees and change their color a section at a time. By making three or four passes we have far more control over the effect.

We'll also use a selection to protect part of the image from the changes; the chapel in our example. We'll then apply an adjustment layer, to warm up the color, using the selection to create a mask so it only affects the chapel.

WHAT YOU'LL LEARN

- Protecting areas of the image with a selection
- Applying color changes to separate sections for greater control of the effect
- Using an adjustment layer to change the tone of elements within the image

1 Duplicate the background layer. Now make a selection of the chapel. Go to Select > Feather. Apply a small amount, around 1 pixel, to soften it. Finally, inverse the selection by pressing *ctrl* *Shift* *I* *⌘* *Shift* *I*.

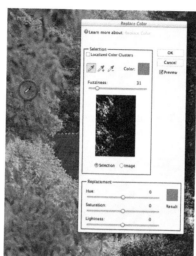

2 Go to Image > Adjust Color > Replace Color. Add the first area by clicking on the image. The large leaves in the foreground are a good starting point. We've kept the Fuzziness amount low to only affect a small section.

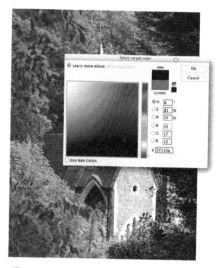

3 Rather than using the Hue slider to alter the color, let's set it directly. Click the Result color chip at the bottom of the dialog. Now we can use the color palette to choose a suitable shade. Click OK to select the color.

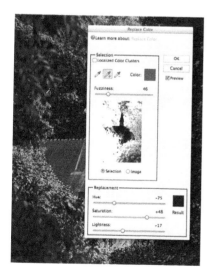

4 Select the Add to Sample eye-dropper. Click the adjacent leaves to add them into the selection. Not too much, we want to leave some untouched. Use the Fuzziness slider to fine-tune the result. Click OK to apply.

5 Open the Replace Color dialog again. Use the eye-dropper to select a different area of leaves. This time, give them a slightly different shade. Apply the changes again. Repeat this a few times more for variety.

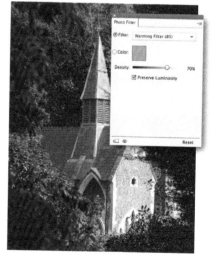

6 The chapel is looking a little stark. Inverse the selection. Go to the Adjustment layer icon at the top of the Layers panel. Select Photo Filter. Set the Filter to Warming (85). Finally, increase the density to around 70%.

HOT TIP

Often, instead of getting a new color, we only get a shade of gray. This is because areas of extreme highlight and shadow have very little color information. If this happens, try and find a neighboring area that contains more information. We can use the Selection color chip in the dialog to check.

113

5 Image adjustments
Miracle healing

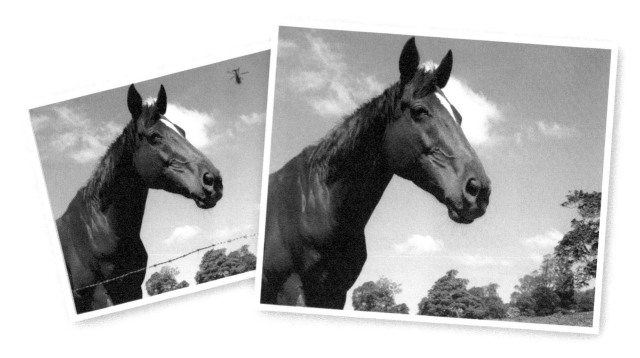

We're not always in control of what appears in our photos when we take the shot; something could move into the frame just as we press the shutter or there could be something that we just can't avoid.

We're going to look at fixing problems using the Spot Healing Brush, specifically its Content-aware feature. This differs from the standard Proximity Match option, which samples the area immediately around the brush cursor. This works well but has its failings. Content-aware fill, on the other hand, analyzes the entire image looking for possible areas that match the affected spot. As we'll see here, the results can be quite remarkable; the tool is now capable of removing complicated items from an image, often in a single stroke.

WHAT YOU'LL LEARN

- Using the different modes of the Spot Healing Brush

HOT TIP

We've mainly been concentrating on the barbed wire in this lesson. Our starting image also has a helicopter and the horse has a bit of a fly problem. Try the different settings of the Spot Healing Brush to see which gives the best results for removing these additional objects.

1 The Spot Healing Brush tools **J** is great at removing unwanted blemishes with a single click. There are times when it can falter. For example: if we want to remove the barbed wire we can't use single clicks, as the tool uses the surrounding area to repair the point where you have the brush. The result, as we can see here, is no good at all; it sees the trees and clouds as different to the pixels directly beneath the brush and assumes it's OK to use those to repair the area. To remove objects like this we need to paint over the whole thing in one go.

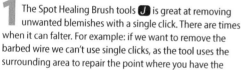

2 Undo the last attempt by pressing *ctrl* **Z** ⌘ **Z**. Make the brush size around that of the barbed wire, including the barbs. Go to the Options bar and change the Type to Content-aware. Now trace along the entire length of the wire from one edge of the image to the other. When we release the mouse the result is very different. Aside from some slight blemishes, it's almost impossible to see where the wire was. The problem areas are fairly isolated so we will not have much trouble removing them. We can switch between Proximity Match and Content-aware in order to tidy up the places that were missed – the strands of hair caught on the barb, for example – or where the tool didn't do such a good job. Overall, what might have taken hours to fix in the past can now be done in a matter of minutes.

5 Image adjustments
Cleaning the scene

WHEN WE'RE IN A BUSY PLACE it can be difficult to get a shot of something without people moving into the foreground. We could try and wait until the shot is clear but that could mean we're waiting around for anything from seconds to hours. Elements has a secret weapon for just these occasions; the Scene Cleaner. With this remarkable tool we can remove people from the scene with just a few strokes of the mouse.

So how does it work? Well, as magical as it sounds, we have to do some groundwork first. We need to take several shots of the same scene; as long as the people are moving, we will have a sequence of photos where different parts of the subject are clear. We load these into the Scene Cleaner; from two to ten images. We start by choosing the image we want to clean. After that we go through each of the other images looking for suitable doner sections. A simple scribble and Elements removes the obstruction.

WHAT YOU'LL LEARN

- Working with the Scene Cleaner
- Removing people using scribble selections
- Rectifying mistakes
- Final image cropping

1 Open all the lesson images. Now go to Enhance > Photomerge® > Scene Cleaner. A message will appear asking for a selection of images or to open all. We want to open them all.

2 First, Elements auto-aligns the images so we get the best possible match to work from. We need to choose our final image. We'll use Image 1. Drag it from the Photo Bin onto the right-hand window.

3 We'll start by removing the man in orange. We need an image where that area is clear. Click Image 2 in the Photo Bin to select it as the source. Scribble over him on the *final* image; he disappears!

4 Now for the woman on her cellphone. Select Image 3 as the source. Paint over her as we did in the last step. She goes but it brings the woman from the source image in. We also have some disembodied legs!

5 Click on Image 4. Start drawing on the woman. Now go all the way down to the bottom of the man's shoe in the foreground. Both are removed leaving us with a completely clear view of the building.

6 Click Done to complete the process. After a short time Elements will return to the main edit screen. All we need to do now is crop away the white border from the image and that's our scene cleaned!

HOT TIP

It's usually possible to fix problem areas where the Scene Cleaner wrongly adds or removes people and objects by working from a different source image. If that's not possible we can always do additional clean-up work with the Clone Stamp once we've taken the image back into the edit workspace.

5 Image adjustments
Changing skies

The background eraser is a fantastic tool for removing areas of similar color. It works by sampling the color beneath the crosshair and deleting all the pixels of that color within the radius of the brush. Here, we're going to use it to replace the dull sky in this photograph of London's Houses of Parliament.

Although we could select and delete much of the background using the Magic Wand tool, that won't select inside fiddly areas such as the tree: this is where the Discontiguous setting of the Background Eraser comes in handy, as we'll see in this example.

As with many destructive techniques, before we start with this tool, it's important to duplicate the layer you're going to work on, hiding the original so there's always a copy we can return to later, in case we need to fix problems.

WHAT YOU'LL LEARN

- Using the Background Eraser tool
- Erasing complex areas
- Fixing problem areas by copying back areas from the original image

118

1 Select the Background Eraser **E**. Change its limits from Contiguous to Discontiguous. A Tolerance setting of 40% works well for this plain sky. Paint around the tower to delete the background. Make sure the crosshair doesn't stray onto the building.

2 When we move into the tree area, we have a problem. Once the crosshair touches the branches, that's the color that's sampled – and so that's the area that is deleted. We need to find another way to remove the sky in there. Undo that step and we'll try again.

3 Make the Eraser brush size much larger – we've used a 175 pixel brush here. Click on a clear area of blue sky within the tree branches and all the sky within the radius of the brush will be deleted. Make sure you don't click on the branches by accident.

4 Continue erasing all the sky within the image, varying the size of the brush as you need to. Don't worry if some areas of the picture are erased that shouldn't be; we can get those back later. For now, concentrate on getting rid of all that sky.

5 When we bring in a new sky layer behind the buildings, we can see a few mistakes: the clock face has been erased; we can see the new sky through it. The same applies a few parts of the buildings. Just as well we were working on a copy of the layer!

6 Make selections around the missing building parts using the Lasso tool **L**. Now return to the original (hidden) layer and press *ctrl* *J* *⌘* *J* to make a new layer from the selection. Move this layer above the clouds layer and the image is complete.

HOT TIP

The Tolerance setting depends on how uniform the background is. The higher the Tolerance, the wider the range of deleted colors will be. It's a matter of judgment for each image individually; start with a setting of around 50% and increase or decrease it as needed.

5 Image adjustments
Catching the drops

WE'VE SEEN HOW TO REPLACE a sky when there are trees and other complex objects in the foreground. Even with the excellent array of tools at our disposal, however, there are instances where it's not possible to capture all the detail using conventional methods.

It's straightforward enough to extract the fountain and its water spurt from the background. The problem we have is all the little splashes of water; we need to keep them because the image would look static and unrealistic without them but it's too much for the Magic Wand to cope with. Zooming in and selecting each one by hand would be far too time-consuming

The key to this task is to make the splashes as visible and contrasted as possible. To do this we'll use the Threshold adjustment, which produces a pure black and white version of the image; the splashes show up as white; we can create some combined selections to make a near-perfect extraction.

WHAT YOU'LL LEARN

- Selecting complex objects
- Making and saving selections
- Using the Threshold adjustment to highlight areas
- Combining saved selections

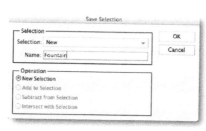

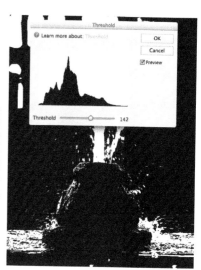

1 Make sure the fountain layer is active. We'll begin by selecting as much of the fountain base and the water spurt as possible. The Quick Selection tool **A** is perfect and makes short work of this.

2 We'll save the selection here: go to Select > Save Selection. We only have the New option. Give it a name and click OK. Now deselect *ctrl* *D* *⌘* *D*. Lastly, press *ctrl* *J* *⌘* *J* to duplicate the layer.

3 Go to Filters > Adjustments > Threshold. This converts the light and dark areas to pure black or white. We can clearly see the water drops. Dragging the slider to the right slightly gives a nice balance. Click OK to apply.

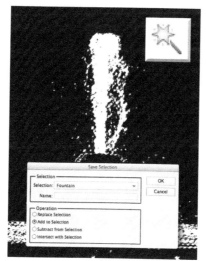

4 We can paint out the areas we don't need using a hard-edged black brush **B**; the windows in the background, for instance. The fountain selection is already saved, so it doesn't matter if we paint over it slightly, as long as we leave the splashes intact.

5 Grab the Magic Wand **A**. Uncheck Contiguous in the Tool Options. Click an area of white to select it all. Open the Save Selection dialog. Pick the previously saved selection from the list and click Add to Selection. Click OK.

6 Hide or discard the threshold layer. Make the fountain layer active again. Load the combined saved selection. Go to Select > Refine Edge. View against black **B**. Apply a very slight feather, around 0.5. Set the output as a new layer with mask. Click OK to apply.

HOT TIP

As an additional step, we could separate the main water spurt from the rest of the image by selecting with the Rectangular Marquee and cutting it to a new layer *ctrl* *Shift* *J* *⌘* *Shift* *J*. We can desaturate it to remove any unwanted color casts and also lower its opacity to make it slightly translucent.

Adding depth of field

GETTING GOOD DEPTH OF FIELD in a picture is essential for separating your subject from the background, especially in portraits. Compact cameras and cellphones often don't have the level of control to be able to achieve the effect. Even with a DSLR or high-end compact camera the situation may not allow it; in very bright conditions, for instance, we often can't use the wide apertures required to achieve the effect.

There is a solution, of course. Elements 11 now has the Lens Blur filter. This differs from the other blur filters as it mimics the way a lens works, giving the effect a much more realistic appearance.

In this tutorial we'll use a selection to isolate part of our photo to keep it sharp, allowing the rest to fall into soft focus. We get a much better result than we would with Gaussian Blur. We also don't get the halo effect that often occurs when using the other filters, so there's no need to clone areas back in afterward.

DOWNLOADS

Engines.jpg

WHAT YOU'LL LEARN

- Making a selection to isolate the effect
- Tidying the selection with Refine Edge
- Adding and adjusting the Lens Blur filter

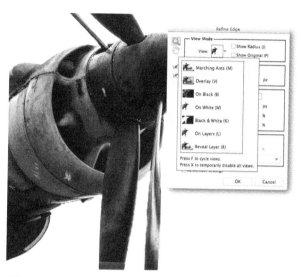

1 Begin by making a selection of the area we want to keep in focus. The Quick Selection Tool **A** is by far the best method. Here we've selected the engine nearest to the left. Make sure that all the sections are included, otherwise we will have blurred areas amidst our focused ones.

2 The selection is a little rough, especially on the straight edges. We need to tidy that up. Go to Select > Refine Edge. View the layer against white **W**, this gives us the best contrast. Double-click the Zoom icon to view at 100%.

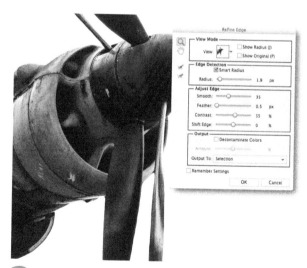

3 As all our edges need to be sharp we can afford to be liberal with the settings. Begin by checking Smart Radius. Now push the Radius slider up to around 1.9. Increase the Smoothness to around 35. Add a feather of around 0.5 pixels. Boost the Contrast up to around 55%. Make sure Output is set to Selection. Click OK to apply the adjustments.

4 Go to Filter > Blur > Lens Blur. The filter's dialog opens. There's an obvious problem; everything apart from the engine is in focus. This is fixed by clicking the Invert box. The blur is perhaps a little too heavy. Drag the Radius slider down to around 10 to lessen the effect. Finally, click OK to apply the blur.

HOT TIP

The filter can be very slow at times, particularly with larger images. We can speed the process up a little by clicking the Faster preview button. If it's still too slow, we can turn the preview off altogther while we are making adjustments, then enable it to check the effect.

But is it art?

THE ART WORLD CAN BE A FICKLE and sometimes intimidating place. Whilst the majority of its denizens are more than happy to welcome new concepts such as digital art with open arms, there will doubtless be the old-school stalwarts who balk at the very notion of something as utilitarian as a computer being the medium for any kind of creative expression. This is nothing new, of course; photography also received the same amount of steely renunciation when people started using it as anything other than a functional method of preserving images of people and places. It took the work of the late, great photographer Ansel Adams and others like him to prove that the photograph could have just as much visual impact and provide the same aesthetic pleasure as paintings by the old masters.

Unfortunately, as with many things, there can also be a degree of fighting within the ranks as well. There are those who frown upon certain aspects of digital art, such as photomontage and 3D imagery, seeing it as compensation for lack of talent because it's not created from scratch and often uses other people's work as a constituent. This is, of course, a ludicrous way of thinking. Nobody thinks to question the validity of art forms such as decorative floristry, which quite obviously doesn't necessarily require the flowers to be grown by the artist beforehand; it is, after all, the end result that matters and not how it was achieved.

Squabbling aside, one of the main accomplishments of the digital age is its ability to unlock and uncover artistic flair. We may shy away from trying out our ideas, often because we lack confidence in our abilities, believing that we'll make irreversible or costly mistakes. Another reason might be one of space and time, or the lack thereof. A studio requires a fair amount of working space and it's not always practical to set one up permanently; it can take a while to ready the materials and pack them away after a session, all of which does nothing to aid the creative process.

This is where computers come into their own. In general they're fairly self-contained, taking up only a small proportion of space and they can be ready for action in just a few minutes. What really sets them apart, however, is their forgiving

nature: make a mistake on canvas and you've got a fair amount of tidying up ahead of you – at worst you'll have to paint over it and start afresh, which is demoralizing to say the least.

Working digitally is a different matter entirely. With technologies such as layers, non-destructive adjustments and styles, and not forgetting the trusty Undo function, you can afford to think more freely in the knowledge that you have these safety nets to catch you, should you falter and lose your artistic balance.

It's not all plain sailing, of course. The standard equipment that comes with a PC, usually a mouse, is great for moving the cursor around the screen to point at links in web pages, menus and highlight passages of text in a word processor, but not so good for creating a masterpiece. Imagine trying to draw with a pencil shaped like a soap bar; it's not impossible, but it can be awkward and become uncomfortable after a while. If you're considering any kind of digital art as a serious hobby or even as a profession then a graphics tablet is an essential purchase. They can take a while to get used to, however; there's often a period where hand-eye coordination causes problems – we are usually more accustomed to looking directly at what we're drawing, rather than away to a screen. Once you have overcome this, it's unlikely you'll want to stop using it; outlining and selections can be achieved in half the time and you can really see the difference with the painting tools. Using a pressure-sensitive device makes shading an absolute delight, rather than the constant size and opacity changing nightmare it once was. Many tablets have configurable buttons on the stylus which can be set to emulate key-presses; for example, you could set one up as the Spacebar, allowing you to pan around the image whilst zoomed in for close-up work. There are, of course, some things that even the most powerful computer technology can't provide you with: imagination and determination. You're on your own there, but without the constraints that may have been holding you back before, you're free to express yourself in whatever way you see fit. There is no rule book to abide by here, just do what seems good at the time.

6

Working with text

WE USE TEXT FREQUENTLY IN ELEMENTS. Although you may not think of it as being an essential component of most images, there are often times when adding a caption can lift an image.

But there's more to text than mere captions. Think how good it would look if you could create a flyer with three-dimensional text, or wrap some text around an object. How about making text follow the outline of an image to create an illustrated poem?

We'll look at the basics of creating text and all these techniques in this chapter.

Introducing the Type tool

WE LOOKED AT TEXT briefly in Chapter two. In this chapter we'll be going into more detail. Elements has a wide variety of ways to apply type to our images and designs.

In this lesson we'll be looking at the basics of the Type tool. We'll see how to add text to a document and look at some of the options we have available to alter the way it appears.

 1 Create a new blank file *ctrl N* *⌘ N*. Use the Elements Default preset and Click OK. Select the Type tool *T*. By default this will give us the Horizontal Type tool. Place the cursor on the document at the left. Click once. We get a flashing cursor and a new layer is created.

2 Let's type something; 'Big Text' seems relevant. As expected, it behaves just the same as any other program. At the moment this is live text. If we click the green check icon, or press *ctrl Enter* *⌘ Enter*, we commit the text and it becomes fixed; though not permanently.

3 Switching to the Move tool *V* lets us move the layer around, just as we would any other. We can always go back and edit the text, however. Double-click the layer's thumbnail in the Layers panel. The text is highlighted and we're automatically switched back to the Type tool.

4 Let's change the font. Go to the Tool Options panel. Click on the font picklist. Scroll down and select Times New Roman. Next, click on the Style picklist. Change it from Regular to Bold Italic. We can also commit the changes by clicking once on the layer's thumbnail.

5 We can also change the color of the text. Double-click on the text to select it again. Go back to the Tool Options. Click on the color picker. Select the RGB red preset. As the text is selected It doesn't look right until we commit it.

6 Almost anything we can do to the whole layer, we can also do to parts of the text. Make sure the Type tool is still selected. Position the mouse between the B and the i. Now click and drag over the B to select it. Here we've changed the font to Verdana and the style to bold.

HOT TIP

By default when we commit the text, Elements switches to the Move tool. This is OK if we're just adding a caption, but if we're working with a text-heavy design, it quickly becomes irritating. Fortunately, it can be turned off in Preferences *ctrl K* *⌘ K*. Uncheck Select move tool after committing text.

Text in paragraphs

Open Mike night

The evening got off to a great start with singer, Mary Smith, performing some of her own songs; a mix of soulful ballads and upbeat foot-tappers.

Amongst the other acts, we were treated to some fabulous comedy and conjuring from our youngest act, Daniel Young. At just 13 he had the audience in the palm of his hand. Or perhaps they were up his sleeve?

AJ.

IMAGE: **ABSOLUTVISION.COM**

WE'VE SEEN HOW to add a single line of text to a document. We can also create blocks of text constrained by a boundary. This is really useful as we can use it in design work where we need the text to fit a particular space.

In this lesson we'll look at how we can add an article next to an image. Once we've created the paragraph boundary, the text flows down as we type, Elements automatically separating the lines out to fit.

We'll see how we can change the spacing between lines of text using the Leading setting. This adds blank space above the text. The term dates back to when type was set by hand; a line of lead was placed between the rows of type to separate them out. We'll also see how we can change the alignment of the text within the paragraph.

WHAT YOU'LL LEARN

- Creating a paragraph boundary
- Changing type styles
- Using leading to change the line spacing
- Changing the text alignment

1 Select the Horizontal Type tool 🅣. Position the cursor next to the top-right of the image, leaving a small margin next to the photo; this is referred to as the gutter in design. Now click and drag down to the bottom-right; again, leave a small margin on the right of the document.

2 We'll start with the headline for our article. Set the font to Arial. Change the style to bold. We'll use 14pt for the size. Set the color to black. Make sure the text is left-aligned; this is the first of three alignment buttons in the Tool Options panel. Now we can type our text.

Open Mike night

The evening got off to a great start with singer, Mary Smith, performing some of her own songs; a mix of soulful ballads and upbeat foot-tappers.

 Amongst the other acts, we were treated to some fabulous comedy and conjuring from our youngest act, Daniel Young. At just 13 he had the audience in the palm of his hand. Or perhaps they were up his sleeve?

AJ.

3 Press *Enter* to drop to a new line. We need to change the text attributes for the text body. Set the style to Regular. Lower the size to 10pt. When we start typing we see the body of the text is too close to the headline.

4 An extra line break would make the gap too wide. Instead, select the top line of the body text. Go to the Leading setting in the Tool Options. This adjusts the spacing between the lines of text. Change it from Auto to 18pt.

5 Now we can finish off the article. We can add an indent for a new paragraph with the Tab key ⇥. The reporter's initials have been set to bold italic here; we've change the text alignment to right-aligned.

HOT TIP

Here we changed the gap between the headline and the text body by selecting only the top line. If we had selected the entire body, the change would affect it all, making the spacing too large. By default, leading is set to Auto, which is 120% of the type size.

Text on a selection

IMAGE: **ABSOLUTVISION.COM**

WE'RE NOT LIMITED to adding text in simple straight lines, of course. Elements has several tools that allow us to shape it around objects. The most practical of these is the Text on Selection tool. This uses the Quick Selection tool to select an object. It then converts the selection to a path, to which we add the text. As we type, the text follows the contours of the path.

As we'll see in this lesson, when we have an object on its own layer we don't need to make a fresh selection, we can load the layer's transparency; the tool can work with any selection, regardless of how we create it.

WHAT YOU'LL LEARN

- Expanding the size of a selection
- Creating a text path with the Text on Selection tool
- Adding text to the path
- Moving the text to the correct part of the image
- Adding a layer style to the text

1 As our bulb is already on its own layer we can load up its selection and use that. We don't want the text right on the edge. Go to Select > Modify > Expand. Set a value of 10 pixels. Click OK.

2 Select the Text on Selection tool **T**. Click once inside the selection. Nothing happens apart from the Apply/Cancel icons appearing. Press *Enter* to apply. The selection becomes a solid outline; it's now a path.

3 Go to the Tool Options. Set the font to Impact. Change the size to 30pt. Go back to the image. Hover the cursor over the path and it becomes a text cursor with a line through it. Click once. We get a flashing cursor.

4 We'll type the text 'BRIGHT IDEAS!'. As we do the text starts to flow around the lightbulb. We have a problem, though. We want it to sit on top of the bulb but it's going the wrong way. We'll fix this next.

5 Move the cursor over part of the text. Hold *ctrl* ⌘. The cursor now has a small arrow next to it. Click and drag on the text. As we do, it moves around the path. Place it evenly at the top. Press *ctrl Enter* ⌘ *Enter* to set it .

6 Let's add a layer style. Select Outer Glows from the list. Double-click the Simple preset to apply it. Go to the style settings. Change the color to white. Now increase the size a little.

HOT TIP

Occasionally, when you're adding text to a path, some of it may not show up. This is usually because the start and end points of the path are too close together. Dragging the points out as we have here will fix it, assuming there is enough space on the object.

Text inside a selection

I wandered lonely as a Cloud
That floats on high o'er Vales and Hills,
When all at once I saw a crowd
A host of dancing Daffodils;
Along the Lake, beneath the trees,
Ten thousand dancing in the breeze.

The waves beside them danced, but they
Outdid the sparkling waves in glee:
A poet could not but be gay
In such a laughing company:
I gaz'd--and gaz'd--but little thought
What wealth the shew to me
had brought:

IMAGE: **BILLY ALEXANDER (SXC.HU)**

P REVIOUSLY WE SAW HOW we could wrap text around an object. Another common technique in design is to have a block of text wrap around another element on the page; usually an image. This adds a more fluid style to the page, as opposed to plain squared-off text.

This technique is possible in Elements, although it's not documented, and requires a little cheating to perform.

In this lesson, we'll add the first two verses of William Wordsworth's poem *I Wandered Lonely as a Cloud* to an old postcard with an image of some daffodils; being on theme with the text. We'll use the selection tools to create a path that follows the contour of the image.

If you don't feel like typing the poem in, you can copy and paste it from Wikipedia:

http://en.wikipedia.org/wiki/I_Wandered_Lonely_as_a_Cloud.

WHAT YOU'LL LEARN

- Making a custom shaped selection
- Creating a text path from a selection
- Fitting text into a path shape

1 Begin by making a selection with the Rectangular Marquee tool **M**. We need to overlap the area we want to have the text wrapping around; the edge of the flowers in this case. Leave a margin at the top, bottom and right hand side of the card.

2 Switch to the Lasso tool **L**. Hold *alt* to switch to subtract mode. Position the cursor at the top-left of the selection. Now draw around the outside of the flowers, leaving a margin between. We don't need to be too precise, just follow the general shape. Close the selection with a loosely drawn path behind the flowers; shown here in red.

3 Grab the Text on Selection tool **T**. Click inside the selection. Press *Enter* to create a path. The current tool is for placing text on a path; we want it inside. Switch to the Horizontal Type tool **T**. When we do this, the path disappears. To get it back press *ctrl Z* *⌘ Z* to undo, which brings the path back. Click inside the path area to place the text cursor.

I wandered lonely as a Cloud
That floats on high o'er Vales and Hills,
When all at once I saw a crowd
A host of dancing Daffodils;
Along the Lake, beneath the trees,
Ten thousand dancing in the breeze.

The waves beside them danced, but they
Outdid the sparkling waves in glee:
A poet could not but be gay
In such a laughing company:
I gaz'd–and gaz'd–but little thought
What wealth the shew to me
had brought:

4 Go to the Tool Options panel. Set the font to Nueva Pro. A size of 11pt fits fairly well. Set the color to black. Now type, or paste in, the poem excerpt. We'll bring the text down at the top by positioning the cursor at the beginning of the line and pressing *Enter*. All that remains is to commit the text by pressing *ctrl Enter* *⌘ Enter*.

HOT TIP

If you find there are some orphaned (instances of a single word on a line of its own) words when you type or paste the text in, you can often resolve the problem by dragging the left or right center handles of the bounding box by a small amount to add some extra space.

Three-dimensional text

When we want text to stand out we tend to use a bold font, often in a different typeface to the rest of the document. To really draw attention to it we can take it a little further and give it a three-dimensional effect so it jumps off the page at the viewer.

Three-dimensional text is usually generated by dedicated programs or by using plug-ins; but, as we'll see in the following tutorial, we can create the effect in a few simple steps using the standard Type tool and a crafty trick with selections, layers and the Move tool. We'll top the whole thing off with a gradient fill layer and some layer styles.

This effect is perfect for show posters and flyers and anything else that requires a little flamboyance.

WHAT YOU'LL LEARN

- Using the Warp Text function
- Creating merged copies of layers
- Copying a layer Using the Move tool to add depth
- Adding layer styles to give the text extra dimension

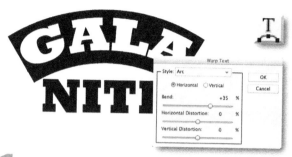

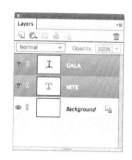

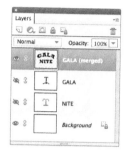

1 Begin by double-clicking the GALA text layer in the layers panel. Go to the Tool Options panel. Click the Create Warped Text button. Select the Arc style from the drop-down list. The initial Bend value is too much. Lower it to around 35%. Click OK to set the changes.

2 Commit the text by pressing *ctrl Enter* ⌘ *Enter*. Hold *Shift* and click the NITE text layer's thumbnail to create a group.

3 Press *ctrl alt E* ⌘ ⌥ *E* to create a merged copy. Now hide the original text layers by clicking their visibilty icons.

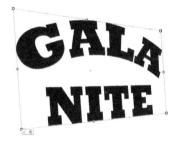

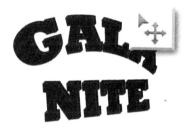

4 Creating the merged layer allows us to distort the text. Press *ctrl T* ⌘ *T* to enter Free Transform. Hold *ctrl* ⌘. Now drag the corner points to put the text in perspective. Press *Enter* to commit the changes.

5 Duplicate the layer *ctrl J* ⌘ *J*. Now click on the original merged layer to make it active again.

6 Press *ctrl A* ⌘ *A* to select all. Grab the Move tool *V*. Hold *alt* ⌥ and press the left arrow key once, then the down arrow key once. Repeat this several times.

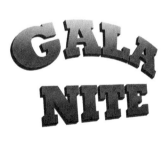

7 Press *ctrl D* ⌘ *D* to drop the selection. Click the thumbnail of the copy we made earlier. Now create a Gradient adjustment layer above it. We'll use the Blue, Red, Yellow preset. Click OK to set the gradient. Now press *ctrl G* ⌘ *G* to clip it to the layer below.

8 Make the top text layer active again. Go to the Effects panel. Choose Styles > Bevels. Double-click the Inner Ridge preset. The default is too large. Open the style settings. Lower the bevel size to around 10px. We can also add a drop shadow to make the text jump off the page.

HOT TIP

Normally we wouldn't want to convert text into a regular layer as we lose its ability to scale without losing quality. It's important, therefore, to make sure we have the text as close to the size we want before we start distorting it.

Creating cut away text

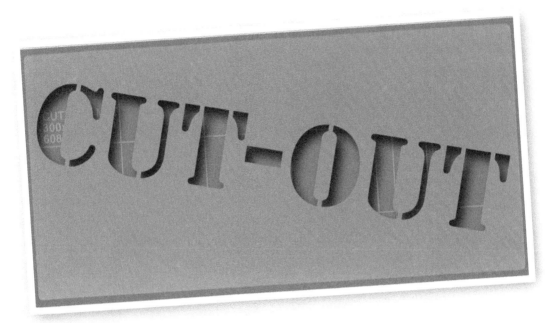

IMAGE: **CARD – BILLY ALEXANDER (SXC.HU); STEEL PLATE – MAYANG'S TEXTURES**

CREATING CUT-OUTS usually requires us to delete parts of an image to let the layers beneath show through, or use a layer mask. The problem with doing this is we lose the ability to change the image easily. Even with a mask, which is non-destructive, we would still need to wipe it and start again to produce a new effect. There is a much better way and we don't need to delete anything.

In this lesson we'll cut out some text from a piece of card. In reality we never cut anything out: the background we see through the text is actually above it; we use a clipping group so we can only see the layer where it covers the text. The effect of depth is created with an inner shadow. This means we can reposition the text, transform it and even change the word whilst maintaining the illusion of seeing through the card.

WHAT YOU'LL LEARN

- Adding layers with the Place command
- Using clipping groups to selectively hide layers
- Adding depth with layer styles

1 Grab the Horizontal Type tool . Select the Stencil Std font from the list. Set the size to 42pt. The color is not relevant as it will be covered up; black is a good contrast while we work. Click on the left side of the document to set the cursor. Now type CUT-OUT.

2 Go to File > Place. Select the Cutting mat file. Click Place to open the image. Press *Enter* to set the layer down. This covers the text completely, of course. Press *ctrl G* *⌘ G* to clip the layer to the text. Now all we see is the mat where it meets the pixels of the text.

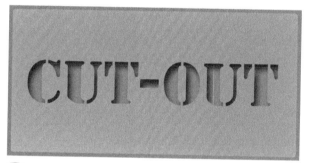

3 The effect isn't very convincing as the text is flat. Click the text layer's thumbnail to make it active. Go to the Effects panel. Select Styles. Choose Inner Shadows. Double-click the Low preset. Now the text appears to have been cut out of the card to reveal the mat beneath.

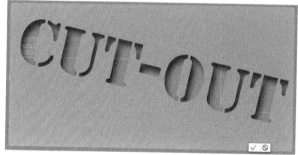

4 The effect gets cleverer still when we move the text around. Press *ctrl T* *⌘ T* to enter Free Transform. We can alter the position and even rotate and scale the text. As we do, it seems like we can see different parts of the background. Press *Enter* to commit the changes.

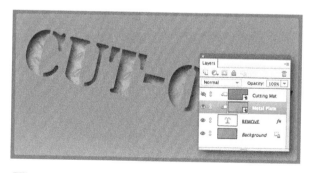

5 If we decide we want a different background showing through, we simply place another image layer above the text as we did in step 2. Here we've used a metal plate texture. When we hide the mat layer, the new background shows through without any need for further change.

6 The other great thing, of course, is that we're using live text. We can change the wording at any time, whilst still retaining the effect. Double-click the text layer's thumbnail. Now type something new; CHANGE is a suitable replacement.

HOT TIP

There are no options for adjusting the properties of the inner shadow layer style. This can be a nuisance as the presets are fairly limited. We have created some of our own presets; these can be downloaded from the book's website and installed using the Preset Manager. See page 288 for details.

Can I get a job doing this?

THE SHORT ANSWER IS: YES. The longer answer is: Well, yes – if you have the skill, determination and free time available, and if you happen to bump into the right people.

The question of whether it's possible to make a career out of doing photomontage work occurs, at some stage, to just about everyone who's ever dabbled in Photoshop or Elements. It's an appealing proposition: the idea of spending one's days tinkering with images for profit sounds like a great way of occupying oneself.

The trouble is, the world just isn't crying out for more photomontage artists. It's not like studying to become a dentist or a plumber. There's no standard course, no regular qualification, and absolutely no guarantee of a career of any sort at the end of the line. This, coupled with the fact that you're not alone in wanting to pursue this path, means that there are far more people out there capable of manipulating images than there is demand for such services.

But if you're really determined, then there are several steps you could take to make the dream a possibility. It all depends on whether you have the free time to develop your skills without being paid to do so.

The first, and most important step, is to get your work published. Art editors are notoriously busy and preoccupied people, who are driven by deadlines and the need to fill the space between the text and the advertisements in their publications. What matters to them are four main factors: Can you interpret a brief? Do you have the skill needed to turn in a good job? Do you have an interesting or unique style? And, above all: Can you be sure to meet a deadline? For ultimately, it doesn't matter how good or inspired your work is if you're unable to turn it in on time. If you don't meet the deadline, you'll never hear from them again.

Art editors are far more likely to take a chance on commissioning work from an unknown artist (yourself) if you can demonstrate that others have already placed their faith in you. Of course, it's something of a catch-22 situation: you can't get the

work unless you've already had work published, and you can't get work published unless someone gives you the work.

One solution is to begin by offering your services, for free, to publications or websites who couldn't afford to pay for them. This might include local newspapers, community and sports magazines, charity websites, church and workplace newsletters, and so on. Get as much work in print or on websites as you can, to show that you're capable of sustained effort.

Only when you have a fair body of work to show should you then approach magazine and newspaper art directors. But start small: writing to The New Yorker offering to draw their covers is unlikely to produce a positive response, at least in the early days.

Self-promotion is a key part of bringing your skills to the attention of those who matter. These days, it's easy to set up and maintain your own website, and you should take the opportunity to show off as much published work as you can in this way. Feel free, as well, to show 'personal' work done for your own entertainment – but be aware that this won't carry as much weight with potential employers as work you've been commissioned to do.

Another way of getting started is to get a job in a publishing office, doing menial tasks such as scanning and filing photographs. Before long you'll come across an image that needs tweaking; show what you can do, and if you're any good your skills will be recognized.

You can, of course, set up a website offering your services directly to the public. Many people offer photo restoration, custom greetings cards, and photo caricature services; a few make a reasonable living out of it.

Decide where your strengths lie. You may be proficient at restoring photographs, removing ex-spouses from family shots, or caricaturing politicians. Develop your area of expertise and find new ways of performing the task. People are far more likely to use you if you can offer a service that no one else can.

7

Quick techniques

BY NOW YOU SHOULD BE REFRESHED and up to speed with Elements' tools and commands. It's time moving further into some more advanced montage and effects techniques.

In this chapter we'll be looking at some fun and useful ideas for one-off images and also techniques to employ in more complex images. We'll discover how to give an image a powerful spot-color effect, restore the appearance of speed to a static image, create a rainbow, make a humorous caricature and turn day into night; to name but a few.

A splash of color

IMAGE: **PHOTOS.COM**

L EAVING AREAS OF PROMINENT COLOR in an otherwise monotone image, known as spot coloring, is by no means a new idea. It's often used in wedding photography to pick out the bride's bouquet and was also used to great effect in the movie *Sin City*, which we'll be paying homage to in this project by leaving the red areas on the woman in the image in color. Elements has the perfect tool for creating this effect; the Smart Brush tool.

The Smart Brush is a combination of the Quick Selection tool and Adjustment Layers: as you click or paint on the image it selects the area but at the same time dynamically builds a mask, so only that part of the adjustment's effect is visible. The great thing is that because they are Adjustment Layers, we can change the look of the image in an instant by simply choosing another preset or by altering the opacity or blend mode.

DOWNLOADS

Lady in red.jpg

WHAT YOU'LL LEARN

- Working with the Smart Brush tool
- Using the Detail Smart Brush tool for tricky areas
- Finessing the selection with Refine Edge

1 Select the Smart Brush tool **F**. Go to the Tool Options panel. Choose Reverse Effects from the preset picker. The first preset is the one we need. It creates the reverse black and white effect.

2 Start to paint over the woman's dress. As we do the rest of the image turns black and white. If we look at the Layers panel, we can see the mask being created on the adjustment layer.

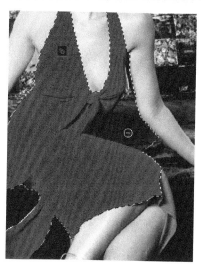

3 Continue painting over the rest of the dress. Occasionally, we might get areas that spill out into the rest of the image. We can fix this by holding **alt** ⌥ to subtract from the selection and paint them out again.

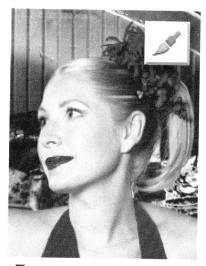

4 For smaller areas we can switch to the Detail Smart Brush tool by pressing **F** again. This is like the Selection Brush, it only paints at the point of the cursor. We can change the brush size with the square brackets **[** **]**.

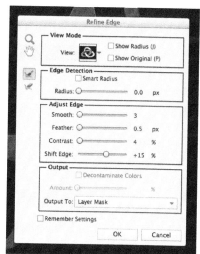

5 As we're working with selections, we can use Refine Edge to tighten up the effect. Notice we're shifting the edge out here; see the hot tip below. Make sure the output is set to Layer Mask. Click OK to apply the changes.

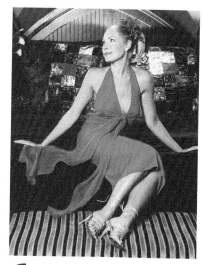

6 The edges of are much smoother now but we have a problem; the effect has been reversed. This is simple to fix. Make sure the adjustment mask is active. Now press **ctrl I** ⌘ **I** to invert the mask.

HOT TIP

When using Refine Edge to edit the selection area, be aware that the some of the Smart Brush presets, such as the one we use here, use an inversed selection to create the effect. This means that when we want to shift the edge in, we must actually increase it in the dialog and vice-versa.

7 Quick techniques
Panorama power

S O MANY OF OUR GADGETS now either come with, or can be fitted with, a digital camera. No matter where we are, we will almost always have a way of taking photos. This is great, of course, but there is a downside. Devices such as cell phones have limited space in which to place the camera lens, so they are generally fairly small and the image quality at a distance isn't that great. It makes taking photos of larger objects difficult.

There is a solution, of course. Elements has an incredible panoramic stitching feature. All we need do is move closer to our subject and take several photos in overlapping sections. Here we took shots across the top half of the building first, then moved back along the bottom. This way we were able to keep the images fairly level. We feed these into Elements which then goes off and does its magic, producing one complete image at the other end. Fantastic!

DOWNLOADS

Panorama (folder)

WHAT YOU'LL LEARN

- Using the Photomerge® Panorama dialog
- Correcting perspective distortion

The Clean Edges feature has worked really well for this image, but it's by no means foolproof. The sky and foreground are fairly uniform here, but if we had been attempting to use it with an image with more complex areas, particularly those close to the edges; as we saw in this image where the tree seemed to gain one of the building's spires, the results may not have been so good. It would be necessary to use the clone and healing tools.

1 Go to Enhance > Photomerge® > Photomerge® Panorama. Select the source to use folders. Click Browse to locate the Panorama Power folder. Click Open and they'll appear in the dialog window.

2 We'll leave the Layout option set to Auto and make sure that Blend Images Together is checked. Click OK and it will begin to perform its magic. The initial result is a little ragged but Elements has a trick up its sleeve: the Clean Edges dialog will appear. Click Yes. A composite layer is created. The gaps are filled using Content Aware technology.

3 Elements has analyzed the areas around the edge and filled them to blend in with the rest of the image. On the whole, it's made a great job of it, with only a couple of small problems on the left by the tree and at the bottom of the grass.

4 We need to fix the photo's crookedness and bowing. Select Filter > Correct Camera Distortion. Increase the Remove Distortion control to around +50. Now alter the angle a small amount using the central spire as a guide; around 357° is about right.

5 Here's our finished image. Overall, it's an astonishingly good result with very little effort required and no need for cloning or additional cropping in this instance, thanks to the incredibly clever Clean Edges feature. Even those minor problem areas from before were cropped when we adjusted the image distortion.

7 Quick techniques

The need for speed

IMAGE: **MARTIN PETTITT (FLICKR.COM)**

CAPTURING THE ESSENCE OF MOTION in a photo can be tricky. There's a fine balance between freezing the subject completely, resulting in the image seeming too static, and going too far the other way, where we end up with nothing but a blur.

Unfortunately, there's not much we can do to rescue a blurry photo but we can certainly restore the appearance of speed to an image that's been stopped in its tracks. In this lesson we'll see how to add some life back to a photo by adding some motion blur to the background of this race car.

DOWNLOADS

Aston Martin.jpg

WHAT YOU'LL LEARN

- Using selection techniques to isolate the subject
- Applying motion blur
- Fixing problems with the clone tools
- Spinning wheels with Radial Blur

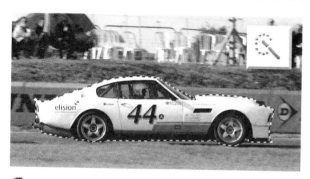

1 Duplicate the background layer. Now use the Quick Selection tool [A] to make a selection of the car. Tidy up any stray areas with the Selection Brush tool. Copy the car to a new layer *ctrl* [J] ⌘ [J].

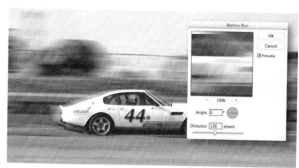

2 Click the background copy in the Layers panel. Go to Filter > Blur > Motion Blur. We want to apply a lot of blur so set the Distance to around 130 pixels. We can leave the angle at 0˚. Press OK to apply.

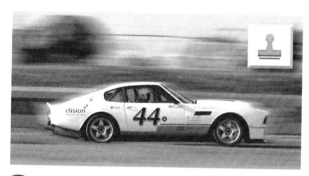

3 The effect is great but we can see a ghosting effect where the blur has also affected the pixels of the car on the original layer. Grab the Clone Stamp tool [S]. Pick a fairly large soft-edged tip.

4 Starting on a clean area of the background; the top of the yellow hoarding is a good place. Hold *alt* ⌥ and click to select the source. Start to clone out the areas that protrude outside the edges.

5 Click on the car layer in the layers panel. Grab the Elliptical Marquee tool [M]. Place the cursor in the center of one of the wheels. Hold *alt* *Shift* ⌥ *Shift*. Drag out the selection so it contains the entire rim.

6 Go to Filter > Blur > Radial Blur. Make sure the Blur Method is set to Spin. Set the amount to around 55. Click OK to apply the effect. Now select the other wheel. Press *ctrl* [F] ⌘ [F] to repeat the effect.

HOT TIP

Make sure the Clone Overlay option is enabled and set to Clipped in the Tool Options of the Clone and Healing Brush tools. This shows the brush with the currently selected area of the image. This makes it much easier to use as you can see exactly what you're about to paint in.

7 Quick techniques
Sunset silhouette

P REVIOUSLY IN THE BOOK we looked
at replacing a washed out sky with a more
impressive one. Simply changing the existing
sky isn't always enough, however; depending on the
type of scene we want to produce, we will often need
to adjust the foreground to match. We'll demonstrate
this by transforming our somewhat drab photo of a
windmill into a lovely evening silhouette.

As the sun sets its light changes, becoming a
richer, more orange tone which, in turn, affects the
scene's colors. We can mimic this by adjusting the
levels of the image, adding more red into the scene.

DOWNLOADS

Windmill.psd

WHAT YOU'LL LEARN

- Quick selections with the Magic Wand tool
- Altering the tones and hues with an adjustment layer
- Creating a shadow with layers and Free Transform

1 Make sure the windmill layer is active. Grab the Magic Wand *A*. Uncheck Contiguous in the Tool Options. Now click an area of the sky. We get most of it in one go. Hold *Shift* and click to add the missing areas.

2 Press *Backspace* to delete the sky. We need to change the tones of the foreground. Invert the selection *ctrl* *Shift* *I* *⌘* *Shift* *I*. Now go to the Layers panel and create a Levels adjustment layer.

3 Drag the midtone slider to the right to make the tones richer and darker. Increase the Shadows slightly. Now select the Red channel. Drag the midtones a little to the left to deepen the red hues.

4 Make the windmill layer active. Grab the Polygonal Lasso tool *L*. Start at the base of the windmill, draw a selection around it. Press *ctrl* *J* *⌘* *J* to create a new layer from the selection. Name the layer Shadow.

5 Press *ctrl* *T* *⌘* *T* to enter Free Transform. Hold *ctrl* *⌘* and drag the top corner points down to distort the layer into a shadow for the windmill. Press *Enter* to commit the changes.

6 Change the shadow layer's blend mode to Multiply. We need to soften the shadow a little. Go to Filter > Blur > Gaussian Blur. Set the Radius to around 4 pixels. Finally, lower the opacity to around 40%.

HOT TIP

Often when we're transforming a layer we need to extend outside of the edges of the document. Press *ctrl* *—* *⌘* *—* a few times to zoom out. If you're using floating windows, select the Zoom tool *Z*. Uncheck Resize Windows to Fit in the Tool Options panel.

7 Quick techniques
Making rainbows

WHETHER IT'S THE PROSPECT of finding the fabled pot of gold or simply its beautiful colors, a rainbow can really lift your spirits on an otherwise dreary day. The problem is that the conditions have to be just right for us to see one. The sun has to be low and behind us, and it has to have been raining to leave moisture in the air. We don't have to rely on science and nature to call the shots, however; we can make our own rainbows in dry comfort.

As we'll see here, in just a few steps we can paint a spectrum across the sky. We'll use a built-in gradient preset to form the basis of the effect. The Polar Co-ordinates filter gives us the arc shape. All we have to do after that is scale and position it over the landscape and blend it into the sky.

DOWNLOADS

Landscape.jpg

WHAT YOU'LL LEARN

- Restricting a gradient with a selection
- Converting a rectangle to a circle with Polar Co-ordinates
- Blending the rainbow effect into the scene

1 Begin by creating a new layer. Now use the Rectangular Marquee tool **M** to create a narrow selection at the bottom of the document. Make it around half the width of the image. We'll be stretching the rainbow later so we don't want it too thick.

2 Grab the Gradient tool **G** Select the Transparent Rainbow preset. Set the mode to Linear. Hold **Shift** to constrain the movement. Now click a narrow strip inside the boundary of the selection. Press **ctrl** **D** **⌘** **D** to deselect.

3 Grab the Rectangular Marquee tool again. Hold **Shift**. Now click and drag up and right from the bottom corner of the image to create a square selection. Go to Filter > Distort > Polar Coordinates. Select Rectangular to Polar. Click OK to apply the filter.

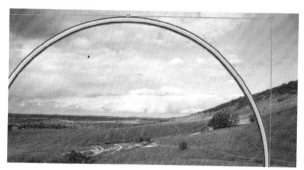

4 Press **ctrl** **D** **⌘** **D** again. Now Press **ctrl** **T** **⌘** **T** to enter Free Transform. Drag the corner handles to scale the rainbow up. Click and drag inside the bounding box to position it so the rainbow fills most of the sky. Press **Enter** to commit the transformation.

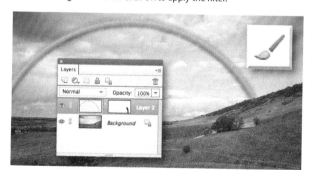

5 We need to soften the gradient. Go to Filter > Blur > Gaussian Blur. Set the radius to around 6 pixels for this size of image. Create a layer mask. Now use a soft black brush **B** to paint away the area where the rainbow overlaps the foreground.

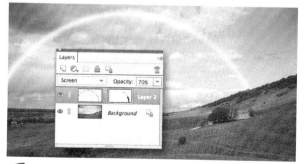

6 We need to make the effect a little more subtle. Change the layer's blend mode to Screen. As a final step we can use a low opacity black brush to paint on the mask to fade out the rainbow against the clear blue of the sky.

HOT TIP

If you find that you have a gap in the circle after running the Polar Co-ordinates filter, it's likely a space was left at one or both ends of the gradient when the square selection was made. It's better to overlap the gradient slightly and erase or mask out the overhang afterwards.

7 Quick techniques
A model village

IMAGE: **KARIN LINDSTROM (SXC.HU)**

I N THE PREVIOUS LESSON we used the Lens Blur filter to create depth of field. For that we used a selection to restrict the area of effect. It is also possible to define how the filter applies the blur using a depth map. This uses a mask or selection to determine where the image should be sharp and where it should be blurred.

In this project we'll use a layer mask with a gradient applied to create the popular tilt-shift effect. This works by keeping only a very narrow section of the image in focus. Our eye is fooled into thinking the photo is of a model because we would never see such a narrow depth of field in the real world.

The best photos to use are those taken from fairly high up, looking down and across the scene. Including familiar objects such as people and vehicles really helps to create the illusion. It's best not to have too much detail, however; an entire city wouldn't be feasable to make as a model, so the effect wouldn't work as well.

DOWNLOADS

Little Village.jpg

WHAT YOU'LL LEARN

- Using a mask and gradient to create a depth map
- Using the map with Lens Blur to define the focus area
- Sharpening the image with Unsharp Mask
- Boosting the effect by over-saturating the colors

1 Begin by duplicating the background layer by pressing *ctrl J* *⌘ J*. Create a layer mask on the new layer. We'll be using this with the Lens Blur filter.

2 We'll define the area of focus. Grab the Gradient tool *G*. Set the gradient to Black, White. Set the style to reflected. Position the cursor at the base of the mast. Hold *Shift*. Now click and drag to the top of the mast.

3 Go to Filter > Blur > Lens Blur. The default settings are to blur the entire image. Select Layer Mask as the source. This uses our gradient to define the area of effect. Black areas are sharp. As it blends to white, the image becomes more blurred. Click OK to apply the settings.

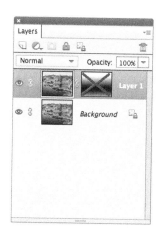

4 We no longer need the layer mask as it was only required to create the map for the filter. We can either delete it or disable it by right clicking its thumbnail.

5 To add to the effect we'll sharpen the scene up a little. Go to Enhance > Unsharp Mask. Increase the Amount to 100%. Set the Radius to 1.5. This gives us more definition in the areas of focus.

6 Models tend to have much more saturated colors. Create a Hue/Saturation adjustment layer. Increase the Saturation to around +20. We don't need too much, just enough to give the scene a larger than life effect.

HOT TIP

The Lens Blur filter retains its settings from the last time it was used. Although this can be very useful, it isn't always what we want. Hold *alt* *⌥*. The Cancel button will change to Reset. When we click it, we are taken back to the filter's default values.

7 Quick techniques
Making notepaper

USING PAPER IN A DESIGN can add that all-important handmade appearance. This might be a piece of rich parchment declaring a special occasion or just a simple Post-it note to draw attention to a particular area of the artwork.

In this tutorial we'll create three different types of paper, each version building upon the previous one. We'll start with a simple piece of plain paper. Next we'll create a heavy ruled notepad style sheet. The last type is the feinter ruled style with a margin and punched holes.

In addition we'll look at a technique for creating a torn edge effect. This really helps to convey the sense of realism.

DOWNLOADS

Desktop.jpg

WHAT YOU'LL LEARN

- Creating a subtle texture for a more realistic effect
- Building different styles progessively
- Making multiple copies of an element
- Naming layers for easy identification
- Creating a torn edge effect

1 Open the background image. Create a new layer. Grab the Rectangular Marquee *M*. Click and drag the selection out to the shape of the notepaper. Fill the selection with white. Press *ctrl D* *⌘ D* to deselect.

2 We'll add a slight texture to the paper. Go to Filter >Noise > Add Noise. We only want a small amount; around 3% is sufficient. Set the Distribution to Gaussian. Check Monochromatic. Click OK to apply the filter.

3 We'll add a small shadow. Go to the Effects panel. Select Styles > Drop Shadows. Double-click the Low preset. It's a litte too big. Open the Style Settings. Lower the size to 2px; set the Distance to 1. Click OK.

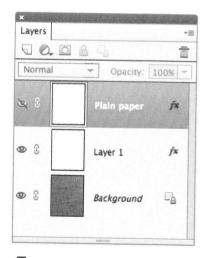

4 Press *ctrl J* *⌘ J* to create a copy of the paper. We can name the layers for clarity as we go along. We'll call the original layer Plain paper. Hide this for now by clicking its visibility icon.

5 Click the original paper layer's thumbnail. Create a new layer. Draw out a selection that extends outside the of the paper. The bottom of the selection marks the first line on the page. This is usually wider than the rest.

6 Go to Edit > Stroke Selection. Set a width of 2 pixels. Click the color chip to open the color picker; choose a greenish blue color. Set the location to Inside. Click OK to apply the stroke. Press *ctrl D* *⌘ D* to deselect.

HOT TIP

Creating a selection before using the Move tool to duplicate parts of your artwork results in the copied area staying on the same layer. This is particularly useful when creating repeating patterns as we have here. Without doing so, we would end up with too many unnecessary layers.

7 Hold *ctrl* ⌘. Click the paper layer's thumbnail to load its selection. Invert the selection *ctrl* *Shift* *I* ⌘ *Shift* *I*. Now press *Backspace* to delete the area outside the paper. Deselect by pressing *ctrl* *D* ⌘ *D*.

8 Press *ctrl* *A* ⌘ *A* to select all. Grab the Move tool *V*. Hold *alt* *Shift* ⌥ *Shift*. Now tap the down arrow key once to create a copy. Now keep *Shift* held. Press the down arrow twice. Repeat this to fill the page.

9 Hide the background layer. Now press *ctrl* *alt* *Shift* *E* ⌘ ⌥ *Shift* *E*. This creates a merged copy of the paper and its rules. Name this layer Heavy rules. Hide this layer and make the background visible again.

10 Creating the merged copy of the two layers has removed the shadow layer style. We'll copy it from another layer. Hold *alt* ⌥. Click and drag the *fx* icon from the plain paper layer down onto the merged layer.

11 Click the original rules layer in the layers panel. Create a new layer. Use the same selection and stroke technique as we before to draw a vertical margin. We've used a different color; a bright pink in this example.

12 The lines of this type of paper are usually less bold than our first version. Lower the opacity of the rules to around 20%. The margin needs to be a little stronger; a value of 40% works well here.

HOT TIP

We can change the opacity of a layer by pressing the number keys on the keyboard. 1–9 set the value to 10, 20, 30 and so on. Pressing two numbers in close succession sets fractional values: 3 and 7 will give us 37%, for example. To get back to 100% we press 0.

13 Let's add the holes. Click the paper layer's thumbnail. Grab the Elliptical Marquee ⓜ. Hold *Shift*. Now click and drag out a small circular selection. Hit *Backspace* to delete the pixels. Repeat for the second hole.

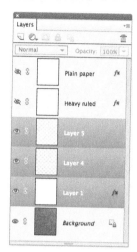

14 Go to the Layers panel. Hold *Shift*. Click the margin layer to select all three layers. Now press *ctrl E* ⌘ E. To merge them into a single layer. Name this layer Feint punched. Duplicate the shadow as before.

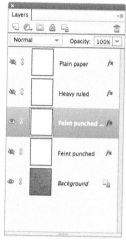

15 Next we'll create the torn edge effect. Duplicate the current layer *ctrl J* ⌘ J. Hide the layer below so we just have the background showing. This will make the effect easier to see.

16 Grab the Freehand Lasso tool ⓛ. Draw a jagged line roughly across the middle of the paper. Draw around the outside of the top half and back to the start to complete the selection. Now create a layer mask.

17 Make sure the mask is active. Now go to Filter > Sketch > Sprayed Strokes. Firstly, set the Direction to vertical. Already we can see the effect taking shape. Set the length to its maximum. Set the radius to around 10.

18 Click the New Effect Layer icon at the bottom of the Filter Gallery. Select Torn Edges from the menu. Set the balance to 13. Set Smoothness to 7. Set the Contrast to 12. Click OK to apply the effects.

HOT TIP

Being able to add effects layers in the Filter Gallery is incredibly useful. The layers behave in much the same way as regular image layers. Their order can be changed, which in many cases completely alters the way the effects appear. We can also selectively hide the filter layers.

Writing in the sand

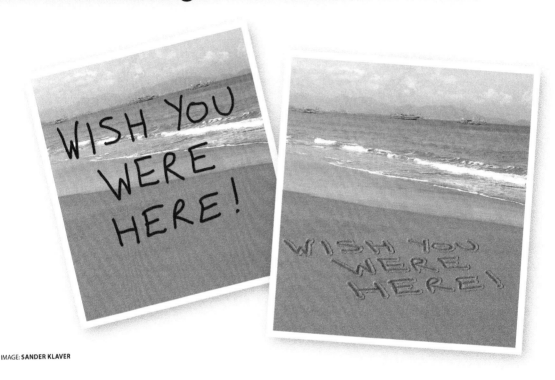

IMAGE: **SANDER KLAVER**

THERE'S SOMETHING ABOUT an expanse of smooth, untouched sand that begs us to write or draw something on it; this could be a message of adoration to a loved one or simply a declaration to say you were there.

We're going to recreate the effect here using distortion and layer styles to carve our message into the sand. To add to the effect, we'll create the excess sand around the letters where it would have been scraped out.

This quick but effective technique lets us write whatever we want, all without getting a single grain of sand between our toes; it won't get washed away, either.

DOWNLOADS

Sandy beach.psd

WHAT YOU'LL LEARN

- Distorting into perspective
- Creating a carved appearance
- Creating a granular effect

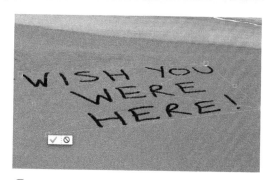

1 Make sure we're working on the message layer by clicking its thumbnail. Press `ctrl` `T` `⌘` `T` to enter Free Transform. Hold `ctrl` `⌘` and drag the corner points to put the text in perspective. Press `Enter` to commit the changes.

2 Load up the layer's selection. Hide the layer by clicking its eyeball icon. Click the background layer's thumbnail to make it active. Press `ctrl` `J` `⌘` `J` to copy the text to a new layer. Set the blend mode to Multiply to make it darker.

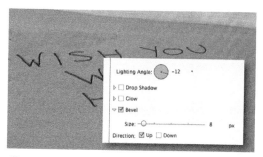

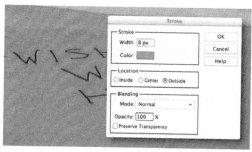

3 Go to the Effects panel. Select Bevels. Apply the Simple Sharp Inner preset. Open the Style Settings dialog. Lower the Bevel value to around 8 px. Adjust the Lighting Angle to around -12° to create a carved appearance. Click OK.

4 Create a new layer. Reload the text's selection. Go to Edit > Stroke Selection Set the width to around 8px. Use the Color Picker to sample a color from the sand, Set the Location to Outside. Click OK to apply. Deselect `ctrl` `D` `⌘` `D`.

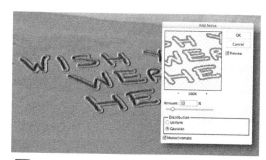

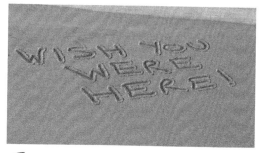

5 Go to Filter > Noise > Add Noise. Set the distribution to Uniform. Check Monochromatic. Set an amount of around 12%. Add a Simple Inner bevel. Set its width to 5px. Set the Direction to Up to give it a raised appearance. Click OK.

6 Set the layer's blend mode to Dissolve. Lower the opacity to around 50% to create a grainy effect. We can also adjust the base text's opacity if it's too dark; here we've dropped it to 65%.

HOT TIP

We wrote the message graphic by hand using a graphics tablet to give it a more realistic appearance; using a text font would be too perfect. If you don't have a tablet, you could write the message text on a piece of paper and photograph it or scan it in.

7 Quick techniques
Rubber stamp it

CREATING EFFECTS sometimes requires a little lateral thinking. To create a rubber stamp effect, for example, we might think the Stamp filter would be a good choice. Sadly not. We wouldn't consider something like the Glass filter; its purpose is to create a glass effect, and very good at it it is, too – see page 262 to see it in action. It's more versatile that its name suggests, however.

In this project we'll create some black and white artwork for our stamp. When we apply the glass filter, it only affects the edges, giving us a roughened appearance; perfect to give the appearance of a well-worn rubber stamp.

WHAT YOU'LL LEARN

- Creating artwork with text and selections
- Creating a rough, worn effect

HOT TIP

To enhance the the worn effect we can add a layer mask to the artwork and use a low-opacity brush to partially erase more areas of the artwork to give the appearance that the ink hasn't been transferred or has worn off the page. The Dry Media brush presets are especially good for this sort of effect. We've done this with the intro image.

1 Create a new layer. Fill it with white. Grab the Horizontal Type tool **T**. Choose Impact as the font. Set the alignment to Center. Set the size to 36. Set the color to black. Click the cursor at the top-middle of the document. Type the text; pressing *Enter* to split the words.

2 Create a new layer. Select the Rectangular Marquee **M**. Holding *alt* ⌥, click and drag the boundary out from the center of the document. Make it large enough to add a fairly wide border and leave sufficient space around the text.

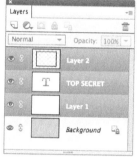

3 Select Stroke Selection from the Edit menu. We need a strong border so a Width of 20 pixels is good for this size image. Set the Color to black and the Location to Inside – this gives us sharp-edged corners; if we'd used Center or Outside, the corners would be more rounded.

4 Before we create the worn effect, we need to merge the three layers together; the filter only works with a flat layer. Click the border layer. Hold *Shift*. Now click the white background. Press *ctrl E* ⌘ *E*. We will now have a single artwork layer to work with.

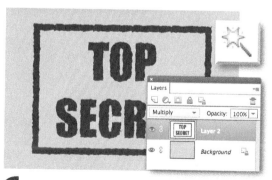

5 Press **D** to reset to the default color palette. Go to Filter > Distort > Glass. Choose the Frosted texture. Experiment with the Distortion and Smoothness settings to roughen the edges a little; it only needs to be a subtle effect. Click OK to apply.

6 Grab the Magic Wand **A**. Uncheck Contiguous in the Tool Options panel. Click the text to select the whole artwork. Choose a dark red for the foreground color. Press *ctrl Backspace* ⌘ *Backspace* to fill the selection. Set the blend mode to Multiply to remove the white.

7 Quick techniques
Creating custom brushes

WHEN WE'RE CREATING IMAGES, photos and designs, it would be nice to be able to sign them, just as we would on a painting or sketch. We could do this on each image, or perhaps have an image file that we open up each time. This isn't exactly the best workflow.

A much better way is to create the signature as a custom brush. These have several benefits over their layer-based counterparts. They are scalable without losing quality. They use the currently selected foreground color. We have the various settings for brushes such as scattering and brush pressure.

Almost any image can be defined as a brush, even color ones, in which case they are converted to grayscale; the tones define the opacity of the brush in a similar way to masks.

We can build up a library of our own brushes that we can access as and when we need them, along with Elements' own presets.

DOWNLOADS

Signature.jpg

WHAT YOU'LL LEARN

- Using predefined graphics to define a brush
- Saving brush presets

1 Open the Signature image. Grab the Rectangular Marquee *M*. Draw a selection around the signature; keep close but stay away from the edges. Now go to Edit > Define Brush from Selection. We get a dialog with a thumbnail of the brush. The number is its default size in pixels. Give it a meaningful name; My Signature is good. Click OK.

2 Nothing more happens, of course. Select the Brush tool *B*. Go to the Tool Options Panel. Click on the brush picker. Choose Default Brushes from the menu if it's not already selected. Our newly defined brush appears last in the list.

3 The brush is automatically stored but it's worth saving it elsewhere to be safe. Click the brush's thumbnail to select it. Now click on the fly-out menu at the top of the brush picker window. Click Save Brushes at the bottom of the menu. A save dialog opens; it should be set to the default Elements location. Give the file a name and click Save.

4 Let's try the brush out. Press *ctrl* *D* *⌘* *D* to deselect if the selection is still active. Create a new layer. Fill it with white. As we move the cursor over the canvas we see the outline of the signature. We can reduce its size by pressing *[*. When we click down it places a copy in the current color. Choose a different color and click again.

HOT TIP

When we save the brush we create a file containing just that preset. We can add more presets to this file at another stage. We can do this either from the brush picker or from the Preset Manager. Remember to include any brushes that were already in the file beforehand, otherwise they'll be lost.

165

Puzzle time

IMAGE: **ABSOLUTVISION.COM**

WITH THE MULTITUDE OF filters in Elements, it's perhaps surprising that, hidden among the stained glass and other effects, there isn't one for creating jigsaws.

Here's a technique that makes use of a custom shape that we've included for you to download from the website. Instructions for installing these shapes can be found on the Goodies page in the download area. There is also a portrait version of the shape for use with images of that orientation; this avoids the pieces stretching out too much.

DOWNLOADS

Kids with bubbles.jpg

Cheat Shapes.csh

WHAT YOU'LL LEARN

- Using custom shape presets
- Breaking an image up using selections
- Cutting individual parts out of a layer

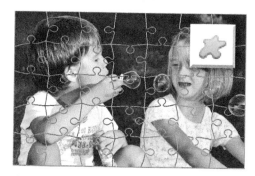

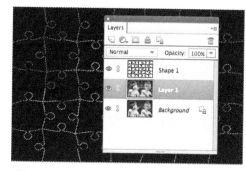

1 Open the image. Grab the Custom Shape tool **U**. Open the preset picker. Choose the Cheat shapes from the menu. Select the Jigsaw Landscape preset. Click in the top-left corner of the image. Drag down to the bottom-right corner. Release the mouse to set the shape layer.

2 The layer will be filled with the current foreground color. Press *ctrl* *Enter* ⌘ *Enter* to load the shape as a selection. Click the image layer's thumbnail. Press *ctrl* *J* ⌘ *J* to create a new layer from the selection. Hide the shape layer for now so we can see the image.

3 Go to the Effects panel. Choose Styles > Bevels. Double-click the Simple Inner preset. This is too harsh. Open the style settings. Lower the bevel to around 2px for this size image. Check the Drop Shadow to add more depth; a size and distance of around 5px. Click OK.

4 Hold *ctrl* ⌘. Click the current layer's thumbnail to load its selection. Go to Select > Inverse. Now create a new layer. Set black as the foreground color. Press *alt* *Backspace* ⌥ *Backspace* to fill the selection. This makes the gaps more defined. Go to Select > Deselect.

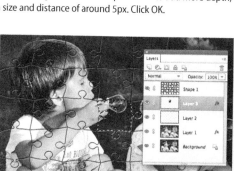

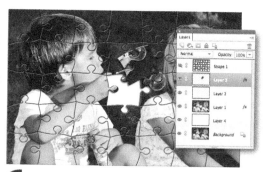

5 Let's remove a piece. Click the lines layer thumbnail's to make it active. Grab the Magic Wand tool **A**. Click inside one of the pieces to select it. Press *ctrl* *Shift* *J* ⌘ *Shift* *J* to cut the piece to a new layer. Go to the Layers panel. Click and drag the piece above the lines.

6 Create a new layer above the background layer. Fill it with white. Now click on the layer with the jigsaw piece. Press *ctrl* *T* ⌘ *T* to enter Free Transform. Now rotate and move the piece around to make it look like it's about to be placed. Press *Enter* to commit the changes.

7 Quick techniques
Bobblehead caricature

IMAGE: **ABSOLUTVISION.COM**

TYPICALLY, CARICATURES focus on one or more of the subject's features which are then drawn greatly exaggerated. Bobbleheads, on the other hand, have huge versions of the person's head atop a ludicrously small body. The head and body are usually connected by a spring, which, when tapped, causes the head to bob about – hence the name. These collectable models generally depict sporting personalities but some movie stars also have their own jittering counterparts.

In this project we'll create the effect using this university graduate as our model. He does have every reason to be big-headed, after all.

The technique begins by cutting away the subject's head; rather than scaling the head up, we leave it at its original size, making the body smaller instead. This stops the features of the face becoming pixelated. We'll follow on to create a plastic-like effect, making it seem more like a model.

WHAT YOU'LL LEARN

- Creating a caricature using selections and layers
- Using filters to create a smooth plastic effect
- Masking out filter effects
- Using Dodge and Burn to add shadows and highlights

1 We'll begin by selecting the man's head. Grab the Quick Selection tool **A**. Drag a selection across his face, making sure that we only go as far as his chin. Hold *alt* ⌥ to switch to subtract mode to remove any areas that stray onto his neck.

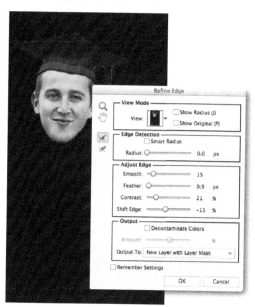

2 Open Refine Edge. Set the view to black **W**. We want to make the edge of his face as smooth as possible. Balance the selection with the edge controls. Set the output to Selection. Click OK. Now press *ctrl* *Shift* *J* ⌘ *Shift* *J* to cut the head to a new layer.

3 Go to the Layers panel. Click the graduate's layer to make it active. Press *ctrl* *T* ⌘ *T*. Hold *alt* ⌥. Use one of the corner handles to scale the body down; around 50% of its current size looks good. Drag it down to the bottom of the document. Press *Enter* to commit.

4 Grab the Move tool **V**. Click the head layer's thumbnail to make it active. Hold *Shift* and drag the down onto the body. Position the head so his chin just overlaps the the neck. We'll also move it over to the right a little, as it seems a little awkward in its original position.

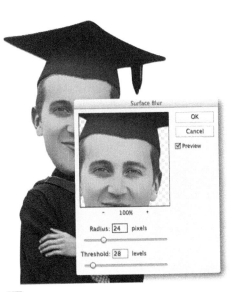

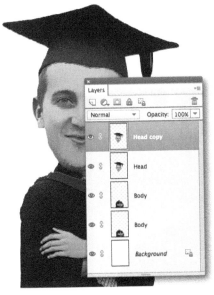

5 Go to Filter > Blur > Surface Blur. This analyses the image, softening the skin but leaving the detail intact. In this case we want to make it slightly cartoon-like. Increase the Radius to around 24 pixels. Set the Threshold to around 28 levels. Click OK to apply the effect.

6 Click the body layer's thumbnail. Now press ctrl F ⌘ F to apply the same blur. Press ctrl J ⌘ J to duplicate the layer. Now make the head layer active and duplicate that as well. We'll apply the next filter to the copies; this lets us alter the amount it affects the image.

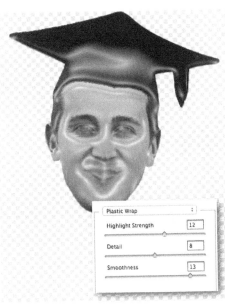

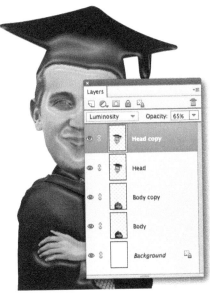

7 Starting with the head copy, go to Filter > Artistic > Plastic Wrap. We need fairly high values here to bring out the highlights. It's going to look awful at the moment but we'll be adjusting it later. Click OK to apply. Now repeat the filter on the body copy layer as before.

8 Go back to the head copy layer. Change the blend mode to Luminosity. This prevents any random color artefacts. Lower the opacity of the layer to around 65%. The effect is more subtle now. Do the same for the body copy layer.

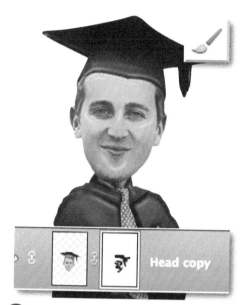

9 Create layer masks on both the copy layers. Grab the Brush tool **B**. Choose a medium-sized soft brush. Set the foreground color to black. Start with the head. Make sure the mask is active. Start to paint away areas of the effect. We only need a few accenting highlights.

10 Once the head is complete we can do the same for the body copy. Again, we want to leave some highlights to give the image a moulded plastic feel. This is particularly effective on his collar bone and where his hands recess into his cloak.

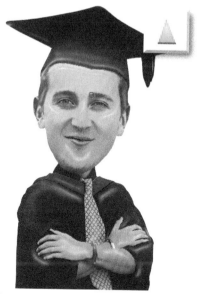

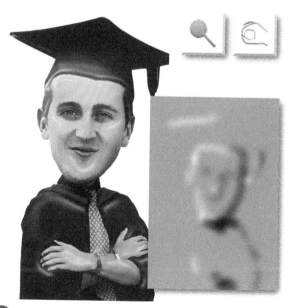

11 Click the original head layer. Grab the Sharpen tool **R**. Select a small brush. Set the strength to around 50%. Make sure Protect Detail is checked. Now paint over the man's features; the eyebrows, eyes and mouth. This gives us a more airbrushed effect.

12 Create a new layer at the top of the stack. Fill it with 50% Gray. Set the blend mode to Overlay. Use the Burn and Dodge tools set to Highlights to paint in some localized shadows and highlights (see inset). This really helps to enhance the plastic model effect.

Letting the dust settle

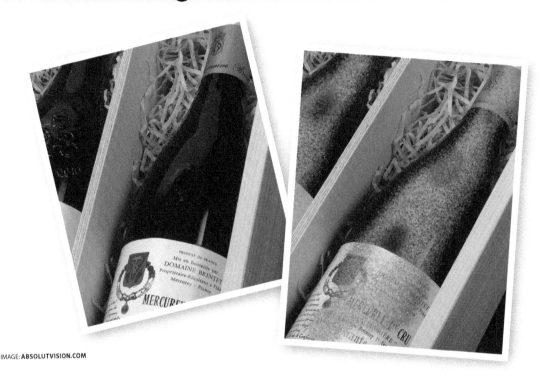

IMAGE: **ABSOLUTVISION.COM**

DUST IS USUALLY SOMETHING we don't like seeing. As with many things, there are exceptions, wine being one. Cellars often have bottles which have rested undisturbed for many years as they reach maturity and, as a result, have accumulated a thick layer of dust.

If, however, you're not a connoisseur and need a picture in a hurry, you can create the desired effect in a few easy steps. We'll be using wine bottles for the project but the technique could just as easily be applied to many different subjects: items in an attic, perhaps. You could even consider using it in promotional material, for a cleaning company, perhaps – a before and after shot, for example.

DOWNLOADS

Wine bottles.jpg

WHAT YOU'LL LEARN

- Creating a soft selection with the Selection Brush
- Filling a layer using a blend mode
- Using noise to randomize tones
- Restoring shading with Dodge and Burn

1 Grab the Selection Brush tool **A**. Set the mode to Mask in the Tool Options panel; this will show us where we're painting the selection. Using a very soft tip, paint over the bottles where we want the dust to be.

2 Switch back to selection mode. We'll need to invert the selection as the mask creates the area not to be selected. Press *ctrl* *Shift* *I* ⌘ *Shift* *I*. The selection looks smaller; areas less than 50% opacity aren't displayed.

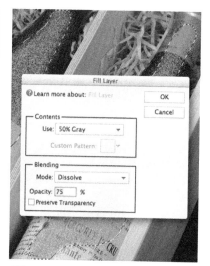

3 Create a new layer. Go to Edit > Fill Layer. Set the Contents to 50% Gray. Set the Mode to Dissolve. This will create the granular effect. Set the Opacity to 75%. Click OK to fill the selection.

4 The effect is too uniform; we'll add some random tones. Press *ctrl* *D* ⌘ *D* to deselect. Go to Filter > Noise > Add Noise. An amount of 15% is enough. Set the Distribution to Gaussian. Check Monochrome. Click OK.

5 The specks are a bit harsh for a dust effect. We'll soften the effect a little. Go to Filter > Blur > Gaussian Blur. We don't need much; just enough to blend the tones more. A radius of around 0.8 is good. Press OK to apply.

6 We'll add some shading back in. Grab the Burn tool **O**. Set the Range to Highlights. Use a large soft brush to darken the edges. Hold *alt* ⌥ to switch to the Dodge tool. Now lighten the front of the bottle.

HOT TIP

For a little added realism we can create some areas where the dust has been disturbed. To do this we add a layer mask to the dust layer and use a low-opacity brush to gradually thin it out. We've used this technique to create the finished image in the intro.

Casting a divine light

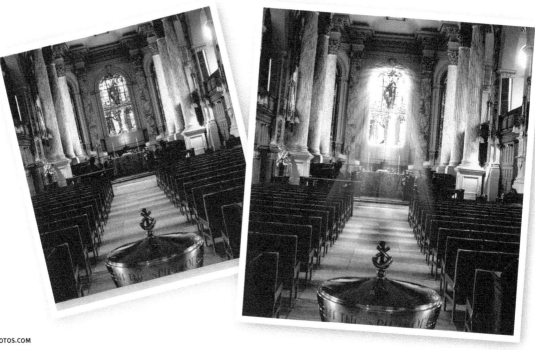

IMAGE: **PHOTOS.COM**

SOMETIMES IT'S NECESSARY to exaggerate an effect (for the purpose of illustration, for instance) and as long as we don't overdo it, a little hyper-reality can really make an image stand out.

We'll demonstrate this by creating the impression of light beaming through a stained-glass window and projecting its image on to the floor of the church. Whilst this is not an unnatural occurrence, it's unusual to see it in such bold effect.

We don't have to use stained glass, of course; we could apply the technique to a normal window, for instance, projecting the shadows of the frame instead of the colors of the glass.

DOWNLOADS

Church aisle.jpg

WHAT YOU'LL LEARN

- Brightening images with blend modes
- Creating beams of light
- Projecting an image onto a surface

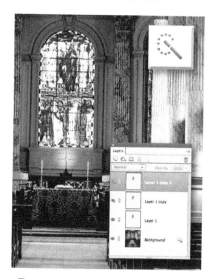

1 Make a selection of the window. The Quick Selection tool *A* works well here. Now press *ctrl J* *⌘ J* three times to make three copies. Turn the last two layers off by clicking their visibility icons in the Layers panel.

2 Make the first copy's layer active by clicking its thumbnail in the Layers panel. Add a Simple Outer Glow layer style; we can keep its default settings. Now set its blend mode to Color Dodge to brighten it up.

3 Now for the light rays. Make the second copy active and visible. Go to Filter > Blur > Radial Blur. Set the Method to Zoom. Set the Amount to 100 and the Quality to Best. Position the Blur Center Near the top. Click OK.

4 Enter Free Transform *ctrl T* *⌘ T*. Hold *ctrl* *⌘*. Click and drag the bottom corner points out to stretch the rays down the aisle. Press *Enter* to commit. Set the layer's blend mode to Screen.

5 Select to the top layer and make it visible. Go to Filter > Blur > Gaussian Blur. Raise the Radius to soften the detail. Go to Image > Rotate > Flip Layer Vertical. Use Free Transform to distort the layer so it lays along the floor.

6 Set the blend mode to Vivid Light. Lower the opacity to fade the colors slightly. Use a small, soft Eraser *E* to tidy up where it overlaps areas such as the ornament in the foreground and the front edges of the steps.

HOT TIP

The Radial Blur filter works really well here as we are viewing the window head-on. If, however, the picture was taken at an angle, it would be a slightly different technique: we would need to duplicate the blurred layers and flip one horizontally so we could have the rays emanating in different directions.

7 Quick techniques
Aging a photo in minutes

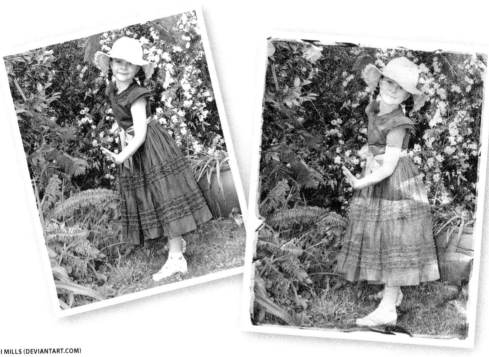

IMAGE: **JENNI MILLS (DEVIANTART.COM)**

THERE ARE MANY WAYS to restore old, damaged photographs. You'll find a technique in almost every digital imaging how-to book. In this tutorial, however, we're going to do the exact opposite. By taking a perfectly good picture and applying a variety of effects we'll create the impression that it has been less than well cared for.

Although this might seem a little perverse, it serves as an extreme example of what can be achieved by combining and blending existing textures with a photo. In this case, we'll use the reverse side of an old, battered book cover. The dents, folds and creases provide an excellent basis for the effect.

DOWNLOADS

Aging a photo (folder)

WHAT YOU'LL LEARN

- Adding layers with the Place command
- Creating a clipping group to hide parts of an image
- Using blend modes to add texture
- Using adjustment layers for color effects

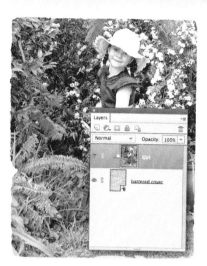

1 Open the image of the girl. Now go to File > Place. Select the battered cover image. Click Place to import into the document. In this instance we don't need to alter the size. Press *Enter* to create the layer.

2 Hold *alt* ⌥ and double-click the girl's layer thumbnail to convert it to a regular layer. Click and drag it above the cover layer. Now press *ctrl* G ⌘ G to create a clipping group with the cover.

3 Change the blend mode of the girl's layer to Multiply. The cover's texture now shows through. Create a Hue/Saturation adjutment layer. Click Colorize. Drag the Hue slider across to create a sepia-like tone.

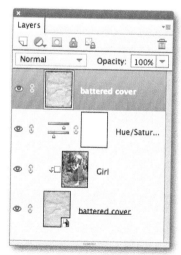

4 Use the Place command to add another copy of the cover. We need to make the layer editable. Go to Layer > Simplify Layer. Press *ctrl Shift U* ⌘ *Shift U* to convert convert the layer to grayscale.

5 Set the layer's blend mode to Overlay. This gives us more of the crumpled texture as well as brightening up the image. Next, we'll add a border. Hold *ctrl* ⌘ and click the layer's thumbnail to load its selection.

6 Make the photo layer active by clicking its thumbnail. Go to Select > Modify > Contract. Set a value of around 15 pixels. Now add a layer mask. This lets us see the cover layer below, creating a border for the photo.

HOT TIP

To extend the aged effect further, we could use a low opacity brush to paint away areas of the mask we created in the last step. This gives the appearance of the pigment of the photo wearing away.

Making sticky tape

IMAGE: **JENNI MILLS (DEVIANTART.COM)**

I N THE PREVIOUS TECHNIQUE we created an old photo. Let's continue the theme by placing the photo on an album page. We'll need something to hold it down on the page, of course; so in this tutorial we'll create the effect of strips of old sticky tape.

This is a fairly straightforward technique using selections to create the tape outline. The outline is filled with neutral gray. We'll use the Dodge and Burn tools to shade the tape to give it the impression that it has air bubbles and creases; these are inevitable, of course! Tape also deteriorates over time so we'll give it a slight aged yellowing.

The selection can be difficult to see on a colored background so we've placed a white layer between the background layer and the photo to make it easier to work with.

WHAT YOU'LL LEARN

- Quickly switching the Polygonal and Freehand lasso
- Using shading techniques to create bubbles and creases
- Creating a realistic plastic effect
- Using blend modes to create transparency

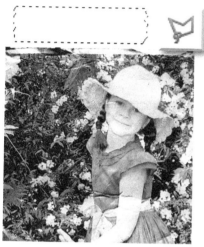

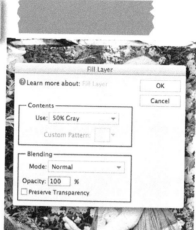

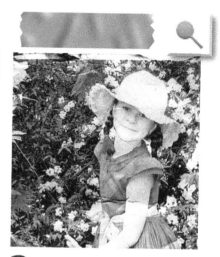

1 Grab the Polygonal Lasso **L**. Click and drag the cursor to create a horizontal line. Hold *Shift* to keep it straight. Hold *alt* ⌥. Draw a shallow zip-zag line to create the cut edge. Repeat to create the rest of the strip.

2 Create a new layer above the photo. Go to Edit > Fill Selection. Select 50% Gray for the contents. We can leave the rest of the settings at their defaults. Click OK. Press *ctrl D* ⌘ *D* to deselect.

3 Select either the Dodge or Burn tool **O**. Set the mode to Highlights. Set the exposure to 50%. Now use a soft brush tip to paint in some shading for the creases. Alternate between the two tools by holding *alt* ⌥.

4 Next we'll give our tape a more plastic-like appearance. Go to Filter > Artistic > Plastic Wrap. Push the Highlight Strength to its maximum. Set the detail to around 10 and the Smoothness to around 8. Click OK to apply.

5 Next we'll age the tape a little. Open the Hue/Saturation dialog *ctrl U* ⌘ *U*. Check Colorize. Adjust the hue and saturation controls to give the tape a yellow tone. Click OK to apply the color. Hide the white layer.

6 Press *ctrl T* ⌘ *T* to enter Free Transform. Rotate and position the tape on one of the corners of the photo. Press *Enter* to commit. Set the tape's blend mode to Hard Light. Lower the opacity to around 80%.

HOT TIP

Instead of creating the tape four times, we can duplicate the first strip and reuse it. After positioning the first piece, press *ctrl alt T* ⌘ ⌥ *T*. This invokes Free Transform and duplicates the layer at the same time. We can scale and distort it each time to prevent it looking too similar.

7 Quick techniques
From day to night

YOU MAY OR MAY NOT KNOW that many of the movies we see where there is a scene set at night are actually filmed during the day. The day for night technique involves deliberately using the wrong white-balanced film or adding a blue filter to the lens to create the colder tones.

We can create the same effect in Elements using layers and blend modes to darken down the scene and cast the bluish hues. When it's dark, the lights go on, of course. We'll see here how we can easily create the appearance of lit windows and lamps, giving the scene a much more authentic feel.

DOWNLOADS

Day to night (folder)

WHAT YOU'LL LEARN

- Creating a night time effect
- Lighting up windows and lamps
- Casting light on the scene

1 First we'll convert the background to a regular layer. Hold *alt* ⌥ and double-click the background layer's thumbnail in the Layers panel. Use the Quick Selection tool *A* to select the sky. Press *Backspace* to delete the selected area. Deselect by pressing *ctrl* *D* ⌘ *D*.

2 Grab the Polygonal Lasso tool *L*. Switch to Add mode in the Tool Options panel. Now select the glass of the lamp and the windows we want lit up. Go to Select > Feather. Set a 1 pixel radius. Click OK. Now press *ctrl* *J* ⌘ *J* to copy the windows to a new layer.

We need to choose the image carefully when creating a day to night effect. Avoid using photos taken in bright sunlight as they will have harsh shadows; this is not something that generally occurs at night, even in strong moonlight.

It's best to take the photo when the day is bright but overcast; this way we get an even amount of light falling across the whole scene.

We can always add our own shadows in afterwards; it's much easier to do that than having to remove them!

3 Click on the building layer's thumbnail. Go to Layer > New Fill Layer > Solid Color. Select a midnight blue color; this will create the night effect. Click OK. Set its blend mode to Multiply and drop the opacity to around 80%. Press *ctrl* *G* ⌘ *G* to create a clipping group.

4 Next we'll create the lit area from the lamp. Click the color layer's mask thumbnail. Select a soft brush *B* set to a low opacity and begin to paint in black over the areas where light would fall around the lamp. This hides the color layer to reveal the original daylight image beneath.

5 Create a new Solid Color layer above the windows. Choose an orange-brown hue. Click OK. Set the blend mode to Linear Dodge. Drop the opacity a little. Now press *ctrl* *G* ⌘ *G* to create a clipping group and restrict the color to the light sources. We now have a warmer light.

6 The final step is to add in a new sky. Go to File > Place. Select the Night Sky file. Click Place. The image is the right size so press *Enter* to set it down. Now go to the Layers pane. Click and drag the layer beneath the building to put it in the background.

Flashlight illumination

IMAGES: **FLASHLIGHT – PHOTOS.COM; BACKGROUND – MAYANG'S TEXTURES**

AS WE SAW in the previous technique, darkness can completely change the mood of an image; a technique frequently used in horror or thriller movies – the lurking terror is very rarely in a well-lit, designer basement, after all.

Here we'll use the day for night effect on a more localized subject. Our starting image is a bit dull and lacks any sense of purpose; it's just a flashlight in a lit room that may just be in the process of being renovated. Its owner's probably gone off to find his sandwich. By turning out the lights and switching on the flashlight, however, we instantly add an air of mystery to the scene: where is this place, and why has the flashlight been left lying on the ground in what appears to be a derelict house?

DOWNLOADS

Flashlight.psd

WHAT YOU'LL LEARN

- Creating effects from existing elements of an image
- Using blend modes and adjustment layers to change the mood of an image

1 Make sure the flashlight layer is active by clicking its thumbnail in the Layers panel. Make a selection around the lens with the Quick Selection tool **A**. Press *ctrl* **J** **⌘** **J** twice to create two new copies.

2 Press *ctrl* **T** **⌘** **T** to enter Free Transform. Now stretch out one of the lens copies to create the shape of the beam area on the floor in front of the flashlight. Press *Enter* to apply the transformation.

3 Press *ctrl* **I** **⌘** **I** to invert the colors. Go to Filter > Blur > Gaussian Blur. A radius of around 6 pixels. Set the blend mode to Linear Dodge. Most of it will disappear, creating the effect of the beam pattern.

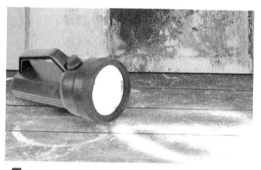

4 The flashlight needs to be switched on to cast its light, of course. Make the second lens copy active and set its blend mode to Linear Dodge. This has the effect of making the already light areas much brighter.

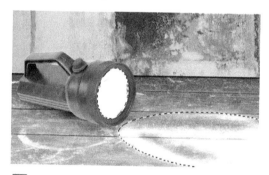

5 Load up both the light beam and lens layers' selections by holding *ctrl* *Shift* **⌘** *Shift* and clicking their thumbnails in turn. Press *ctrl* *Shift* **I** **⌘** *Shift* **I** to invert the selection.

6 Create a Levels adjustment layer. Drag the right-hand output slider to the left to darken the image. Increase the Shadows a little. Now use a soft black brush **B** to paint inside the rim of the torch to brighten it up.

HOT TIP

It's always important to pay attention to the minor details of an image. Here for instance, we've added the lighting around the inside of the torch rim. Although it's a subtle change it is noticable, even if it's only subconsciously.

Instant candlelight

IMAGE: **PHOTOS.COM**

EVEN THOUGH CANDLES have long been obsolete as a source of lighting, we still rely on them for the warm atmosphere they bring and for the sense of occasion they lend to any event.

On the previous pages, we looked at how to create a fireball. Making a single candle flame is a slightly different process, in that it's painted entirely 'by hand', using no filters.

This isn't a difficult procedure, but it can result in a spectacular image: the trick is to paint each stage slowly, building up the effect as we go along.

DOWNLOADS

Candlelight.psd

WHAT YOU'LL LEARN

- Using the Brush, Dodge and Burn and Smudge tools

1 On a new layer, paint a rough shape in pale orange, using a soft-edged brush. Don't worry too much about the exact shape yet.

2 Use the Burn tool **O** set to Midtones, and darken the bottom of the flame around the wick to give the flame depth.

3 Switch to the Dodge tool, set to Highlights, and use it to brighten the center of the flame, turning it from orange to yellow.

4 Continue painting the flame in with the Dodge tool until the center is a brilliant, glowing white (but don't overdo it).

5 Now use the Smudge tool **R**, with a large brush size, to twist the candle flame into a more appropriate shape.

6 Continue smudging the top of the flame, perhaps switching to a smaller brush, until you're happy with the overall shape.

7 Changing the mode of the flame layer from Normal to Hard Light gives it added impact by increasing the strength of the tones.

8 For a stronger result, paint a low opacity soft glow on a new layer behind the flame, using the same orange we started with.

HOT TIP

When we started to brighten the flame in step 3, we brought the yellow down into the orange a little way. Continuing with the Dodge tool in step 4 hardens the edge between the yellow and the orange, automatically producing the subtle glow effect we see at the base.

Complex reflections

IMAGE: **PHOTOS.COM**

PREVIOUSLY IN THE BOOK we saw how to create a reflection for an object that had been photographed head-on; a simple task of flipping the image vertically and placing it beneath the original. Problems start, however, when the photo is taken from an angle, as we can see from the example image. Elements can only work in two dimensions so inverting the image gives undesirable results.

No amount of transformation would allow us marry up the edges to the box. Instead, we need to break the reflection down into separate layers. The front and side panels in this example. We can then distort them individually to fit. Once we have the reflection in place we can use layer masks to fade it out as we did previously.

WHAT YOU'LL LEARN

- Breaking down an object into separate components
- Transforming layers into position
- Fading objects out gradually

HOT TIP

We chose a box to demonstrate the technique as it's an easy shape to break down into different parts. Not all tasks are as straightforward as this, of course; the more detailed the subject, the more layers would be required to create the reflection. There is a point where it would become far too complex and time-consuming to create such an effect; a car for example, may have to be broken down into hundreds of layers.

1 The first step is to divide the object into separate layers: grab the Polygonal Lasso and make an outline around one side of the box. Press *ctrl* *J* *⌘* *J* to copy it to a new layer. Now repeat this for the other side; remember to make the original box layer active again.

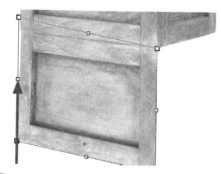

2 Go back to the front panel layer and flip it vertically, then press *ctrl* *T* *⌘* *T*. Drag it down and match one of the corresponding corners on the base of the original box. Hold *ctrl* *Shift* *⌘* *Shift* and drag the opposite center handle up to skew the panel into position.

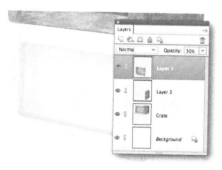

3 Repeat the last step to add the side panel. At present we have two boxes on top of each other; a good effect in itself but we need to make it more like a reflection. The first thing to do is drop the opacity: around 30% works well here – do this for both layers.

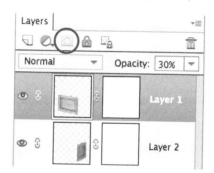

4 We need to fade the reflections out but we can't do this in one hit because the angles on the front and side are different. Add a layer mask to both the front and side layers by clicking the Add Layer Mask icon at the top of the Layers panel.

5 Select the Gradient tool *G*. Choose a Linear Black, White gradient. Click one of the mask's thumbnails to make it active. Click on the leading corner at the bottom of the reflection. Drag straight up to around half way up the solid box. Repeat this for the other panel.

6 Finally, we'll add a shadow to place the crate firmly on the ground. Create a new layer above the background. Use the Polygonal Lasso *L* to draw a selection around the bottom of the crate. Fill this with black. Use Gaussian Blur to soften the edge a little.

Lifting the lid

IMAGE: **HEMERA PHOTO OBJECTS**

DESPITE THE HUGE AMOUNT of images available through stock photography sites, there will come a time where you cannot find exactly the right one for your project. This is not always a problem, as we'll see in the following tutorial.

The image of the wooden box is perfect except it's closed and we want it open. Unlike the real thing we cannot simply remove its lid: the rear sides of the box don't exist. With a few selections and transformations we'll create the missing areas using copies of the remaining sections.

DOWNLOADS

Box.psd

WHAT YOU'LL LEARN

- Cutting away sections with selections
- Using layers to fill in missing areas
- Increasing the document size
- Adjusting the shading of an object

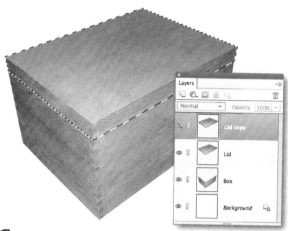

1 Our first task is to isolate the lid from the rest of the box. The Polygonal Lasso **L** is perfect for this. Create a selection around the whole of the lid. Press *ctrl* *Shift* *J* ⌘ *Shift* *J* to cut it to a new layer. Press *ctrl* *J* ⌘ *J* to duplicate the lid. Hide this copy for now.

2 Make the lid visible again. Click and drag the lid layer behind the box in the layers panel. Enter Free Transform *ctrl* *T* ⌘ *T*. Start by lowering the lid so its front corner lines up with the corner of the box. Hold *ctrl* ⌘. Distort the outer corners to match. Press *Enter* to commit.

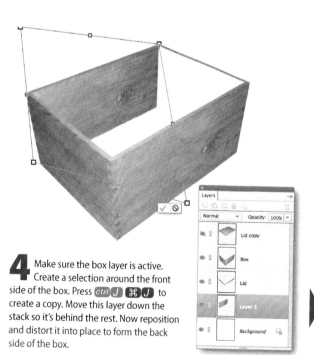

3 Next we'll cut a hole in the top. This will give the top of the box thickness; we can also use the edges as a guide for the missing sides. Create a selection following the perimeter of the lid but a few pixels inside the edge. Press *Backspace*. Press *ctrl* *D* ⌘ *D* to deselect.

4 Make sure the box layer is active. Create a selection around the front side of the box. Press *ctrl* *J* ⌘ *J* to create a copy. Move this layer down the stack so it's behind the rest. Now reposition and distort it into place to form the back side of the box.

HOT TIP

Distorting to perspective is tricky at the best of times; not having a complete guide can make it even more difficult. We need to take our cues from what ever we can find. Sometimes when we only have part of the picture it helps to imagine the complete object in your mind's eye.

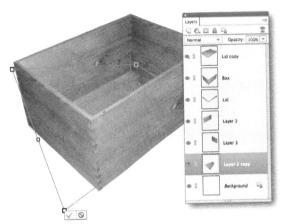

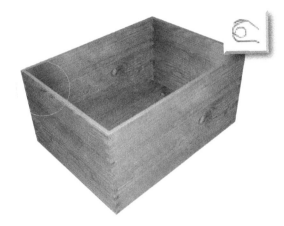

5 Repeat the last step using the side panel to create the missing opposite side; remember to switch back to the box layer first. Switch to the back side layer. Make another copy. Again, move it to the bottom of the layer stack. Distort this to create the floor of the box.

6 Next we'll add some shading. Grab the Burn tool **O**. Set the mode to Midtones. Use a large, soft brush to paint in some shadows on the inside; we'll need to switch between the layers. We only need a few subtle areas in this instance as the original lighting works quite well.

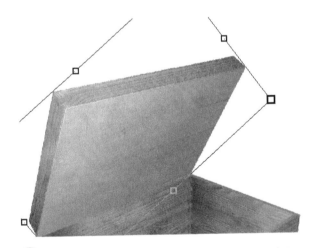

7 Now for the lid. We'll need to add some space on the document first. Go to Image > Resize > Canvas Size. Check Relative. Click the bottom-middle anchor so the space is only added at the top. Now enter a value of 30 percent for the height. Click OK to apply.

8 Make the lid copy layer visible and click its thumbnail to make it active. Go to Image > Rotate > Flip layer Vertical. Now press *ctrl* **T** ⌘ **T** to enter Free Transform. Rotate and distort the lid with the corner handles to line up with the back of the box. Press *Enter* to commit.

HOT TIP

When we're using Free Transform, Elements will always try to snap to the edges of the document or to the nearest layer. This can make aligning parts of a montage very difficult. A workaround is to zoom into the area we're working on; this gives us more control over the handles.

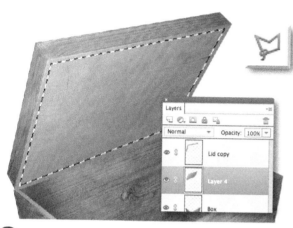

9 The lid looks a little heavy. Use the Polygonal Lasso **L** to create a selection a few pixels within the edge of the lid's panel. Press *ctrl Shift J* ⌘ *Shift J* to remove the area and place it on its own layer. Now drop it behind the lid copy layer in the Layers panel.

10 Grab the Move tool **V**. Use the arrow keys to nudge the panel toward the rear of the lid. We can hold *Shift* to move it quickly then release it to position it more precisely. This creates a recessed area. Again we'll need to create the missing sections at the back and side.

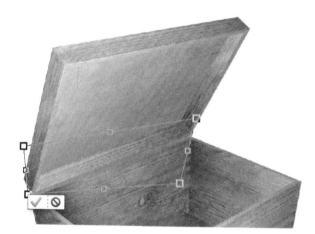

11 Click the lid layer's thumbnail to make it active. We can use the same technique here as we previously did to create the missing sides of the box; remember to move the layers below the lid copy layer in the Layers panel so they appear behind the lid.

12 Now we can use the Burn tool **O** to shade the inside of the lid as we did with the box. We'll need to make it darker than the inside of the box, as it would be facing away from the light. We can also add some shadowing to the back edge of the box itself.

HOT TIP

Once the box is complete, we can merge the component layers together. Remember to leave the lid separate from the box, of course. We could also create another duplicate of the lid at the beginning of the process; this would give us three different versions to use.

7 Quick techniques
Room with a view

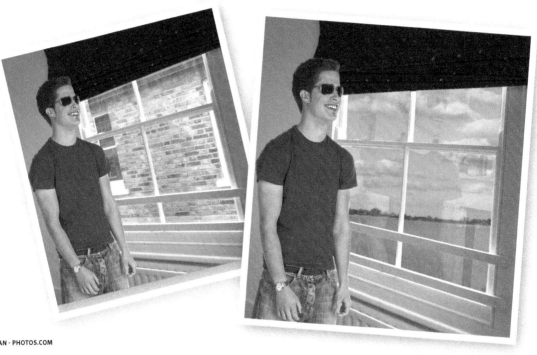

IMAGE: **MAN - PHOTOS.COM**

THE VIEW THROUGH this man's window is far from inspiring: The side of the house next door makes the scene dull and lifeless. We'll replace it with something a little more picturesque.

Changing the view outside is easy enough, we make a selection around the window panes and create a filled layer using their shapes. We then group the scenery layer above it, giving the impression that we're looking through the window.

The problem we have is we need to keep the man's reflection in the window to keep the appearance of there being glass between him and the outside world.

Here we'll not only bring back his reflection, we'll also add a reflection of the room behind him; currently it seems to be rather empty. We'll also see how to stack the reflections in order for the man, who is closest to the window, to appear in front of the room's reflection.

WHAT YOU'LL LEARN

- Using clipping groups
- Creating multiple reflections
- Changing layer opacity to partially hide the content

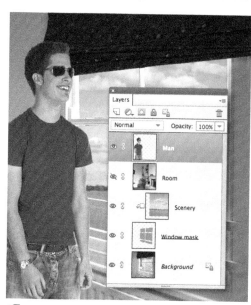

1 We've already created the mask layer for the window by using the Lasso tool to select the glass, then filling the selection with neutral gray on a new layer, just above the background layer. The Scenery layer is grouped with the mask. We only see the view 'through' the window.

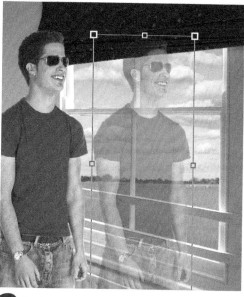

2 Duplicate the man's layer `ctrl J` `⌘ J`. Reduce the opacity to around 50%. Use Free Transform to shift the copy to the right. Scale him down slightly to allow for perspective. Drag the copy layer's thumbnail above the Scenery layer. Press `ctrl G` `⌘ G` to group it to the mask.

HOT TIP

Our man just happened to be at exactly the right angle to allow us to 'translate' him through the window. In most cases, you'd need to flip your figure horizontally in order for the reflection to work properly. It's a lot easier if the window isn't at an angle as extreme as the one in our example.

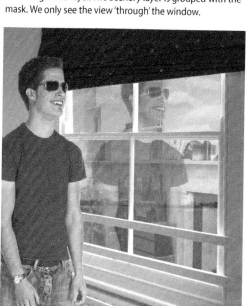

3 Make the Room layer visible. Drag its thumbnail below the man's reflection. It automatically joins the group. The problem we have here is we can see the room's reflection through the man. The room is behind him so he should partially obscure it.

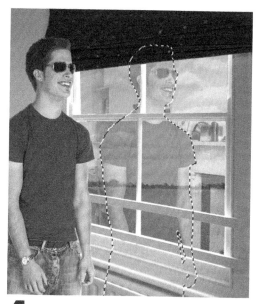

4 Hold `ctrl` `⌘` and click the man's reflection thumbnail to load its selection. Now click the room layer's thumbnail to make it active. Press `Backspace` to delete the selected area. The reflections are a little stronger than they should be; lower both layers' opacity to around 20%.

7 Quick techniques
The classic head-swap

IMAGE: **COUPLE – PHOTOS.COM; ARNOLD SCHWARZENNEGER – WIKIPEDIA.ORG**

ONE OF THE MOST IMPRESSIVE tricks we can play in Elements is to place a celebrity's head on the body of a family member. It's easy enough to come across suitable celebrities on the internet: one of the best places is Wikipedia, which includes thousands of images of celebrities that are free to use in its Wikimedia Commons department.

The trick to making this technique work lies in choosing a head shot at the right angle to work with your image. Don't worry about the size and the color, as we can easily fix that later; all that matters for now is that the orientation is as close as you can find to the head in the original photograph.

DOWNLOADS

Heads on bodies (folder)

WHAT YOU'LL LEARN

- Choosing the correct image to use
- Extracting the head from its background
- Gauging the correct size and angle
- Blending the new head onto the target image

1 This picture of Arnold Schwarzenegger is just the right angle to fit on the body of the man in the image. The first step is to cut it out from its background, The Quick Selection tool **A** and Refine Edge are the first choice, of course.

2 Drag the cut-out head into the image where you want it to appear. To make it roughly the right size, it helps if you position it next to the target head, rather than on top; by being able to see both at the same time, we can be sure to get the size right.

3 Rotate and further scale the head as necessary using Free Transform, and place it on top of the original head. Take your time with this step, as it's the key to making the montage work. Here, we've rotated the head anticlockwise slightly for a more appealing look.

4 Although we got the size and angle right in the previous step, Arnie's coloring didn't match the rest of the photograph. The best way to adjust the color of the new head is to use the Levels adjustment *ctrl* **L** ⌘ **L**, which also allows us to correct the contrast.

5 There's a hard line under Arnie's chin that needs to be dealt with. The simplest way of removing this is to use a small, soft-edged Eraser **E** to smooth out the join; for more control, however, it's always best to use a layer mask as any changes are reversible.

6 Finally, we need to remove the pieces of the original head that are still visible behind Arnie. On the background layer, use the Clone Stamp tool **S** to sample pieces of the background and paint them in to cover up the original ear and other features that stick out.

Keeping it real

POSSIBLY THE GREATEST COMPLIMENT you can receive for one of your montages is when the viewer does not realize it is one in the first place. It may not survive close scrutiny, but unless we're trying to conclusively prove to NASA that we had reached the moon long before Neil Armstrong, we can afford ourselves a little artistic license.

Creating a realistic image depends on a number of factors: most importantly the individual components of the artwork need to fit together as seamlessly as possible. The direction at which the people and objects are lit needs to be the same – there's no point having someone caught in a spotlight, for instance, if their face still appears to be in shadow. We also need to make sure the shadows themselves are correct and, more importantly, present to begin with; everything casts a shadow of some sort, even if they are too faint to notice initially — they help to define depth, placing their associated object within its surroundings. Getting the color right also plays an essential role: be careful not to use garish hues as this could result in an unnatural-looking image.

So, with all that said, how do we go about translating it into our artwork? The answer is often staring right back at us: a lot of the time we'll be adding to an existing photo so we can take our cues from there, adjusting the new elements accordingly and sampling the colors and tones, comparing them as we go. Things become trickier when it comes to building a picture from the ground up where our clues aren't there to guide us — we're far from helpless though.

Just as a traditional artist studies their subject and surroundings, we can do the same. It's not a crime to use reference material to make sure we achieve the correct effect and it's certainly preferential to trying to use guesswork alone. A good starting point is, of course, the internet; image search engines such as Google or Yahoo are superb resources. It's highly probable that we'll find what we're looking for and, because we're not actually including the image within our artwork, copyright is not an issue. We need not be too concerned with the image's dimensions as long as it's possible to see the detail. We can, of course,

take our own reference shots as well; again, these don't need to be award-winning photographs, they just need to be of a good enough quality to see the effect — quick snaps from a cell phone should be sufficient.

There will be occasions when we need to see different versions of the same effect and also have the ability to view it from different angles; something that a still image cannot offer. In these situations improvising with props is often a great solution as they don't necessarily need to be the exact objects and only need to be crudely put together; as long as the outcome is a good representation, we can transpose it to our design. It's surprising how many things we can find within immediate reach with which we can improvise. We might, for example, want to see how a shadow falls across an uneven surface such as a staircase; so instead of grabbing the nearest family member and have them stand in different positions, we can quickly put together an impromptu mock-up by folding a sheet of paper and positioning a suitably illustrative object, then use a flashlight or similar maneuverable light source to create the desired effect.

We're not always going to be producing images depicting plain old reality, of course. We'll often be creating montages that are highly stylized or in a fantasy theme; there will always be a demand for fairy princesses and other such magical pictures, after all. This often demands more attention to detail than with their more sublime counterparts; people tend to scrutinize them far more closely, even though they know they cannot be real. It's highly unlikely we'll stumble across a real photo in a search but we can still apply the same principles from the real world to our artwork: reflections, shadows, and color still play their part in creating a convincing scene. We do have the advantage that nobody can really say how a picture of this ilk really should look, so we can be a little more lenient with the rules.

Finally, remember that there will always be flaws and unexpected elements in a real scene; try not to make your images too clinical. Try adding some random areas of light and shadow — it's often attention to the smallest details that have the most impact.

8

A change of scenery

WOULDN'T IT BE NICE if we could choose the exact location for our photos, or perhaps have the ability to summon a magical backdrop for our kids to act out their dreams and fantasies? Whilst we can't do this for real yet, with Elements we can do the next best thing.

This chapter is all about changing the backdrop of our photos. Whether it's to transport a young wizard from his front door to a mystical moonlit castle, in order for him to cast his spells, or put a wannabe starlet on the stage created from thin air. We can do it all with photomontage.

Fairy gets her wings

IMAGES: **FAIRY GIRL – JENNI MILLS (DEVIANTART.COM); BUTTERFLY WING – ABSOLUTVISION.COM; TOADSTOOL – MATTHEW KIRKLAND (FLICKR.COM) ; BUTTERFLY – LIES MEIRLAEN**

CHILDREN LOVE DRESSING UP: either to mimic the latest movie or television characters or just to play a part in their own imagination-fuelled fantasies. With Elements at our disposal, however, we can take things a stage further and turn their fantasy into something more realistic.

The following project we'll use a photo of a little girl, who clearly wants to be a fairy, and grant her wish. To put this image together we'll first extract the girl from her background. We'll then give her some beautiful butterfly wings; picking up a technique for applying selective opacity to a layer. We'll place her onto a new background, adding shadows and color adjustments to blend her into the new scene.

DOWNLOADS

Fairy gets her wings (folder)

WHAT YOU'LL LEARN

- Extracting the subject from the background Pages (201)
- Opening a duplicate view window to create a before and after view Pages (202)
- Selectively adjusting the opacity of a layer Pages (203)
- Adding extra space with the Crop tool Pages (204)
- Blending layers together Pages (204)
- One-click color correction Pages (205)

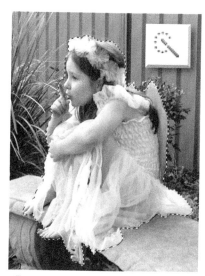

1 To start off we need to extract the girl from her current background. Grab the Quick Selection tool **A**. Drag over the girl to make an initial selection.

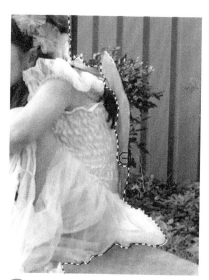

2 We don't need the wings she's wearing, as we'll be adding our own. Hold *alt* ⌥. Now drag over the wings to remove them from the selection.

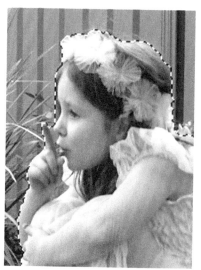

3 Go around tidying up any stray areas. There are a few small areas, such as the space between her hand and mouth, that are tricky to catch. Leave those for now.

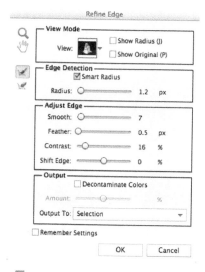

4 Open the Refine Edge dialog. Enable Smart Radius. Set a value of around 1.2 pixels. Now tighten the selection using the edge adjustments. Leave the dialog open.

5 Select the Refine Radius Tool **E**. We only need to paint around the top of her hair to add the whispy areas. Make sure Output is set to New Layer and Layer Mask. Click OK.

6 Click the layer mask thumbnail to make it active. Now select a small hard edged brush **B**. Now paint over the areas we left earlier using black.

HOT TIP

Sometimes it's better to leave the smaller, more intricate parts of an image until after the main selection has been made. As powerful as they are, the selection tools can also be a little clumsy. We can be much more precise using a brush to edit the resulting layer mask afterward.

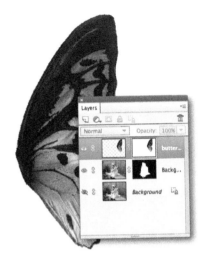

7 Go to File > Place. Select the butterfly wing.psd file. Click Place. Use the transform controls to scale and position the wing; we've also made it slightly narrower. Press *Enter* to commit the changes.

8 We need to be able to edit the layer. Go to Layer > Simplify Layer. Next add a layer mask. Click back onto the wing's image thumbnail. Hold *ctrl* *⌘* and click the thumbnail to load its selection.

9 Press *ctrl* *C* *⌘* *C* to copy the wing to the clipboard. Now hold *alt* *⌥* and click the mask's thumbnail. We're now working on the mask. Press *ctrl* *V* *⌘* *V* to paste the wing. Press *ctrl* *D* *⌘* *D* to deselect.

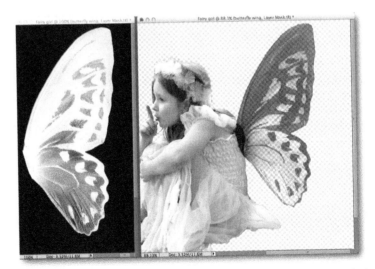

10 At present we can't see the result of adding the mask. Go to View > New Window for Fairy Girl. We now have a second window. This is the same file but in an independent view.

11 Click the Layout icon at the bottom of the workspace Choose All Floating. Resize both windows so we can see them side by side. We can now see the effect the mask is having on the image. At present, the black areas are ghosted; we need those to be solid. Make sure the wing mask window is active. Press *ctrl* *I* *⌘* *I*. This inverts the colors of the mask so the blacks become white and vice-versa. The wing is now much more opaque but still needs adjusting.

HOT TIP

If the All Floating option is not available in the Layout menu it's because floating windows is disabled. Open the Preferences dialog *ctrl* *K* *⌘* *K*. Click Allow Floating Documents In Expert Mode. Click OK to apply the settings.

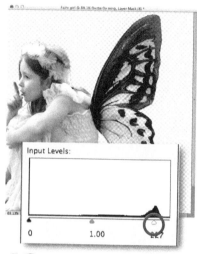

12 Open the Levels dialog *ctrl* *L* *⌘* *L*. Begin by dragging the Highlights slider in from the right. As we do, the black areas of the wing become more solid. We'll leave it in the center of the peak.

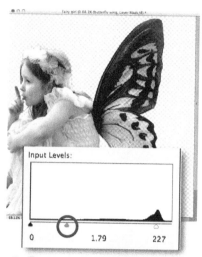

13 To increase the opacity of the colored areas we use the Midtone slider. Drag it over to the left; around 1.80 is enough. The colors are now much stronger and we can still see a little of the backround. Click OK.

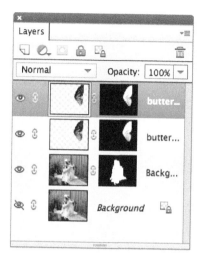

14 We can close the second window now. Click the wing's image thumbnail to exit mask mode. We need two wings, of course. Press *ctrl* *J* *⌘* *J* to duplicate the layer.

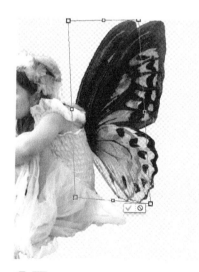

15 Click and drag the new layer down the stack so it's behind the girl's layer. Now use Free Transform *ctrl* *T* *⌘* *T* to move it to the left and distort it slightly. Press *Enter* to commit the changes.

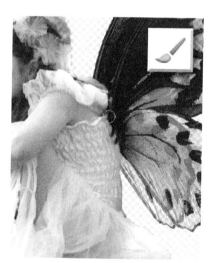

16 Make the top wing's mask active by clicking its thumbnail. Grab the Brush tool. Paint in black over the area of the wing where it meets the girl's body. We just want to make it look like it's slightly behind her.

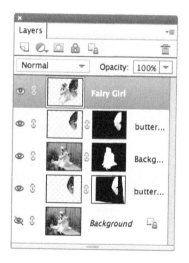

17 Before we move to the next step we'll create a merged copy of the layers. This will make it easier to work with later. Press *ctrl* *alt* *Shift* *E* *⌘* *⌥* *Shift* *E*. We now have a composite layer.

HOT TIP

When working on long projects such as this, it's good practice to save your progress periodically. Save it separately to the images you already have open and make sure it's saved in Photoshop (.psd) format; this ensures that any layers or saved selections are retained in the file.

18 Click the layer thumbnail below the composite we just created. Now go to File > Place. Select toadstools.jpg. Click Place. We have a problem. Even after our fairy to fit the scene, she won't have enough space to sit on the toadstool. Turn the fairy's layer off for now by clicking the visibility icon.

19 Grab the Crop tool **C**. Click and drag across the entire image to select it all. Press *ctrl* *–* *⌘* *–* a couple of times to zoom out. Now drag the top-middle handle up. Increase it by around a quarter. It's better to add too much and crop it later than it is to have to add more after we've worked on it. Press *Enter* to commit the change.

20 We've now created some additional space. We need something to fill it. Go to File > Place. Choose Daisies.jpg. Click Place. Drag it up so its bottom edge is around half-way up the image. Press *Enter* to commit.

21 Go to Layer > Simplify Layer to convert it to a regular layer. Add a layer mask. Now grab a large, soft-edged black brush **B**. Paint across the harsh edge to blend the two layers together.

22 The focus of the layers don't match so it looks a little out of place. Click the daisy image's thumbnail. Go to Filter > Blur > Gaussian Blur. A Radius of around 9 pixels gives us a good match. Click OK to apply.

HOT TIP

Clicking the cursor in the preview window of a filter temporarily shows us the original image. This is useful when working on localized areas where we need to see the effect at 100% but also need to see the image as a whole.

23 The background is almost complete. We just need to adjust the color slightly. Go to Enhance > Adjust Smart Fix. Adjust the slider and compare the tones. Around 12% works well. Click OK to apply.

24 Make the fairy visible again. Click her layer thumbnail. Press *ctrl* *T* *⌘* *T* to enter Free Transform. Scale down and rotate the layer so she sits nicely on the toadstool. Press *Enter* to commit the changes.

25 Click the toadstool layer's thumbnail. Create a new layer above. Grab a soft black brush *B*. Paint a shadow just underneath the fairy. Lower the layer's opacity to around 30%.

26 The girl has a slight blue cast. We'll fix that next. Click the fairy's thumbnail. Go to Enhance > Adjust Color > Adjust Color for Skin Tone. Click once on the girl's forehead. Perfect! Click OK to apply.

27 Go to File > Place. Choose Butterfly. psd. The file has been saved at the correct size so we just need to position it; we'll place it on the left on her eyeline. Press *Enter* to set the layer down.

28 To finish off, we'll boost the color to give the scene a more fantasy-like appearance. Create a Hue/Saturation adjustment layer at the top of the layer stack. Increase the Saturation by around +15.

HOT TIP

As with so many techniques in Elements, there are many different ways to correct the color of an image or layer within a document. There is no right or wrong way, of course; use the technique that works, even if it wasn't intended for exactly that purpose.

8 A change of scenery
I have the power!

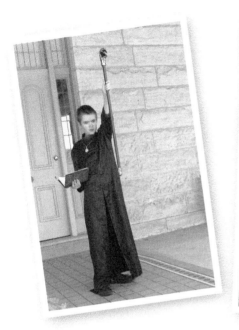

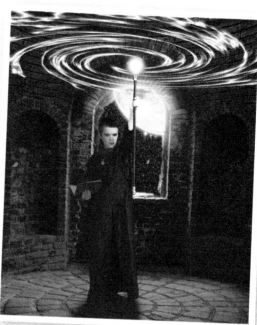

IMAGES: **WIZARD – JENNI MILLS (DEVIANTART.COM); CASTLE – CLAUDIA (DEVIANTART.COM); MOON AND STARS – NASA.GOV**

F LITTLE GIRLS WANT TO BE FAIRIES, it's likely that little boys might want to be powerful wizards. Our example image shows just such a young Merlin. Although he looks the part, his backround is not exactly the best place for him to practice his art.

In this project we'll not only transfer our wizard to a more fitting place, we'll also create a swirling magical vortex eminating from his staff.

As well as creating a much more striking image, we'll discover some useful tricks and techniques along the way. We'll find out how to adjust the perspective of the background image so our subject better fits his scene. We'll also work with blend modes and adjustment layers to create a night time effect. Then there's the lightning vortex, of course. To round the image off, we'll add some colored lighting to pull the whole montage together.

DOWNLOADS

I have the power (folder)

WHAT YOU'LL LEARN

- Adjusting the perspective of a photo Pages (207)
- Creating a night time effect Pages (208)
- Adding shadows and shading Pages (209)
- Creating a lightning effect Pages (210)
- Casting additional light on a scene Pages (211)

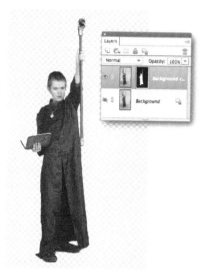

1 Extract the boy from his background using the Quick Selection tool **A** and Refine Edge. Make sure Output is set to New Layer and Layer mask. This is a straightforward job with only a few adjustments needed afterward.

2 Open the Castle Room image. Go to the Photo Bin. Click and drag the boy's thumbnail onto the castle image. Notice that the image has been simplified. It's important, therefore, to ensure the cutout is perfect first.

3 Now that the boy is in place we can see a problem: the perspective of the floor doesn't match that of the boy. This is due to the different lenses and angles used when the photos were shot. Let's fix it.

4 Click the background layer's thumbnail to make it active. Grab the Elliptical Marquee tool **M**. Place the cursor in the center of the floor. Now hold **alt** and drag out the selection to fit the edge of the floor.

5 Press **ctrl T** **⌘ T** to enter Free Transform. Drag the bottom-middle handle up; the floor's perspective changes. Use the boy's feet as a guide to how much distortion is needed. Press **Enter** to commit the change.

6 Press **ctrl D** **⌘ D** to drop the selection. We now have some space at the bottom of the image. Grab the Crop tool **C**. Drag out the box across the image. Line it up with the bottom edge. Press **Enter** to crop it.

HOT TIP

It's always useful to look for visual guides in an image that will help us with gauging perspective and also for making accurate adjustments; here we have the perfect starting point for our selection as the center of floor has its own crosshair to line up to.

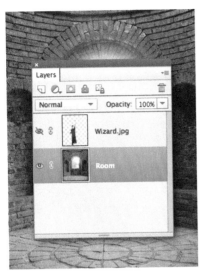

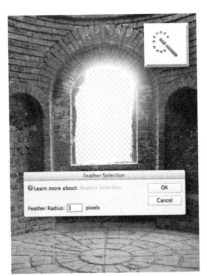

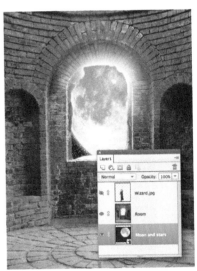

7 The room was photographed during the day. We'd prefer a night scene with our own backdrop. Hide the boy's layer for now. Hold *alt* ⌥ and double-click the background layer to convert it to a regular layer.

8 Use the Quick Selection tool *A* to select the inside of the window. Go to Select > Feather. Set a 1 pixel radius. Click OK. Press *Backspace* to delete the area. Deselect by pressing *ctrl* D ⌘ D.

9 Go to File > Place. Select the Moon and stars image. Click Place. Press *Enter* to set the layer down. Drag the layer below the room layer in the layers panel. We can now see it through the window.

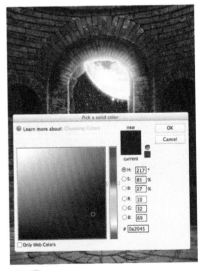

10 The moon is too big. Press *ctrl* T ⌘ T to enter Free Transform. Drag a corner handle in to reduce the size. Then move it into position. The top-right of the window is good. Press *Enter* to commit.

11 We also need to darken the room down. Make the room layer active by clicking its thumbnail. Press *ctrl* J ⌘ J to duplicate the layer. Now set the layer's blend mode to Multiply.

12 We'll give the scene a blue nightime cast. Go to Layer New Fill Layer > Solid Color. Choose a dark blue. Click OK. Set the blend mode to Color. Now lower the opacity to around 60%

HOT TIP

It's important to make sure different components of a montage fit and blend together as much as possible. Here we've positioned the brighter area of the moon in the corner of the window where the sun was shining through in the original version of the image.

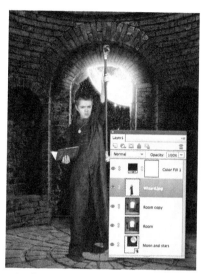

13 Go to the Layers panel. Make the boy's layer visible again. We need to include him in the color toning we gave the room. Click and drag his layer beneath the color fill layer.

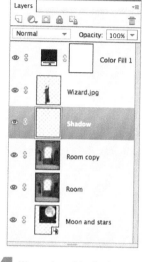

14 We need to add a shadow on the floor. Click the layer below the boy in the layers panel. Create a new layer above it _ctrl_ _Shift_ _N_ _⌘_ _Shift_ _N_. Name the layer Shadow. Click OK.

15 Grab the Brush tool _B_. Choose a large, soft tip. Select black as the foreground color. Now paint a shadow on the floor in front of the boy in the direction of the moonlight. Lower the opacity to around 80%

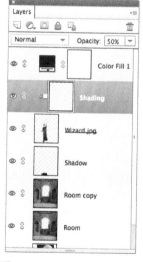

16 As well as a shadow on the ground, we need to add some shading to the boy. Create a new layer above the boy. Name this Shading. Press _ctrl_ _G_ _⌘_ _G_ to create a clipping group. Set the opacity to around 50%.

17 We'll focus on the left side as that's facing away from the light. Use the edge of the brush to add a touch of shading to his face. We don't need to be precise as it's clipped and will only show on the boy's layer.

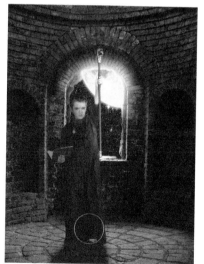

18 Carry on painting over the rest of the boy. Leave the right side of his face and upper body as we'll be working on that later. If the shading is too harsh, or not strong enough, we can always adjust the opacity.

HOT TIP

It's always advisable to apply shading on separate layers. Firstly because it's far easier to rectify any mistakes; each brush stroke counts as an action and you can only go back so far with the Undo command. Secondly, we also have much more control over the result as we can use opacity and blend modes.

8 A change of scenery

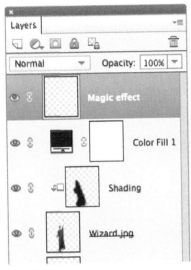

19 Let's create some magic. Add a new layer at the top of the stack, above the blue adjustment layer; we don't want it to be affected by the tone. Press **D** to select the default color palette.

20 Go to Filter > Render > Clouds. This gives us a random pattern. Now go to Filter > Render > Difference Clouds. This blends with the previous effect, giving us a veiny, textured appearance.

21 Press *ctrl* **I** ⌘ **I** to invert the colors. Open the Levels dialog *ctrl* **L** ⌘ **L**. Drag the Shadows slider over to the right. As we do, the veins become more defined and lightning-like.

22 Our lightning needs a more magical color. Press *ctrl* **U** ⌘ **U** to open the Hue/Saturation dialog. Click Colorize.Drag the Hue slider into the purple hues. Increase the Saturation to make the color richer. Press OK.

23 Now we'll create a vortex effect. Go to Filter > Distort > Twirl. Click the - button to zoom the preview out. Now adjust the angle value. Around 400° works well here. Click OK to apply the effect.

24 Set the blend mode to Screen to remove the black. Press *ctrl* **T** ⌘ **T** to enter Free Transform. Hold *ctrl* ⌘. Drag the corner handles to put the effect in perspective. Press *Enter* to commit.

HOT TIP

When we're using filters that produce random effects, such as Clouds, we don't always get the desired effect the first time. Rather than going through the menus each time, we can press *ctrl* **F** ⌘ **F** to repeat the last filter. We can do this as many times as we like, until we get the best result.

25 Load the boy's selection by pressing *ctrl* ⌘ and clicking his layer thumbnail. Grab the Eraser tool **E**. Paint over the effect where it's in front of the staff. The effect now appears to be above the staff.

26 Press *ctrl D* ⌘ *D* to drop the selection. There are areas of the effect that have been cut off where they were at the edge of the document. Use the Eraser to tidy them up and any other stray parts we see.

27 Create a new layer. Grab the brush tool. Hold *alt* ⌥. Click to sample a purple hue from the vortex. Use a soft brush to paint a glow at the top of the staff. Switch to white and paint a smaller glow inside.

28 The staff would cast light on the boy. Load his selection again. Now hold *ctrl alt* ⌘ ⌥. Click the shading layer's thumbnail. This subtracts the area from the boy's selection leaving just the brighter area.

29 Create a Hue/Saturation adjustment layer; a mask is added from the selection. Click Colorize. Adjust the Hue to purple. Increase the Lightness slightly. Change the blend mode to Overlay for more contrast.

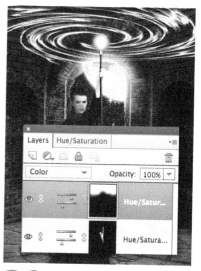

30 Press *ctrl J* ⌘ *J* to duplicate the adjustment layer. Change the blend mode to color. Fill the mask with black. Now use a large white brush to paint at the top of the room to add a purple glow on the wall.

HOT TIP

The colored light layer blends in really well with the shading on the boy as it was painted using a soft brush; that acts as feathering on a selection. If we had created the effect using a completely fresh selection we would first need to use the feather command to allow the edges to fade out gradually.

All the world's a stage

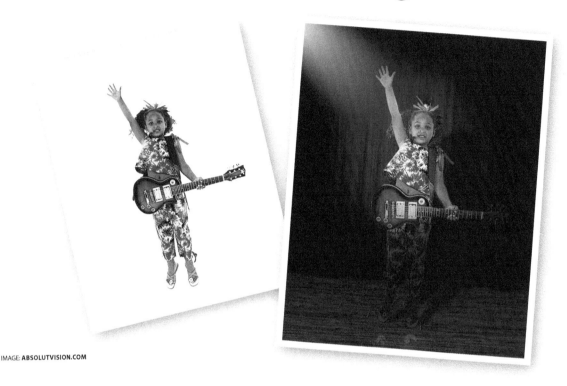

IMAGE: **ABSOLUTVISION.COM**

alent shows are all the rage at the moment; everyone wants to be a megastar, it seems. For the lucky few, this can become a reality. for those of us who just want to fast-track to the limelight, without the need to go through the arduous selections, auditions and subsequent tears; we can simply use a little Elements know-how to put ourselves on stage.

In this project we'll be creating all the components from scratch to put our wannabe rockstar in the spotlight. First, we'll create a wood texture. We'll turn this into a parquet-style floor pattern. After distorting the floor into perspective to create the stage, we'll add a heavy stage curtain and light the scene with a spotlight.

DOWNLOADS

Guitar girl.psd

WHAT YOU'LL LEARN

- Making a woodgrain texture (Page 213)
- Creating a parquet floor effect (Page 214)
- Making the floor three-dimensional and shiny (Page 215)
- Creating a plush material texture (Page 216)
- Adding shadows across objects (Page 217)
- Creating a spotlight effect (Page 218)
- Making a visible light source (Page 219)

1 We'll start by making the wood effect for the stage. Hide the girl's layer for now. Create a new layer above the background. Go to Edit > Fill Layer. Use 50% Gray as the contents. Click OK. Duplicate the layer *ctrl* **J** ⌘ **J**.

2 Press **D** to set the default colors. Go to Filter > Render > Fibers. We want an even grainy effect. The variance slider controls the length and shift of tone. Strength controls the closeness of the indivdual strands. Click OK.

3 Now go to Filter > Distort > Liquify. Select the Turbulence tool **T**. Set a medium sized brush. Lower the Brush Pressure to around 50. Now make a few random vertical strokes, in a slight zig-zag motion to distort the grain.

4 Switch to the Clockwise Twirl tool **C**. Lower the brush size. Now create some knot marks randomly around the texture by using a small scribble motion in the same area. Click OK to apply the effect.

5 Set the grain layer's blend mode to Soft Light; it becomes more subtle. Click the plain gray layer's thumbnail. Open the Hue/Saturation dialog *ctrl* **U** ⌘ **U**. Click Colorize. Set the color to a light brown. Click OK.

6 Switch back to the grain layer. Press *ctrl* **E** ⌘ **E** to merge it with the color layer. Open the Levels dialog *ctrl* **L** ⌘ **L**. Drag the Shadows slider silghtly to the right to darken the wood. Click OK to apply.

HOT TIP

Using the tools in the Liquify filter can be a little hit-and-miss. If it all goes wrong, you can use the Revert button to take it back to the original. There is also the Reconstruct tool **E**. This is like a time-machine; as you paint over an area it gradually reverses whatever changes you made. Very useful!

7 We have our wood texture but floors are made up of many smaller strips. First, go to the Effects panel. Select Styles > Bevels. Double-click the Simple Inner preset. Open the Style Options. Lower the bevel to 1px. Click OK.

8 We'll create some guides to ensure the strips are equal. Go to View > New Guide. Click Vertical. Now set the position to 10%. Click OK. Repeat this step increasing the amount by 10% each time.

9 Make sure Snap to Guides is checked in the View menu. Grab the Rectangular Marquee tool *M*. Draw a selection in the first guide section. The box will snap into place. Press *ctrl J* *⌘ J* to copy to a new layer.

10 Press *ctrl [* *⌘ [* to reselect the layer below. Now repeat step 9 on the next section to create another strip. Keep doing this for the remaining sections. Remember to go back to the original layer each time.

11 Hide the guides by pressing *ctrl ;* *⌘ ;*. Hold *ctrl* *⌘*. Now click on every other strip layer's label in the Layers panel to group them. Go to Image > Rotate > Flip Layer Vertical. This breaks any obvious patterns.

12 Click on the top strip to clear the group. Draw a loose selection with a random height. Press *ctrl J* *⌘ J* to create a new layer. This splits the strip down into two. Repeat this for the rest of the strips.

HOT TIP

As an additional step we could use the Levels command to change the brightness of the individual floor strips. This would give the effect a natural, less manufactured feel.

13 Before we continue, we need to flatten the layers. Make sure the last strip layer is selected. Hold *Shift*. Now click the top strip layer. This selects all the pieces of the floor. Press *ctrl E* ⌘ *E* to merge them.

14 Hide the original wood layer. For the stage we need the floor strips to run horizontally. Make sure the new floor layer is active. Now go to Image > Rotate > Rotate Layer 90° Right.

15 Press *ctrl T* ⌘ *T* to enter Free Transform. Hold *ctrl* ⌘. Now drag the corner handles to put the floor in perspective. Hold *Shift* to keep the horizontals straight. Press *Enter* to commit the changes.

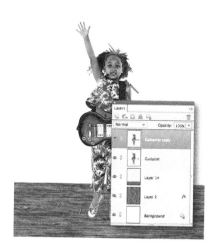

16 Make the girl's layer visible to check the perspective. It looks OK. The effect looks a little flat, though. Let's create a reflection. Make the girl's layer active. Now duplicate the layer *ctrl J* ⌘ *J*.

17 Go to Image > Rotate > Flip Layer Vertical. Grab the Move tool *V*. Hold *Shift* to constrain the movement. Drag the layer down. The girl has been photographed jumping so leave a small gap between the two.

18 Lower the opacity of the reflection. Around 40% works well. Go to Filter > Blur > Gaussian Blur. We only need a very small amount, just enough to make the reflection slightly hazy.

HOT TIP

If the image you're working on is wider than it is tall, placing the floor in perspective would involve stretching it out considerably. This might cause the image to become pixelated. In this case we would want to duplicate the layer and overlapping it at the end of the original, then masking out the join.

19 Make a new layer. Grab the Freehand Lasso **L**. Draw a shallow wavy selection just below the top edge of the floor layer. Complete the selection by drawing an outline around the outside of the image.

20 Fill the selection with 50% Gray. We're using the Fibers filter again. We need to change the color palette first. Choose a bright red for the foreground. Make the background a much darker, reddish-brown.

21 Open the Fibers filter. We'll use a more subtle effect here. Lower the Variance to 8. Set the Strength to 18. Click OK to apply. This gives us the appearance of heavy material. Press *ctrl* **D** ⌘ **D** to deselect.

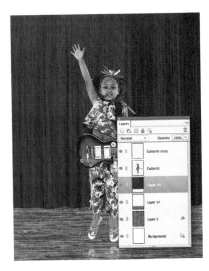

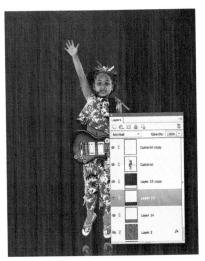

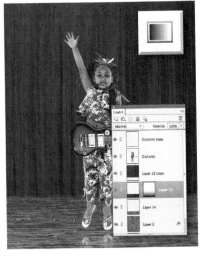

22 Before we continue we'll move the curtain behind the girl. Go to the Layers panel. Click and drag the curtain layer down beneath the gir's layer. The scene is starting to come together nicely.

23 The curtain needs a reflection. Duplicate the layer. This time click back to the original layer. Flip it vertically. Drag the layer down but leave the wavy area tucked behind the copy. Add a slight blur as before.

24 We need to fade the reflection out. Add a layer mask. Grab the Gradient tool **G**. Select a Linear Black, White gradient. Start at the bottom of the document. Hold *Shift*. Drag up to around the top of the guitar.

HOT TIP

Although we'd usually make our texture effects on a mid-gray layer to begin with and adjust them later with Hue/Saturation and Levels, in this case it's better to define the colors first. We can always make minor tonal adjustments with Levels afterwards.

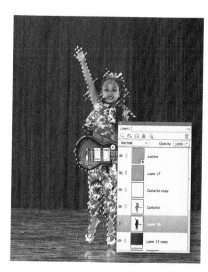

25 We'll add some shadows. Create a layer between the curtain and the girl. Load the girl's selection. Press *D* do set the default palette. Now press *alt* *Backspace* *⌥* *Backspace* to fill the selection with black.

26 Press *ctrl* *D* *⌘* *D* to deselect. We're going to have a spotlight coming from the left. Grab the Move tool *V*. Drag the shadow to the right, leaving it parallel to the girl.

27 The shadow will need to go along the floor and up the curtain. Grab the Rectangular Marquee *M*. Make a selection around the bottom of the shadow. Start around the knee area and finish just below the feet.

28 Press *ctrl* *T* *⌘* *T*. Grab the top-middle handle. Drag down to the bottom of the curtain. Hold *ctrl* *⌘*. Click the bottom-middle handle. Drag the shadow to just parallel and to the right of her toes. Press *Enter*.

29 Deselect. Make a new selection around the rest of the shadow. Enter Free Transform again. This time click inside the bounding box and move the shadow down to meet the other half. Press *Enter* to commit.

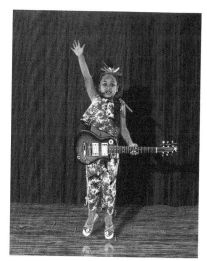

30 Deselect. We need to soften the edge of the shadow a little. Open the Gaussian Blur filter again. Set the Radius to around 3 pixels. Click OK to apply the blur. Lower the layer's opacity to about 50%.

HOT TIP

The shadow here only falls a short distance so it would keep a fairly consistent opacity. If we're creating shadows that fall away further, we might need to use a gradient mask to make it lighter the further away it is from the subject.

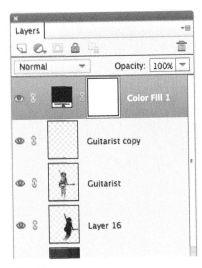

31 Next we'll add a spotlight. Go to the Layers panel. Click the top layer in the stack. Go to Layer > New Fill Layer > Solid Color. Set the color to black. Click OK. This turns the whole image black, of course.

32 Make sure the fill layer's mask is selected. Grab the Elliptical Marquee tool *M*. Hold *Shift* to constrain to a circle. Drag out a fairly large selection. Don't worry about the position, We can change that later.

33 Press *ctrl* *Backspace* ⌘ *Backspace* to fill the selection with black. This knocks a hole in the mask, letting us see through to the image below. Press *ctrl* *D* ⌘ *D* to Deselect.

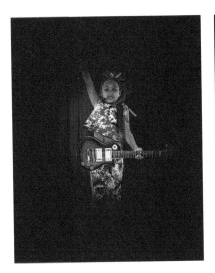

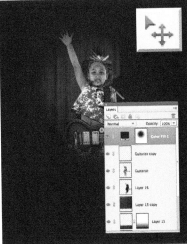

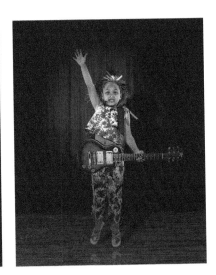

34 Spotlights have soft edges, of course. Open the Gaussian Blur filter. Dial in a fairly large radius; around 50 pixels works well here. That's looking much more like a spotlight.

35 The spotlight's placing isn't right. The 'light' is just an object on a layer and behaves in the same way. Grab the Move tool *V*. Click and drag on the spotlight to move it into a better position.

36 It's unlikely that our stage would be pitch black. We should be able to see a little more of the girl outside of the spotlight. This is easily fixed. Lower the opacity of the fill layer to around 75%.

HOT TIP

Normally if we were creating a fill or adjustment layer where we wanted to limit it to a selection, we'd make the selection area first, then create the layer; automatically defining the mask. We can't in this case because the mask area would stop at the edges and leave gaps when we moved it around.

37 The girl is lit from both sides in the photo. The spotlight would put her right side slightly more in shadow. Create a Levels adjustment layer above the girl's layer. Press _ctrl_ _G_ _⌘_ _G_ to create a clipping group.

38 Lower the overall brightness by dragging the right output slider to the left. We've set it to 100 here. This puts the whole girl in shadow, of course. We'll use the layer's mask to adjust the effect.

39 Grab the Brush tool _B_. We need a fairly large, soft tip to avoid harsh edges. Now paint in black on the area we want lit. As we do we're hiding the adjustment to reveal the original lighting.

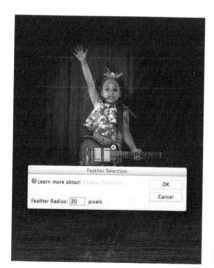

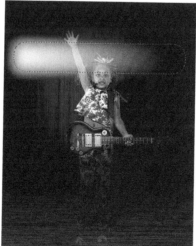

40 Create a new layer at the top of the stack. Grab the Rectangular Marquee tool _M_. Create a shallow selection slightly narrower than the image. Go to Select > Feather. Set a value of 20 pixels. Click OK.

41 Set the foreground color to a pale yellow. Select the Gradient tool _G_. Choose a linear, foreground to transparent gradient. Click and drag from the left of the selection to the right. Deselect _ctrl_ _D_ _⌘_ _D_.

42 Press _ctrl_ _T_ _⌘_ _T_ to enter Free Transform. Rotate and distort the glow to form a visible light coming in just from the top-left corner. Press _Enter_ to commit the changes. This completes our image.

HOT TIP

Creating shading can be tricky and requires some practice to get right. Using adjustment layers gives us the freedom to experiment and refine the effect as we have both the mask and the layer's non-destructive qualities. We can also try different blend modes to see how that affects the image.

8 A change of scenery
A winter wonderland

IMAGE: **GIRL – JAMIE BASSO (FLICKR.COM); BACKGROUND – ANDI O (SXC.HU)**

WE DON'T SEEM TO GET the same amount of snow as we did in years gone by; whilst some people would say this is a good thing, it is a shame not to see the stunning white backdrop blanketing the streets and countryside – it does make a particularly great photo opportunity, after all. This is not a problem for the montage artist, however. With a little effort we can take almost any scene and add a little wintry magic.

In this project we'll extract a girl from her city background and place her in a more scenic location. We'll add a snow effect created by combining filters and blend modes. We'll also add extra depth to the scene by layering the snow effect so it appears larger and out of focus in the foreground, becoming finer in the background. We'll finish the effect by adding a blue color cast to make the scene colder.

DOWNLOADS

Winter girl.psd

Action available

WHAT YOU'LL LEARN

- Using view modes in Refine Edge to assist with selection adjustments
- Combining filters to create a snow effect
- Creating a sense of depth with layered effects
- Using subtle tone changes to alter the feel of an image

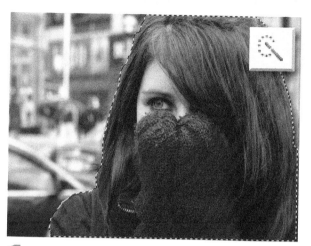

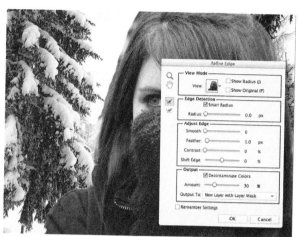

1 First we need to extract the girl from the background. Click her layer in the Layers panel. Now use the Quick Selection tool **A** to make a selection. There's a high contrast between her and the background so it's an easy task.

2 Open the Refine Edge dialog. Set the View Mode to On Layers **L**. We can now see the layer below. Grab the Refine Radius tool **E**. Use a small brush to outline the hair. Add a small amount of feather. Enable Decontaminate Colors. Set the value to around 30%. Click OK.

3 To start we'll create a new layer above the girl. Go to Edit > Fill Layer. Set the Contents to 50% Gray. Click OK. Now go to Filter > Noise > Add Noise. Set the amount to 100%. Set the Distribution to Gaussian. Check the Monochrome box. Click OK to apply the filter.

4 Go to Filter > Blur > Gaussian Blur. We want a soft, mottled effect. A radius of around 6 pixels gives a good result. If we push it any further we wouldn't have enough contrast to create the effect. Click OK to apply the filter.

HOT TIP

Using the View On Layers setting is really useful. When enabled we can see exactly how the cut-out is going to look when placed against the new background. It's still worth checking with the other view modes as well to make sure we get the best possible results.

5 Open the Levels adjustment *ctrl* *L* *⌘* *L*. Start by dragging the Highlights slider to the left to meet the right edge of the histogram. Now drag the Shadows slider over to the right toward the Highlights. As we do, we create snow-like flecks. Click OK to apply the adjustment.

6 Duplicate the layer *ctrl* *J* *⌘* *J*. Label the layer Foreground. Press *ctrl* *T* *⌘* *T* to enter Free Transform. Go to the Tool Options panel. Set the Width and Height to 150%. This scales the flakes up and gives them a slight crystalline appearance. Press *Enter* to apply.

7 Hide the Foreground layer. Click the original snow layer's thumbnail to make it active. Enter Free Transform again. Set the reference point to top-left. Now set the width and height to 50%. This halves the size and positions it in the top-left corner. Press *Enter* to apply.

8 Grab the Move tool *V*. Hold *alt* *⌥* and drag across to the right. Hold *Shift* to constrain the movement. This gives us a duplicate layer. Go to Image > Rotate > Flip Layer Vertical. Now Flip it again, this time Horizontally. This helps to prevent too many obvious patterns.

HOT TIP

The amount of noise, blur and the settings of the Levels adjustment will vary greatly depending on the size of the image. You can also alter the settings to make the flakes larger or smaller to suit the type of scene you're applying the effect to.

9 Press *ctrl* **E** ⌘ **E** to merge the two sections. Now Repeat the last step to create the bottom half. Merge the layers again to create a single layer. Flipping the layers has created visible lines across the center of the image. We'll sort this out next.

10 Grab the Clone Stamp **S**. Pick a fairly small, soft brush. Hold *alt* ⌥. Click an area of the image some distance away from the section we want to fix. Now start to paint over the lines to replace the areas with random flakes. Repeat this until we have removed the lines.

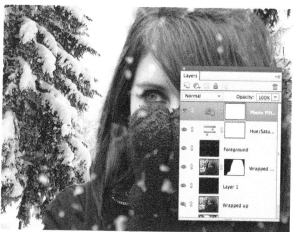

11 Go to the Layers panel. Click and drag the current layer behind the the girl's layer. Set the layer's blend mode to Screen. We can now see the background with the snow falling. Click the Foreground layer to make it active. Make it visible and change its mode to screen as well.

12 Snow tends to draw the color from a scene. Create a Hue/ Saturation adjustment layer. Drop the Saturation to around -40. Now create a Photo Filter adjustment. Set the Filter to Cooling Filter (80). This adds a slight blue cast to give a more wintry feel to the image.

HOT TIP

We've created an action to create the snow effect; run it after completing step 2. It can also be used to create more snow layers in the foreground or background. Duplicate one of the snow layers then run the action from the 'Hide Current Layer' step. We've done this to create the project's intro image.

The great escape

THE 'OUT OF BOUNDS' TECHNIQUE is a popular one with Elements artists and it's not hard to see why: breaking a picture out of its frame makes for an arresting image. The process can be as simple or as complex as you want to make it.

Normally, we would apply the effect to an image where the subject is already heading out of the picture, as it were; a train heading towards the viewer, for example. We would put a frame around the image but cut it back enough for the subject and often some of its surroundings to protrude. This would be placed against a white or plain-colored background.

Here, we'll look at a rather more detailed version of the trick, using not a photograph but a painting – Little Thieves or Petites Maraudeuses, by William-Adolphe Bouguereau. The concept is the same but in this instance the frame is the painting's real surround and our subjects are seen escaping into the gallery.

DOWNLOADS

The great escape (folder)

WHAT YOU'LL LEARN

- Matching existing perspective
- Creating new scenery from scratch
- Brightening up dark areas of the image
- Adding shadows to create depth

1 We'll begin by using the Quick Selection tool **A** to make as selection of the two figures. Switch to the Selection Brush to select the smaller sections and tidy any stray areas.

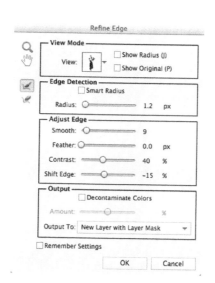

2 Open the Refine Edge dialog. View against white **W**. Adjust the settings to tidy the selection, roughly as shown. Set Output to New Layer with Layer Mask. Click OK.

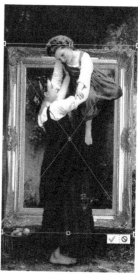

3 Make the background layer visible again and click its thumbnail to make it active. Go to File > Place. Choose the frame file. Click Place. Don't commit the layer just yet.

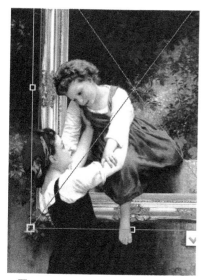

4 Move the frame into position and scale it down. We want it fairly high; let the top and right go outside the image. Place it so the little girl's foot clears the bottom of the frame.

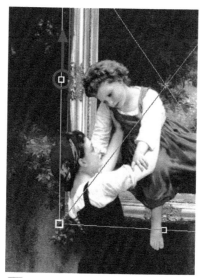

5 Hold *ctrl* *Shift* ⌘ *Shift*. Push the left-middle handle up to skew the frame until it matches the perspective of the wall in the painting. Press *Enter*.

6 Now let's add the wall. Create a layer below the frame. Use the Rectangular Marquee **M** to mark out a selection that fills the image but stops at the top of the basket.

HOT TIP

It can be difficult making selections on images with dark areas. A useful trick is to create a Levels adjustment layer above the target layer. We can increase the brightness in order to see the image properly without affecting it directly. Once the selection's been made, we can delete the adjustment layer.

7 Go to Edit > Fill Selection. Choose Color as the content. Choose a soft beige color from the color picker. Click OK to fill the selection. Press *ctrl* D ⌘ D to deselect.

8 Create a layer above the wall layer. Draw a rectangular selection from the bottom of the wall up to create the skirting. Fill this with an off-white color.

9 Nudge the selection up to just below the top of the skirting. Grab the Dodge tool **O**. Set the Range to Highlights. Paint across the skirting to create a bevel edge. Deselect.

10 Press *ctrl* T ⌘ T. Hold *ctrl* *Shift* ⌘ *Shift*. Drag the right-middle handle down slightly to skew the skirting into perpective. Press *Enter* to commit.

11 To create the floor: add a new layer below the wall. Draw a rectangular selection from the behind the wall to the bottom of the image. We've filled it with brown.

12 Go to Filter > Noise > Add Noise. Add a small amount of Monochromatic Gaussian noise. Click OK. Use Filter > Blur > Blur More to soften the effect. Now Deselect.

HOT TIP

Using skewing to create perspective works in this instance as we area only seeing a small section of the image. The frame extends outside the image and the skirting only has a single reference point. If we could see the whole room, we would need to be more precise with the distortion.

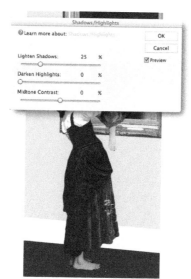

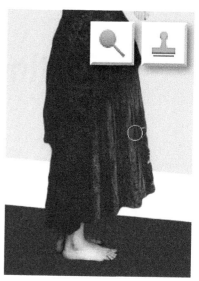

13 Grab the Magic Wand **A**. Make the frame layer active. Click inside the frame's aperture. Make the wall layer active. Press *Backspace* to reveal the painting behind.

14 Deselect. Make the Girls' layer active. Go to Enhance > Adjust Lighting > Shadows/Highlights. Use the default settings but lower the Lighten Shadows slider. Click OK

15 Use the Dodge tool **O** set to Highlights to lighten up the woman's feet. Now grab the Clone Stamp **S** and clean away the vine from her skirt.

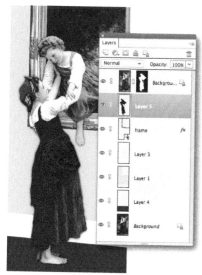

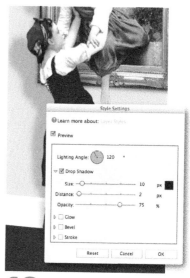

16 Hold *ctrl* ⌘. Click the Girls' mask thumbnail. Create a layer below the girls. Fill the selection with black. Deselect. Now apply a Gaussian Blur of around 6-8 pixels.

17 Press *ctrl* *T* ⌘ *T*. Scale and distort the layer to create a shadow on the wall to the left. Press *Enter* to commit. Lower the layer's opacity to around 20%.

18 Make the frame layer active. Go to the Effects Panel. Select Styles > Drop Shadows. Double-click the Low preset. Open the Style Options to adjust its size. Click OK.

HOT TIP

When we distorted the shadow of the girls to fit the scene, we lost the part of the shadow for the little girl's leg. This can be painted in on a separate layer with a small soft black brush. It's closer to the frame so should be a little darker than the main shadow. You can see this in the introduction image.

Finding images for free

MOST OF THE TIME, you'll be using your own images for the project you're working on – you won't find a more inexpensive source than that. There will be situations, however, when you'll need a photo of an object you don't have the time or resources to take. It may be completely impractical because it's not something you normally find in your home town or even the country you live in; a famous building or indigenous animal, for example. Whilst you could improvise by altering the project or modifying an image of something similar, there is a much better way of tracking down that elusive picture: the World Wide Web.

In recent years, as more people have switched to digital cameras and fast internet connections become more commonplace, huge online stock photography sites have sprung up, containing hundreds of thousands of images. Sites such as *stock.xchng* (www.sxc.hu) and the curiously named *Morguefile.com* (traditionally a publishing term given to reference libraries of old images and cuttings) provide categorized and searchable libraries of people, places and objects from all around the world. Because they are submitted by the public for the public, the quality is not always superb; it does mean, however, that you have a good chance of finding something bizarre which would not make it past the strict scrutiny of the commercial libraries. The biggest benefit, of course, is that they are completely free. The sites are kept running solely on advertising and the good will of public donations. This, of course, is great news for the montage artist on a tight or nonexistent budget.

The exact terms of use vary from site to site. Most, however, allow unlimited use for both private and commercial projects, providing it's not detrimental to either the photographer, their subject or the site itself. When you download an image, it's usually anonymously; the photographer may like to know how their photo has been used but it's rarely mandatory. *stock.xchng* allow the contributors to set their own requirements: some require you to apply for explicit permission, depending on the content – generally, and understandably, when there are recognizable faces. It's one thing to allow someone to post photos of you but quite

another to find yourself placed in an image of questionable content.

In addition to the dedicated libraries, there are also community sites such as *Flickr.com* and more recently, *Wikipedia Commons* (commons.wikipedia.org). These operate under the new Creative Commons license – a system devised for intellectual rights management on the internet. Under this license, photographers can determine what can and can't be done with their images. This ranges from complete free rein to total copyright protection; the latter is very often negotiable through polite communication with the person concerned. Another site worth checking out, if you're looking for images to use in fantasy scenes, is *DeviantArt.com*; there is a dedicated stock section where members post their images. Do check their individual rules, however, as some images are not to be used outside of the site. Be warned, some of the content is not for the faint-hearted!

It's also worth noting the governmental public domain libraries. These offer more specific images: military, political figures and, of course, there is NASA.gov which holds a wealth of scientific, aeronautical and astronomical photos. Again, these images are all free to use for private projects but commercial use carries some regulations; these can be found in the site's terms and conditions.

If all else fails, you can always try a search through *Google images*. Great care must be taken here. Grabbing images from web searches puts you right in the middle of the copyright minefield. If you're using the pictures at a purely personal level, making backgrounds for your computer desktop and so on, you'll be OK. If, however, you intend to publish these images as part of your website or as a printed design, make sure you obtain permission from the owner of the site or photo. There's usually an address to write to. If you are in any doubt as to the copyright status, don't risk it; at the very least, you'll receive an irate email asking for removal of the image, and at worst, you may find yourself in court.

As long as you respect the rules and guidelines, there is a wealth of useful content to be found. Browsing the sites can also be a good source of inspiration; something you find by accident can often spark a whole new project idea.

9

Art & design

WE'VE SEEN THAT ELEMENTS is more than capable of creating photomontages, tidying up and enhancing photos and applying stunning effects. Now let's explore another branch of image creation: digital art and design.

In this chapter we'll be conjuring chrome spheres over a seascape, creating a wanted poster, making a neon sign, putting together a vintage-style movie magazine cover and much more. You'll also find the project to create the portrait from the front of this book.

As with the projects throughout the book, these are all techniques that can be used as is, or repurposed for your own requirements.

9 Art & design
Soft textured portrait

IMAGE: **ADRIENNE – JOSIE JOHNS**

I N THIS PROJECT we're going to create a stylized image from a photograph using blend modes, filters and one of Elements' built-in graphic backgrounds to add an artistic, textured effect.

This is a highly versatile technique and can be applied to almost any type of image; everything from portraits of people and animals to landscapes and still life images. Aside from giving the image a nice artistic look, it can be particularly useful for disguising a busy or lackluster background; thus rescuing the photo from the recycle bin!

Experimentation is very much the key word here and because we're using non-destructive techniques, we can keep changing the different elements of the picture until we're happy with the result.

DOWNLOADS

Dandelion girl.jpg

WHAT YOU'LL LEARN:

- Using blend modes to change the appearance of a layer
- Adding artwork from Elements' graphics library
- Using masks to hide areas of a layer
- Using gradient adjustment layers for subtle effects
- Creating soft framing with a vignette border

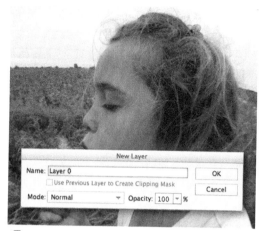

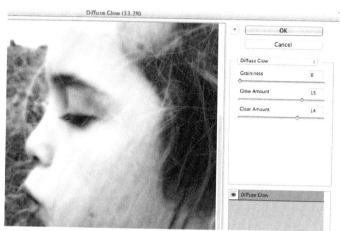

1 We'll begin by opening the project image. Before we continue, however, we must convert the backround layer to a regular layer – see the hot tip below. We can do this by going to the Layer menu and selecting New > Layer From Background. A dialog will appear. Click OK to accept the default settings.

2 Create a duplicate of the layer using *ctrl* **J** / ⌘ **J**. Make sure the foreground and background colors are set to the default black and white by pressing **D**. Go to the Filter menu and select Distort > Diffuse Glow. This will give the image a hazy high-key effect. We don't want to add any extra texture, so drop the Grain amount to 0. Set the Glow Amount to around 15. Now set the Clear Amount to around 14. Click OK to apply the effect.

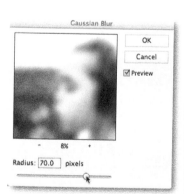

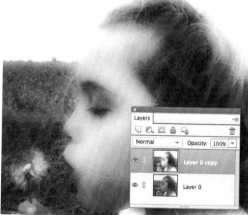

3 We're going to blend the glow layer with the original photo to add some richness. Firstly, we'll apply some blur. Go to Filter > Blur > Gaussian Blur. Increase the amount to around 70 pixels. Click OK to apply.

4 Next, we'll set the layer's blend mode to Hard Light. This gives the girl's skin a soft appearance, whilst keeping the glowing effect we applied earlier. This is also gives us nice rich tones in the darker areas. If the effect seems a little harsh, we can always drop the opacity to reduce its strength; here we've lowered it to 90%.

5 Now to add the texture layer. Bring up the Graphics panel. If it's not visible, go to the Window menu and choose it. Select Backgrounds from the second menu. Now find the Blue Swirly preset and double click to open it.

HOT TIP

When you add a background from the Graphics Panel, Elements will always add the image and convert it to a background layer; if one exists already it will be replaced. This is why it's essential to convert the existing background layer to a standard layer beforehand.

9 Art & design

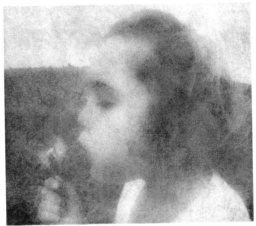

6 Notice that the layer has been added as a background layer. First, convert it to a regular layer as we did in step 1. Now we need to move it to the top of the layer stack. We can do this by clicking and dragging its thumbnail in the Layers panel.

7 We have an obvious problem here: we're going to mask out the texture where it covers the girl but the layer is totally opaque, so we can't see the photo underneath. The easist way to get around this is to temporarily lower the layer's opacity; we've set it to 40% here, which is enough to see the girl and also keep the texture itself in view.

8 Make sure the texture layer is still highlighted by clicking its thumbnail. Create a mask by clicking the New Layer Mask icon at the top of the Layers panel. This won't have any effect yet, as, by default it's set to reveal all (completely white).

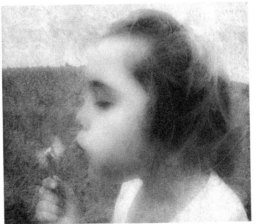

9 Select the Brush Tool **B** from the Toolbox. Go to the Tool Options panel. Choose a large soft brush from the brush picker; around 300 pixels is fine for this image. Finally, set the Opacity of the brush to around 30%.

10 Make sure you're working on the texture layer's mask by clicking its thumbnail in the Layers panel. Choose black as the foreground color. Now begin to paint over the area of the girl's head. As we do this, we can see the photo start to show through. Because we're using a low opacity brush, we are not revealing the layer completely; if we go over the same area a few times, it will gradually show more of the layer beneath. The aim here is to remove most but not all of the texture from the girl's face; leaving a few light patches, especially around the edges will add to the overall effect. If we make a mistake or reveal too much we can switch the foreground color to white by pressing **X**. Now as we paint, it will start to hide the area again.

HOT TIP

We can also convert the background layer to a regular layer by double-clicking its thumbnail in the Layers panel. If we hold down *alt* ⌥ and double-click, we can bypass the dialog box.

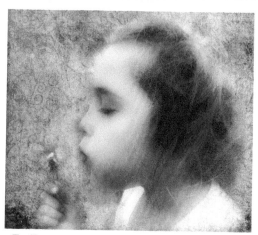

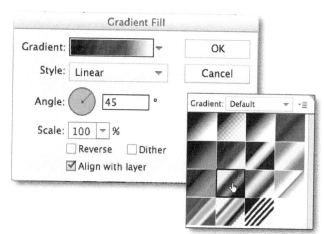

11 With the main areas revealed, we can bring the opacity of the texture back up. We've settled on 90%; this lets a small amount of the background show through. Continue painting on the mask to tidy up and remove any heavier patches from her face and hand – we don't want it to look like a horrible skin condition!

12 We'll add some vibrancy to the image and at the same time give the it a more painterly appearance by blending in a colored gradient. Click the New Adjustment Layer icon at the top of the Layers panel and select Gradient. Open the gradient picker and choose the Yellow, Violet, Orange, Blue preset. Choose the Linear Style. Now set the angle to a diagonal, around 45°. Click OK to create the adjustment layer.

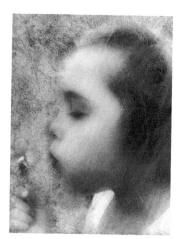

13 To blend the color into the image, we'll first change the layer's Blend Mode. Soft Light works well but the effect is a little overpowering. We can tone it down by lowering the layer's opacity; around 50% is a nice compromise.

14 To finish off we'll add a vignette border. The method we'll use needs a flattened version of the image. We don't want to do this permanently, of course, as we may want to edit the effect at a later date. Instead, we'll create a merged copy of the layers. Make sure the gradient layer is highlighted. Now press *ctrl* *alt* *Shift* *E* *⌘* *⌥* *Shift* *E*. A new composite layer will appear at the top of the stack.

15 Go to the Filter menu. Select Correct Camera Distortion. All we're concerned about here is the Vignette adjustments. Normally we would be using these to remove the effect from a photo but it's just as effective at creating it. Drag the Amount slider to the left, this controls how dark the the effect will be. Around -35 works well. Now Drag the Midpoint to the left. This controls how much of the image is affected. Around 25 looks good. Finally, click OK to apply and we're done!

235

9 Art & design
Perceptions of a distant sun

MONTAGES AND EFFECTS don't always need to be used to produce something practical. Sometimes it's fun to let our imaginations run a little wild and produce images that are a little more arty and abstract.

In this tutorial we'll be using several different techniques to create a surreal landscape. The main part of the effect is creating the shiny spheres. These are produced by copying sections of the background onto new layers, then distorting and twisting them to appear like they are reflecting the world around them; in a stylized way, of course. We'll also use a neat trick to apply the Lens Flare filter in a way that allows us to use it non-destructively.

We've also included a custom action, part of the Cheat Actions set, that takes most of the work out of creating the spheres. This can be used on any of your images, of course. Try it on different scenes; cityscapes or close-ups of objects, for example.

DOWNLOADS

seascape.jpg

Action available

WHAT YOU'LL LEARN

- Using the Polar Coordinates filter (page 237)
- Adding a Gradient to create spherical shading (page 238)
- Adding shadows to objects to depict distance (page 238)
- Adding a Lens Flare non-destructively (page 239)
- Using the Photo Filter adjustment to alter the mood of the scene (page 239)

1 We'll begin by making a square selection. Grab the Rectangular Marquee tool **M**. Hold *Shift* to constrain the proportions. Now drag the bounding box out. Here we've included the sun on the far right and a fairly equal amount of the sky and land.

2 Create a new layer from the selection *ctrl J* *⌘ J*. We'll need to reload the selection to contain the filter. Hold *ctrl* *⌘* and click on the new layer's thumbnail in the Layers panel. Now go to Filter > Distort > Polar Coordinates. Select Polar to Rectangular. Click OK to apply.

3 This is a two-stage effect using the same filter. Before we run it again, however, we need to rotate the layer. Go to Image > Rotate > Rotate Selection 180°. Open the Polar Coordinates filter. This time, select Rectangular to Polar. Click OK to apply. Here's the result.

4 We need to trim the square edges off to make our globe. Press *ctrl D* *⌘ D* to remove the current selection. Grab the Elliptical Marquee tool **M**. Position the cursor in the top-left corner of the square, Now hold *Shift* and drag down to the bottom right corner.

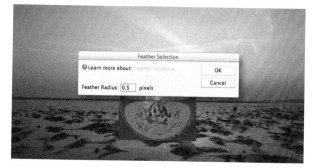

5 Because we're adding the sphere to a photographic background, we don't want its edge to be too sharp, as it would not blend in as well. Go to Select > Feather. We don't want it to be too soft; an amount of 0.5 pixels is enough. Click OK to apply. There's no obvious difference yet.

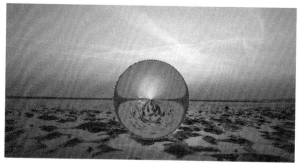

6 We need to invert the selection in order to trim our sphere. Press *ctrl Shift I* *⌘ Shift I* Now everything apart from the sphere is selected. Press *Backspace* to delete the unwanted areas. That's the basic effect completed.

HOT TIP

In previous versions of Elements it was possible to open the last used filter along with its settings by pressing *ctrl* *alt* *F* *⌘* *⌥* *F*. Unfortunately, this no longer works in the current version. Instead, we can hold *alt* *⌥* as we select the last filter option at the top of the Filter menu.

7 Although the distortion image gives the effect of the surface being curved, it's still a little two-dimensional. Invert the selection again. Click on the Adjustment Layer icon in the Layers panel. Select Gradient from the list. We have a new layer with a mask created from the selection.

8 We need to make some alterations. Click the arrow next to the gradient preview. Select Black, White from the list. Change the Style from Linear to Radial. We need to switch the colors around so we have a white spot fading to black; click Reverse to do this.

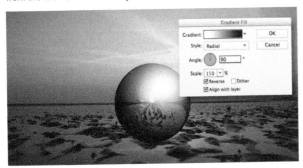

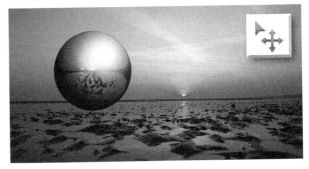

9 Click and drag on the image to move the gradient's position. Place the center of the white spot at around the 2 o'clock position, a little way in from the edge. Increase the scale to 150%. Click OK to close the dialog. Now set the adjustment layer's blend mode to Hard Light.

10 Let's start recomposing the scene. Press *ctrl* *E* ⌘ *E* to merge the shading layer with the sphere to create a single layer. Select the Move tool *V*. Click and drag the sphere over to left and up so most of it is above the horizon.

11 Next we'll create a shadow on the ground. Press *ctrl* *J* ⌘ *J* to duplicate the sphere layer. Press *D* to set the default palette. Now press *alt* *Shift* *Backspace* ⌥ *Shift* *Backspace* to fill the layer with black; the current foreground color.

12 Press *ctrl* *T* ⌘ *T* to invoke Free Transform. Click and drag the top-middle handle down to compress the layer into a narrow ellipse. Now hold *alt* ⌥ and drag one of the side handles in to scale it horizontally around the center. Press *Enter* to apply the changes.

HOT TIP

Holding the *Shift* key when using the shortcut to fill a layer forces the fill to honour the layer's transparency; only the circle is filled in our example. If we're using the fill dialog we would check the Preserve Transparency box to achieve the same.

13 Use the Move tool to position the shadow on the ground below the sphere. The sphere is lit from the front at the 2 o'clock position, so move the shadow a little to the left of the sphere so it looks like it's projected diagonally behind.

14 The shadow is too harsh. Let's soften it. Go to Filter > Blur > Gaussian Blur. Set the Radius to around 4 pixels. That gives us a more subtle edge. Set the blend mode to Soft Light. Now lower the opacity to around 70%.

15 Next we'll add a lens flare effect. Start by creating a new layer at the top of the stack. The Lens Flare filter can't be applied to an empty layer. Fill the layer with black. Go to Filter > Render > Lens Flare. We get this slightly confusing dialog.

16 We'll use the 50–300mm Zoom preset. Lower the Brightness a little, we don't want it too overpowering; around 80% is good. Click on the image preview. We can drag the flare around. For this effect we want to have the spots almost aligned in the center. Click OK to apply.

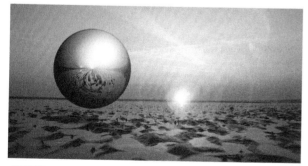

17 We used black as the fill for a reason. Set the layer's blend mode to Screen. This hides everything apart from the flare. We can use the Move tool to reposition the flares on the image. Place the brightest area over the sun. We can lower the opacity slightly if required.

18 We can give create an other-worldly appearance by adding a Photo Filter adjustment layer. We've used the Violet preset here. We can add more spheres from different areas of the background by repeating the steps manually, or with the custom Chrome Ball action.

HOT TIP

Pressing _alt_ ⌥ in a filter dialog changes the Cancel button to Reset. In this case, this only takes it back to the settings it opened with; the Lens Flare filter retains its settings each time it's used. To reset the filter completely, press _ctrl_ ⌘. This changes the Cancel button to Default.

Hollywood glamor

IMAGE: AGNIESZKA WRÓBEL (DEVIANTART.COM); UTILITY FONT: PATRICK BRODERICK (ROTODESIGN.COM)

WOULDN'T IT BE NICE to be a famous actor appearing the covers of glossy magazines? For most of us that's something that we can only dream about. There's nothing to say that we can't act out our fantasy, however. With Elements, there's always a way to achieve the images we want.

In this project we'll be doing two things. Firstly we'll change the appearance of a modern photograph to look more like it was taken in the golden age of cinema by applying a soft, high-key effect. Following that, we'll mock up a magazine cover for our glamorous star to adorn. Here we'll see how we can use guides to mark out the margin for laying out text. We'll also be using the Crop tool in a surprisingly useful way.

DOWNLOADS

Woman in veil.jpg

Utilityps.zip (Mac)
Utilitytt.zip (Win)

WHAT YOU'LL LEARN

- Converting a photo to black and white
- Applying filters ro soften a person's features
- Creating a high-key effect
- Using the Crop tool to extend the image
- Blending hard edges with a mask
- Using guides to create a layout template
- Working with different text styles

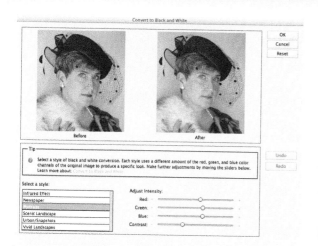

1 We'll be using destructive effects here so press `ctrl` `J` `⌘` `J` to duplicate the background layer. Now we'll make our photo black and white. Go to Enhance > Convert to Black and White or press `Shift` `alt` `B` `Shift` `⌥` `B`. We have some preset effects to choose from; Portrait works well as a starting point.

2 The preset has given us a good tonal balance. We want our image to be a little more contrasted. Increase the Contrast amount. We've used +40 here, that's around the same as the Blue slider; you can see the value by hovering the mouse over the slider control. This value will vary from image to image. Click OK to apply the changes.

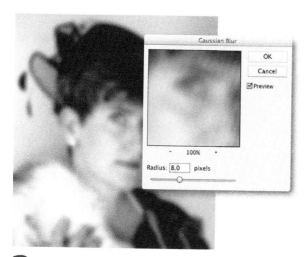

3 The next stage is to soften out the model's skin. We'll use a blur to do this. Go to Filter > Blur > Gaussian Blur. Increase the Radius to around 8 pixels. Click OK to apply the filter. Now set the layer's blend mode to Overlay. Changing the blend mode applies the softening and also gives us some more contrast.

4 Create a duplicate of the blurred layer. Go to Filters > Distort > Diffuse Glow. Set a moderate amount of Graininess. The Glow should enhance the highlights but not overpower the image. Finally, set a high Clear Amount. This controls the amount of diffusion, similar to opacity. Click OK to apply the effect.

HOT TIP

Knowing how much blur to apply and the settings of the Diffuse Glow filter isn't an exact science. There's a lot of trial and error involved, especially when you add blend modes into the mix. It can be hepful to make a note of the values as you apply them so you can refer back at a later stage.

241

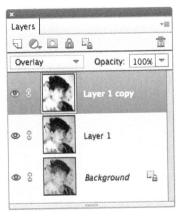

5 The initial effect is far too intense, let's tone it down a little. Set the layer's blend mode to Hard Light. Now we'll drop the opacity; an amount of 50% gives us a good compromise.

6 We have the skin looking good but we've lost a lot of detail from the rest of the image. We'll need to combine the two effect layers first. Press *ctrl* **E** ⌘ **E** to merge the layers.

7 We'll use a layer mask to selectively hide the effect from areas of the image. Grab the Zoom tool **Z**. Click and drag the selection box around the woman's eyes. Now add a layer mask by clicking its icon in the Layers panel.

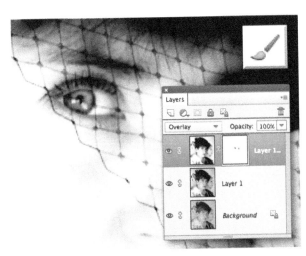

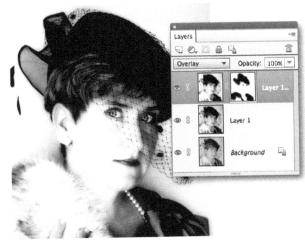

8 Grab the Brush tool **B**. Choose a small soft-tipped brush. Set the foreground color to black. Now start painting over the eyes to bring back their original detail. Be careful not to go too far outside the eyes themselves as that will reveal too much of the lighter layer below. If we do stray outside the area, we can switch to white to cover it up again.

9 Once we've finished working on the eyes, we can bring back the detail in the other areas. Press *ctrl* **0** ⌘ **0** to go back to viewing the whole image. Increase the brush size by pressing the right square bracket **]**. Now paint over the woman's hair, the hat and the coat to restore the detail.

HOT TIP

Remember that we can change the size of the brush using the square bracket keys **[** to make it smaller and **]** to make it larger. We can also change the hardness of the tip by pressing *Shift* **[** to make the brush softer and *Shift* **]** to make it harder.

10 Now let's continue and put our hollywood star onto a magazine cover. Press *ctrl* *alt* *Shift* *E* / *⌘* *⌥* *Shift* *E*. This creates a single merged copy at the top of the stack.

11 We'll need to add some space at the top for the magazine's nameplate. Press *D* to set the default colors. Select the Crop tool *C*. Drag the bounding box across the whole image.

12 Zoom out by pressing *ctrl* *–* / *⌘* *–* a couple of times. Grab the top-center handle. Drag it up so the bounding box becomes the rough dimensions a magazine format. Press *Enter* to apply the crop. Our document has been extended.

13 The extra space is white; the crop uses the background color to fill in. We will need it to match the photo. Hold *ctrl* / *⌘*. Click the new layer icon. A layer is created below the current layer.

14 Select the Paint Bucket tool *K*. Hold *alt* / *⌥*. This lets us sample a foreground color from the image. The light gray above her hat is good. Release the key. Click to fill the layer.

15 Click the woman's layer to make it active again. Create a layer mask. Grab the Brush tool *B*. Paint over the join with black using a large, soft-edged tip. The feathering gives us a perfect blend. Now press *ctrl* *E* / *⌘* *E* to merge the two layers.

HOT TIP

Using the Crop tool to extend the image seems counter-intuitive; cropping is supposed to remove areas, after all. It is, however, far easier to add space on an ad hoc basis, as we are working by eye, rather than guessing at precise dimensions as we would with the Canvas Size command.

16 We can start working on the magazine layout. Go to the View menu. Click Rulers to display them in the workspace. We can also do this by pressing `ctrl` `Shift` `R` `⌘` `Shift` `R`.

17 Click the cursor inside on the left-hand ruler. Now drag over to the right. As we do a new guide is created. Position it two tenths of an inch in from the left of the image. Click and drag from the left ruler again. This time position it two tenths in from the right.

18 Do the same from the ruler at the top to create vertical guides at the top and bottom of the image. Again, leave a two tenths margin at the edge.

19 We'll start with the nameplate. Select the Horizontal Type tool. Choose a suitable font; Palatino Linotype is good. Set the initial size to something small; we'll alter it later. Set the weight to bold.

20 Click the cursor in the blank space at the top of the image. Our magazine is going to be called Movie Time. We'll start by typing the word MOVIE. Press `ctrl` `Enter` `⌘` `Enter` to set the text.

21 We started the text off small to ensure it would fit the image. Now we'll resize it to fit. Press `ctrl` `T` `⌘` `T` to enter Free Transform. Drag the corner handles to meet the vertical guides and the top horizontal guide. Press `Enter` to apply.

HOT TIP

As well as dragging them from the rulers, we can also set up guides manually. Go to the View menu and select New Guide. From there we can specify the position and orientation precisely using the dialog box.

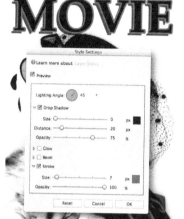

22 We deliberately didn't take the text right up to the guides to leave space for some additional styling. Go to the Effects panel. Select Strokes. Double-click the Brown Stroke 5px preset.

23 Next, select Drop Shadows. Double-click the Hard Edge preset. We'll alter the settings. Click the Blue Cog icon in the Effects panel. Change the Lighting Angle to 45˚. Click OK to set.

24 Create a new type layer. Change the font style to Bold Italic. Set the color to Pastel Red Orange. Type Time. Now hold `ctrl` `⌘` to bring up the transform box. Scale the text and align it to the right hand guide. Press `ctrl` `Enter` `⌘` `Enter` to set.

25 Create a new horizontal guide that aligns with the top of Time. Make sure you have the Utility font installed. Now add the month. Scale and align it to the new guide.

26 Click and drag to draw out a paragraph box in the corner. Set the font size to 18pt. Set the color to Pastel Red Orange for the sub-heading. Switch back to black for the rest of the text.

27 The price is a little more tricky. The Utility font doesn't have the cents symbol. Start with 36pt. Type the 15. Now change the size to 14pt. For Windows press `alt` and type 0162 on the numeric keypad. For Mac, press `⌥` `4`.

HOT TIP

If your keyboard doesn't have a numeric keypad – when using a laptop for instance – you can use the Character Map to locate and insert symbols instead. This can be found on the Start Menu under Programs > Accessories > System Tools > Character Map.

9 Art & design
Creating a wax seal

IMAGE: **COURTNEY KEENE (DEVIANTART.COM)**

We've seen how we can create depth and distance by adding subtle shading to our artwork; changing a simple flat object into a three-dimensional one. The same is true for creating raised surfaces.

In this project we'll first create a design using shapes and text layers. We'll then process the image using the Lighting Effects filter. The filter simulates a variety of different lighting styles, allowing us to precisely control its appearance. It also has a very useful feature called texture mapping. This uses a selection (alpha channel) to create the impression that the surface of the image has raised areas; bright areas appear high and dark areas seem to be recessed; or vice-versa. We'll use this feature to create a traditional wax seal using the black and white logo.

DOWNLOADS

Parchment.jpg

WHAT YOU'LL LEARN

- Creating scalable artwork using shapes and text
- Distorting with the Liquify filter
- Working with alpha channels
- Creating selections from masks
- Creating three-dimensional objects from flat artwork

1 Start by opening the parchment image. We'll create our artwork centered to make it easier to work with. Go to View > New Guide. Create one vertical guide at 50%, then create a horizontal guide, also at 50%.

2 Grab the Custom Shape tool **U**. Select the Ornaments presets from the shape picker. Choose the Fleur-De-Lis preset. Place the cursor in the center of the guides. Hold `alt` `Shift` `⌥` `Shift`. Now drag out the shape.

3 Switch the the Text on Shape tool **T**. Choose Ellipse. Set the font to Trajan Pro. Set the style to bold. A size of 18pt is right for this image. Click the path and Type out the text. More on this tool can be found on (page 275).

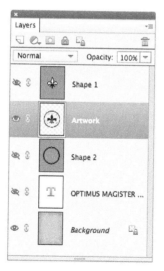

4 Switch back to the Custom Shape tool. This time choose the Circle Thin Frame preset from the Shapes presets. Drag out the shape as before. Leave sufficient space outside the text to create the uneven effect.

5 Hide the background layer. Press `ctrl` `alt` `Shift` `E` `⌘` `⌥` `Shift` `E`. This creates a merged copy of our artwork. Hide the component layers. Make the background layer visible again.

6 Go to Filter > Distort > Liquify. Select the Bloat tool **B**. Set the brush size a little larger than the outer ring. Go around the circle, clicking and dragging to distort the edge. This gives the effect of the wax being spread out.

HOT TIP

When using the shape tools we can click the From Center option in the Tool Options panel to draw the shape from the center of the cursor position. In this case, as with the constrain proportions option for the Marquee tools, when we use the modifier keys they have the reverse effect.

7 Now for the wax effect. Press *ctrl ;* *⌘ ;* to hide the guides. Add a layer mask to the artwork layer. Hold *alt* ⌥. Click the mask's thumbnail to edit it as an alpha channel. Go to Filter > Render > Clouds.

8 We need to blend the tones and soften the overall effect. Go to Filter > Blur > Gaussian Blur. Set the radius to around 25 pixel for this size image. This will produce an uneven surface for the wax.

9 Hold *ctrl* *⌘* and click the artwork's thumbnail to load its selection. Make sure black is the background color. Press *ctrl Backspace* *⌘ Backspace* to fill the selection. Press *ctrl D* *⌘ D* to deselect.

10 Open the Gaussian Blur dialog again. This time we want a much more subtle blur. A radius of around 4-5 pixels will be enough. This will create smooth rounded edges when we apply the effect.

11 Hold *ctrl* *⌘*. Click the mask's thumbnail. This loads the layer's luminance selection and will be the texture map. Go to Select > Save Selection. Give the selection a name. Click OK. Now Deselect.

12 Hold *Shift*. Click the mask to hide it. Click the artwork's thumbnail. Grab the Magic Wand *A*. Click Outside the edge of the artwork. Press *ctrl Shift I* *⌘ Shift I* to invert the selected area. Hide this layer.

HOT TIP

The amount of blur we apply to the artwork affects the steepness of the raised areas when we apply the Lighting Effects filter. A light blur would give us sharp, angular effect. Applying more blur would create a more gradual sloping appearance.

13 Create a new layer. Fill the selection with white. Go to Filter > Render > Lighting Effects. Drop down the Texture Channel list at the bottom of the dialog. Choose the name we gave our selection.

14 Select Omni as the light type. This gives a more even spread. Go to the preview window. Click and drag one of the handles to make the light larger. This is too bright. Lower the intensity to around 8.

15 Set the Gloss to 100. Set the Material to -100. This gives us a more shiny appearance. Uncheck White is High; the artwork now appears raised up. Increase the height to 100. Click OK to apply the effect.

16 The effect is good but it's still a little matt; wax has a mixture of flat and shiny areas.. Go to Filter > Artistic > Plastic Wrap. Use the sliders to add a more moulded effect. Click OK to apply.

17 The edge is a little ragged. Go to Select > Refine Edge. Increase the radius to around 3–4px. Set the smoothing to 100. Add a slight feather. Set Shift Edge to -100. Set the Output to New Layer. Click OK to apply.

18 Open the Hue/Saturation dialog **ctrl U** **⌘ U**. Click Colorize. Increase the saturation and lower the lightness a little. Finally, add a small drop shadow layer style. Now we can resize the seal to fit the page.

HOT TIP

When using the shape tools we can click the From Center option in the Tool Options panel to draw the shape from the center of the cursor position. In this case, as with the constrain proportions option for the Marquee tools, when we use the modifier keys they have the reverse effect.

9 Art & design
The Graphic Novel filter

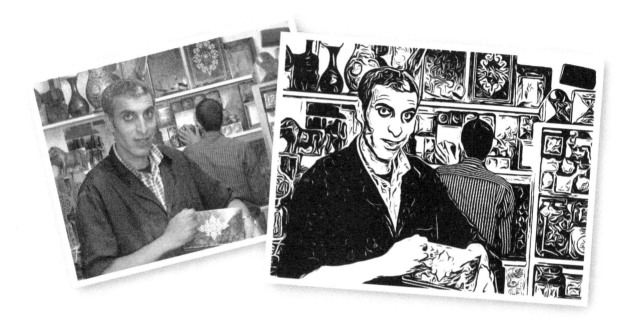

SOME GREAT NEW FILTERS have been added in Elements 11. One of the most impressive is Graphic Novel. As the name suggests, it converts a photo into a monotone line drawing.

Here we'll see just how good the filter is by applying it to a photo of a Moroccan shop. The filter's controls let us fine-tune the effect. We're able to bring out the detail of the main subject, the shop owner, whilst keeping the background a little less distinct, which prevents it from looking too cluttered.

As with any filter of this kind, however, the results will vary greatly from image to image. Some will turn out much better than others. One way the filter excels is it's really forgiving about the quality of the original photo. It will work just as well with a high-resolution image as it will with one from a cell phone; lower quality images are sometimes better, in fact!

DOWNLOADS

Moroccan shop.jpg

WHAT YOU'LL LEARN

- Using the presets in the Graphic Novel filter
- Using the manual controls to fine-tune the result

1 Go to Filter > Sketch > Graphic Novel. Its dialog opens. There are four presets and a set of manual controls. The presets are always a good place to start. We found Twisted Plot to be the best.

2 Let's fine-tune the image. We'll start with Darkness. This determines how much of the darker areas to bring in to the result. We've increased it very slightly to add detail to the man's face.

3 Next is Clean Look. This controls the level of fine detail the filter includes. We'll lower it slightly. If we go too far back, it's too intense. Here we have a good balance; leaving a hint of detail in his jacket.

4 The next slider is Contrast. If we lower it we begin to introduce more gray into the image. We want our effect to be purely black and white, so we'll leave this at its maximum setting.

5 The final slider is Thickness. This controls the thickness of the finer detail in the image. Again, this setting only needs minor adjustments. We've increased it slightly from the preset's setting.

6 Possibly the most important setting is Smoothness. This softens the jagged edges of the image. It has two levels, applied by clicking the Add button. We've applied it once here.

HOT TIP

It's alway best to have the preview at 100%, especially with larger image sizes where some of the detail may not show up when set to fit the view. To do this, press the 1:1 button at the bottom-left of the dialog. To go back to the full view, click the Fit to View button.

9 Art & design
Notebook sketching

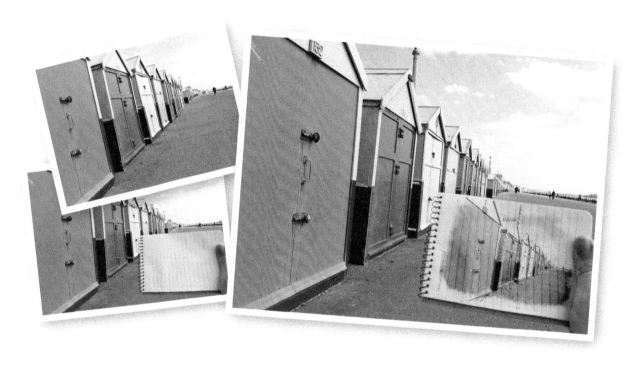

T HERE HAS BEEN A RECENT TREND where people make a sketch of their location. They would then hold it up against the real thing and take a photo of it. For those of us that lack the artistic skill to produce one of these fabulous works, we can use some digital trickery to achieve a similar effect.

The key to creating the effect is taking two photos at the time. One of the background on its own, the other needs to be one with us holding a blank notebook or sketch pad. The two scenes don't have to be identical, as long as the subject is visible in both.

The next stage is to apply a painterly effect to the first photo, then add it to the one with the notebook. We can transform it down to fit the page, then blend it in to look like it was created at the time.

DOWNLOADS

Notebook sketching (folder)

WHAT YOU'LL LEARN

- Importing an image into a document
- Creating an outline with the Graphic Novel filter
- Using multiple filters to build an effect
- Using Free Transform on linked layers
- Using special effect brushes with a mask

1 Begin by opening the Huts and notebook image. Now go to File > Place. Select the Huts normal image and click Place. As the images are the same size, we can press *Enter* to commit. As the layer is currently a Smart Object, we'll need to turn it into a regular layer before we can edit it. Go to Layers > Simplify Layer.

2 Press *ctrl J* *⌘ J* to make another copy of the layer. Double-click the top layer's label in the Layers panel. Rename it to Huts outline. Now do the same for the layer below. This time, name it Huts Paint. It's good practice to name our layers, even when we only have two or three.

3 The first part of the effect is to create a sketched outline. Click on the Huts outline layer in the Layers panel to make it active. Go to Filter > Sketch > Graphic Novel. Begin by selecting the Fine Detail preset. This gives us a good starting point for the sketched outline effect. We won't make any adjustments here. Click OK to apply the effect.

4 Open the Graphic Novel filter again; we need to adjust its settings so use its full menu path instead of running it from the last filter option. All we need to do is remove the heavy black areas. Click the Fine Detail preset again. Lower the Darkness slider to around -0.3. Now apply Smoothness once to remove the jagged edges. Click OK to apply.

HOT TIP

Some of the best techniques come from happy accidents. Creating the outline was one such time. Whilst writing this project it was difficult to get a good balance of the solid black and the lighter lines. I inadvertently ran the filter on the same layer twice, resulting in a perfect effect.

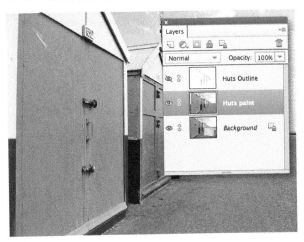

5 Hide the Huts outline layer for now by clicking its visibility icon in the Layers panel. Now click the Huts paint layer to make it active. Make sure the default foreground and background colors are selected by pressing **D**. Many of Elements' filters use them as a basis; the results can be unpredictable when other colors are selected.

6 We want the appearance of a color wash with very little detail. Go to Filter > Artistic > Paint Daubs. Set the Brush Size to around 22. Lower the Sharpness to 0. Set the Brush Type to Wide Blurry. Click OK to apply the filter.

7 Press *ctrl J* *⌘ J* to Duplicate the Paint layer. Now go to Filter > Artistic > Palette Knife. This part of the effect will give us a slightly uneven appearance, as though the paint has spread on the paper. Set the Stroke Size to 25. Now take the Stroke Detail to its maximum. Increase the Softness to its maximum as well. Click OK to apply.

8 The edges of the effect are still a little harsh. Go to Filter > Blur > Gaussian Blur. Set the Radius to around 2 pixels. Click OK to apply the blur.

9 Set the blurred layer's blend mode to Lighter Color. This overlays the spread effect. Press *ctrl E* *⌘ E* to merge the layers together.

HOT TIP

As with all the filters in Elements, the amount they affect the image depends greatly on its size. Some aren't powerful enough when applied to very large photos, even at maximum strength. Running the filter a couple of times can often give better results.

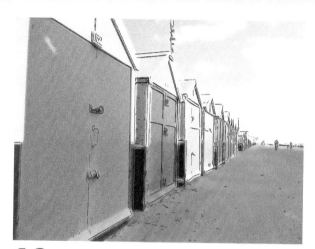

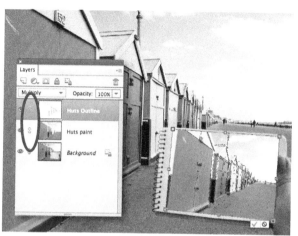

10 Click on the Huts Outline layer in the Layers panel. Make it visible again. Now change its blend mode to Multiply. This removes the white background. We now have the ink outlines overlaying the painted layer. We won't merge these layers as we need to be able to leave the ink outlines intact later on.

11 Click the chain icon next to the Paint layer's thumbnail. Press *ctrl* *T* *⌘* *T* to enter Free Transform. Holding *ctrl* *⌘* click and drag the corner points in to distort the layer down to fit the page. Because we linked the layers together. both are transformed at the same time. Press *Enter* to commit the changes.

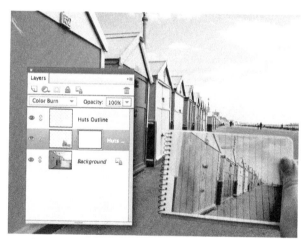

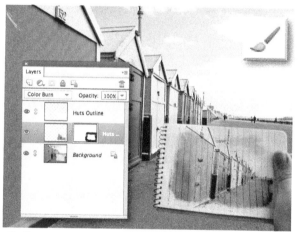

12 We need to be able to see the page beneath. Click the Huts Paint layer to make it active. Set the its blend mode to Color Burn. Straight away this gives us a painted over effect. The edges are far too square to be convincing. We need to make them more uneven. Create a layer mask on the Paint layer.

13 Grab the Brush tool *B*. Go to the brush picker. Select the Wet Media Brushes. Choose the Watercolor Light Opacity preset. Make sure black is the foreground color. Now start to paint around the edges. The texture of the brush gives us a nice uneven pattern. Make sure there's no overlap on the thumb.

HOT TIP

The brush we chose to paint out the mask has a built-in opacity setting. We don't need to alter the main brush opacity as well. We can paint over the same area a few times to remove it completely, or leave it with a slightly layered effect.

Wanted: preferably alive

IMAGE: **ABSOLUTVISION.COM**

P UTTING FRIENDS AND FAMILY on a wanted poster is always good fun; it would be very remiss of us not to include a project on making one. As we're creating the whole poster from scratch, we have full control over the design and appearance. The finished image can be used simply as a poster, or alterered to make a great birthday card.

We'll be using several techniques to put the poster together; we'll be making aged paper, using guides to mark out margins and as a basis for adding centered text. We'll also see how to create a faded, low-quality photo from a sharp, digital image. Not forgetting a great way to add beard stubble to someone's face!

DOWNLOADS

Outlaw.jpg

WHAT YOU'LL LEARN

- Making an old paper texture (page 257)
- Adding beard stubble (page 258)
- Creating a grainy, faded photo (page 259)
- Creating precisely positioned guides (page 260)
- Aligning text to guides (page 260)
- Creating composite layers (page 261)
- Softening text with a stippled edge effect (page 261)

1 We'll start by making the paper. Create a new blank file *ctrl* **N** **⌘ N**. For this project use a width of 610 pixels and a height to 800 pixels. Click OK. Go to Edit > Fill Layer. Choose 50% Gray as the content. Click OK.

2 Press *ctrl* **J** **⌘ J** to duplicate the gray layer. Go to Filter > Noise > Add Noise. We don't need a lot, around 2–3% is enough. Set the Distribution to Gaussian. Click Monochromatic. Now click OK to apply.

3 Using a separate layer means we can further adjust the effect. Set the blend mode to Soft Light. We still keep the same amount of noise but it's now more subtle. Press *ctrl* **E** **⌘ E** to merge the layers.

4 Press *ctrl* **U** **⌘ U** to open the Hue/Saturation dialog. Click Colorize. Alter the Hue, Saturation to create a sandy color. Increase the Brightness a little but don't overdo it as it will lose the texture. Press OK.

5 Press **I** to select the Color Picker tool. Click the layer to sample the color as the foreground. Click the background color chip in the Toolbox. Click on the layer again. Select a slightly darker tone. Click OK to set the color.

6 Go to Filter > Render > Clouds. This makes the color less uniform. Grab the Burn tool **O**. Set the Range to Midtones. Now using a large soft brush, paint an uneven border around the edge of the paper.

HOT TIP

It's usually best not to use the Lightness slider in the Hue/Saturation dialog, especially if we are adjusting a photographic image; it usually results in the image being washed out. It's far better to make the color adjustments then use Levels to control the brightness.

7 Go to File > Place. Select the Outlaw file. Click Place. Press *Enter* to set the layer down. Go to Layer > Simplify Layer to make the layer editable. Our outlaw should look a little more unkempt. Let's roughen him up a little.

8 Create a new layer above the outlaw. Grab the Brush tool **B**. Select a fairly large, soft tip. Set the foreground color to mid-gray. Paint the shape of a beard over his face. We don't need to be too precise at this stage.

9 Open the Noise filter again. This time push the amount up higher. Around 15% for this size image. The filter will only apply where there are pixels, so it's only affecting the beard area we drew.

10 Grab the elliptical Marquee tool **M**. Click the cursor on the bridge of the nose. Hold *alt* to force the area to draw from the center. Drag a selection out that's a little larger than the man's face.

11 Go to Filter > Blur > Radial Blur. Set the method to Zoom. We only need a tiny amount; around 3–5%. Click OK. We now have the beginning of an unshaven stubble effect. Press *ctrl* D *⌘* D to deselect.

12 Set the layer's blend mode to Hard Light. Open the Levels dialog *ctrl* L *⌘* L. Increase the shadows and midtones slightly to darken the effect. Click OK to apply. Press *ctrl* E *⌘* E to merge the layers.

HOT TIP

As well as simply constraining filters, creating a selection can also affect the way the filter behaves. In this instance centering the circular selection on the man's face caused the blur filter to radiate outward. This give us a more realistic effect as the stubble follows the direction of the face.

13 Photography of 100 years ago wasn't as high quality as modern cameras. Press `ctrl` `Shift` `U` `⌘` `Shift` `U` to remove the color. Go to Filter > Blur > Blur More. This softens the image slightly.

14 Next we'll add some grain. Go to Filter > Artistic > Film Grain. Set the amount to 6. Keep the Highlight area fairly low at around 4. The Intensity needs to be fairly low as well; around 2 is good. Click OK to apply.

15 We need to scale the photo down to fit the text in. Press `ctrl` `T` `⌘` `T` to enter Free Transform. Hold `alt` `⌥` to scale around the center. Now drag one of the corner points in. Around half the size works well.

16 We'll give the image the appearance that the ink has faded. Set the layer's blend mode to Color Burn. This gives us a burnt sepia effect. It also allows some of the paper texture to show through.

17 We've lost the photo's solid background. Press `ctrl` `J` `⌘` `J` to duplicate the layer. Set the blend mode to Color Dodge. The effect is far too harsh so lower the opacity; around 15% is enough of a balance.

18 We'll add a border. Load up the photo's selection. Create a new layer. Go to Edit > Stroke. Set the color to black. A width of around 5px. Set Location to Inside. Click OK. Press `ctrl` `D` `⌘` `D` to deselect.

HOT TIP

Although we can add a stroke with Layer Styles it wouldn't work in this instance. The only strokes available by default are outer strokes. These produce rounded corners on angled objects and would look ridiculous. We also need to keep the border separate in order to blend it later.

19 Now we'll add the text. First we'll create some guides. Go to View > New Guide. Much of the text will be centered so we'll start with a central guide. Select Vertical. Now type 50% in the position box. Click OK.

20 Now we'll add the margins. Open the New Guide dialog again. Select Vertical. Enter 5% for the position. Click OK. Add another vertical guide, this time at 95%. Repeat this twice more for the horizontal guides.

21 We'll start with the headline. Select the Horizontal Type tool . We're using Chapparal Pro. Set the style to Bold. Set the size to 24pt for now. Click on the left margin guide near the top. Type the headline.

22 Hold *ctrl* ⌘. We get the transform box. Click and drag a right corner handle to the right margin. Click and drag inside the box to align the text to the top guide. Press *ctrl* *Enter* ⌘ *Enter* to commit the text.

23 Change the font size to 12pt. Hold *Shift*. Click the cursor on the center guide below the headline. Change the text alignment to centered . As we type the sub-heading it flows either side of the guide.

24 Commit the sub-heading. Now continue adding the rest of the text below the photo. Note the change of fonts: we used Trebuchet regular 8/6pt for the captions and Caslon Pro bold 19pt for the reward details.

HOT TIP

The reason for holding *Shift* when we added the sub-heading is to force Elements to create a new text layer at the cursor position. If we hadn't done this, we would have reactivated the headline text layer again. We can see how far a text layer extends outside of the type by the size of its bounding box.

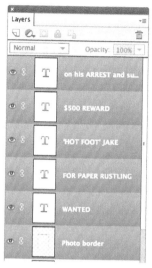

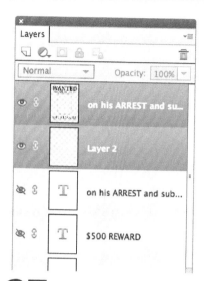

25 Next we'll roughen the edges of the text and photo frame. Go to the Layers panel. Click the top text layer. Hold *Shift*. Click the Frame layer. Press *ctrl* *alt* *E* *⌘* *⌥* *E* to create a merged copy.

26 Hide the original text and frame layers by clicking their visibilty icons. Set the composite layer's blend mode to Dissolve. This gives us a speckled appearance to the text and frame.

27 The result is a bit harsh. If we try to blur it now it will only increase the effect. Create a layer below the composite. Group it with the composite layer. Now press *ctrl* *E* *⌘* *E* to merge the layers together.

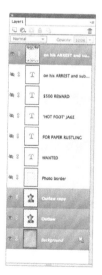

28 Merging the layers has created a normal layer but with the dissolve effect intact. Go to Filter > Blur > Gaussian Blur. Set a very low radius; around 0.5 pixels. Click OK. Lower the opacity to around 70%.

29 To finish we'll make a new document comprising all the poster components. Hold *ctrl* *⌘*. Select the paper background, the two photo layers and the composite text layer to group them together.

30 Press *ctrl* *alt* *Shift* *E* *⌘* *⌥* *Shift* *E* to create a merged copy. Go to Layer > Duplicate Layer. Select New as the destination. Give the document a name. The name of the outlaw is a good idea. Click OK.

HOT TIP

Although it can become cluttered, it's preferable to create merged copies of layers instead of flattening the image, as we may decide to edit the image later. This is especially important with projects such as this where we can go back and change the name and photo to use again for different people.

9 Art & design
Rapid stained glass

IMAGE: **WWW.COLEBROTHERS.COM**

STAINED GLASS has been an artform for centuries. From the huge ornate windows of churches and cathedrals to the understated adornment of an urban door, people love its radiance and color.

You may have discovered the Stained Glass filter in Elements; its results are passable but tend to resemble a mosaic more than the traditional effect. In this tutorial, we'll use a real stained glass pattern template as our starting point. We'll use a combination of color fills, filters and layer styles to create the effect.

The artwork we used here was from *http://www. colebrothers.com/articles3/glasspatterns2.html*. There are numerous places to get templates online and in art stores. Kids' coloring books are another useful resource. You could, of course, create your own using pen and paper and scanning it in, or tracing the outline of an image in a photograph and creating the base artwork from that.

DOWNLOADS

Bird artwork.jpg

WHAT YOU'LL LEARN

- Using black and white artwork as a template
- Creating realisic frosted glass and leading effects

1 Grab the Magic Wand **A**. We need to select the black outline. Uncheck Contiguous in the Tool Options panel to disable it. Now click anywhere on the outline. The whole outline is selected at once.

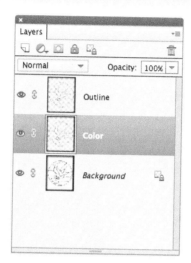

2 Press *ctrl* **J** ⌘ **J** twice to create two copies. Click the first copy in the Layers panel to make it active; we've labeled it Color and the second copy Outline. Check Contiguous again in Tool Options to enable it.

3 Click inside the bird's head to select it. Go to Edit > Fill Selection. Select Color as the content. We'll pick a flame orange. Click OK to set the color. Click OK on the Fill dialog to apply the fill the selection.

4 Press *ctrl* **D** ⌘ **D** to deselect. Click a different area pick another color and fill that as before. Repeat the process for the rest of the image. Choose bright, slightly over-saturated colors. They will be toned down later.

5 Add a new layer above the color layer. Go to Filter > Render > Clouds. Now select Filter > Distort > Glass. Set the texture to Frosted. A Smoothness of around 2–3. Increase the distortion to around 12. Click OK to apply.

6 Change blend mode to Multiply. Click the Outline layer's thumbnail. Go to Effects > Styles > Wow Chrome. Double-click the Shiny Edge preset. Open the style options. Lower the bevel to 4px. Click OK to apply the changes.

HOT TIP

At first glance, many of the special effects styles that are shipped with Elements appear to have little practical use. If you were to apply Wow Chrome to a normal layer, it wouldn't look that good. As we saw here, however, it makes a fantastic edge effect; in fact, on larger images, they look even better.

263

Blueprint for design

Kids have wonderful imaginations and can come up with all kinds of fantastic inventions – such as this idea for a failsafe alarm clock involving boiling water, melting ice cubes and a tipping glass at the end of the process.

The trouble is, these designs are always sketched on whatever materials come to hand – in this case, a page torn from a spiral-bound notebook. We're going to see how to turn this sketch into an official-looking blueprint, but first, we need to find a way to get rid of the lines in the background of this ruled paper.

Next we'll create a grid pattern and save it as a pattern preset. Not only does this make it easy to add a grid to this image, we can use it over and over for different projects and being a tiled pattern its size is infinite and will cover any image size.

DOWNLOADS

Drawing.psd

WHAT YOU'LL LEARN

- Cleaning up a scanned drawing
- Creating a re-usable tiled grid pattern
- Hiding areas of a pattern with a mask

1 Open the drawing image. Go to Enhance > Adjust Lighting > Brightness/Contrast. Drag both sliders all the way to the right. This makes the rules feinter and also removes the torn edge on the left.

2 We'll make the image pure black and white. Start by removing the color *ctrl* Shift U ⌘ Shift U. Now go to Filter > Adjustment > Threshold. We don't need to adjust the settings. Click OK to apply.

3 The adjustment has left the artwork jagged. Go to Filter > Blur > Blur More. Open the Levels dialog *ctrl* L ⌘ L. Drag the Shadows slider to the right. As we do, the image becomes smoother and more defined.

4 Now we've cleaned up our drawing, we can start to create our blueprint. First we need to change the artwork from black to white. Go to Filter > Adjustments > Invert or press *ctrl* I ⌘ I.

5 Set the blend mode of the drawing layer to Screen. The drawing diappears. Click the background layer in the Layers panel. Go to Edit > Fill Layer. Select Color as the Content. Choose a midtone blue. Click OK.

6 The white drawing is a little harsh. Make the drawing layer active again. Open the Hue/Saturation dialog *ctrl* U ⌘ U. Click Colorize. Lower the lightness a little. Now adjust the hue to a pale blue. Click OK to apply.

HOT TIP

The combination of Brightness/Contrast and Threshold usually does a good job of removing the rules on note paper. If there are any stray remains, we can use the Brush tool to paint them out using either black or white to match the background color.

9 Art & design

7 Our blueprint is looking good. The next task is to add a grid overlay. We'll start by hiding the drawing layer to avoid any distraction. Create a new layer above the background layer.

8 Grab the Rectangular Marquee tool **M**. Go to the tool options. Set the Aspect to Fixed Size. Enter a width and height of 8px. Position the cursor around the middle of the document. Click once to create the selection.

9 Go to Edit > Stroke Selection. Set the width to 1 pixel. Set white as the color. Set the location to Inside. Click OK to apply the stroke. Grab the Zoom tool **Z**. Enlarge the image so it's easier to see the square.

10 Switch to the Move tool **V**. Hold *alt* ⌥. Now press the right arrow key once. This creates a duplicate of the square. Release the *alt* ⌥ key. Nudge the square over with the arrow key so the edges overlap.

11 Repeat the previous step to create another two squares. Press *ctrl* **D** ⌘ **D** to deselect. Now press *ctrl* **A** ⌘ **A** to select all. Do the same as before, this time nudging down to create four new rows.

12 Deselect again. Lower the layer's opacity to around 50%. Create a layer above the squares. Grab the Rectangular Marquee again. Set the Aspect back to Normal. Draw a selection around the entire square.

HOT TIP

For a more accuracy we can use Elements' built-in grid as a guide. Go to View > Grid. Open the Preferences dialog *ctrl* **K** ⌘ **K**. Go to Guides & Grid. We can change the number of subdivisions and the distance between the lines; this happens in real time so we can judge the size of our grid.

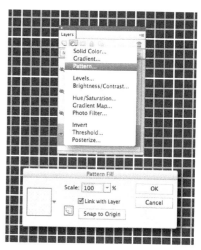

13 Stroke the selection as before. Deselect. Now make a new selection around the square but stop just inside the right and bottom edges. This will ensure we create a perfect repeating pattern.

14 Hide the background layer. Go to Edit > Define Pattern from Selection. We've named it with the dimensions of the square. Click OK. Deselect. We can hide or discard the two squares layers now.

15 Make the background layer visible again. Click its thumbnail to make it active. Click the split circle icon at the top of the Layers panel. Choose Pattern. The preset we just made is set by default. Click OK.

16 Press *ctrl* **O** **⌘ O** to fit the image to the screen. Lower the opacity of the pattern layer to 25%. This gives the grid a lighter appearance. Now make the drawing layer visible and active again.

17 Grab the Move tool **V**. Reposition the drawing so it's centered on the document. Now use the Rectangular Marquee tool to mark out a selection for the designer credit. Place it just inside the bolder lines.

18 Click the pattern layer's mask thumbnail. Fill the selection with black. This knocks a hole in the grid. Switch to the Type tool **T** to add the text. Use a plain font such as Arial. 8pt fits nicely here.

HOT TIP

Naming the pattern preset with its dimensions makes it easier to spot in the presets picker. This is especially useful if we have created several presets with a variety of subdivisions and scales to use with different sizes of image.

Neon signs with layer styles

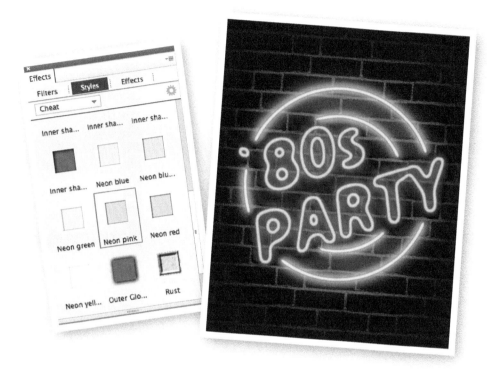

NEON SIGNS ARE EYE-CATCHING. We see them everywhere from the immense billboards of Broadway all the way down to the flashing displays in fast-food restaurants' windows.

In this project we'll use a neon effect as the basis for an invitation to an '80s party; it was the neon decade, after all.

We'll be working with the little-used Type Mask tool here to make the text. This creates a selection instead of a text layer; we'll use the Refine Edge tools to round off the sharp edges to give us the familiar tubing effect.

We also need the brightly colored glow, of course. For this we'll use layer styles. Elements has built-in neon styles but they are not particularly convincing. For this reason, we have created a set of our own; these can be downloaded from the website. Load them in with the Preset Manager. More information on this can be found at the end of the book.

DOWNLOADS

Brickwork.jpg

Cheat Styles.asl

WHAT YOU'LL LEARN

- Creating artwork from selections and strokes
- Using the Type Mask tool
- Rounding off hard edges
- Working with custom layer styles

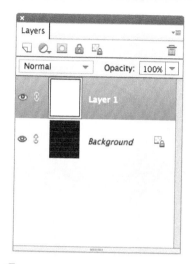

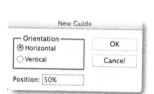

1 Open the Brickwork file. Go to the Layers panel. Click the New Layer icon. Press *ctrl* *Backspace* ⌘ *Backspace* to fill the layer with white. This makes it easier to see than working against the bricks.

2 Go to View > New Guide. Enter 50% for the position. Click OK. Create another guide, this time select Horizontal. Enter 50% for the position as before. Click OK. We now have a marker for the center of the document.

3 Grab the Elliptical Marquee **M**. Position the cursor at the center of the guides. Hold *alt* ⌥ and drag out a selection. Hold *Shift* to constrain it to a circle. Make it fairly large but leave a reasonable border space.

4 Create a new layer. Go to Edit > Stroke Selection. Set the Width to 10 pixels; this will be the thickness of our neon tubing. We can leave the color as black. Set the Location to Center. Click OK to apply the stroke.

5 Go to Select > Transform Selection. Hold *alt* ⌥ to scale around the center. Click and drag one of the corner handles towards the middle of the document to make an inner circle. Press *Enter* to commit the changes.

6 Go to Edit > Stroke Selection again. The settings are retained from the last time we used the command so we can just click OK to apply the stroke again. Press *ctrl* *D* ⌘ *D* to deselect.

HOT TIP

We used the Transform Selection command here instead of duplicating and scaling the first circle layer. If we had done that the width of the stroke would also be scaled. By scaling the selection then applying the stroke we ensure that the two circles stay at the same width.

7 Grab the Horizontal Type Mask **T**. We need a strong typeface; Myriad Pro is good. Set the style to Bold Italic. Set the size to 48pt. Set the Leading to 44pt. This will ensure the lines are spaced correctly.

8 Create a new layer. Click the cursor on the left of the document; we won't worry about positioning it at the moment. Type the text pressing *Enter* to split it onto two lines. Press *ctrl Enter* *⌘ Enter* to commit the text.

9 Instead of getting a text layer, we have a selection. Go to Select > Transform Selection. Rotate, scale and position the text to fit in the center over the circles. Press *Enter* to commit the changes.

10 The ends of the letters are too angular; neon tubing is curved. Open the Refine Edge dialog. Set the View mode to Black & White **K**. This will allow us to see the adjustments properly.

11 Set the Smooth slider to its maximum. This rounds the ends off but they're fuzzy. Set the Contrast to around 50% to sharpen it. Set the feather to around 2px. Make sure Output is set to Selection. Click OK

12 The text has a much rounder appearance now. Go to Edit > Stroke Selection once more. Click OK to apply the same settings from earlier. We have a smooth curved tubing effect. Press *ctrl D* *⌘ D* to deselect.

HOT TIP

The font we use is important with this technique. It's best to stick to a fairly plain, bold style. Fancy text with lots of intricate detail might not work so well as its edges will be prone to losing definition when we apply the rounding effect.

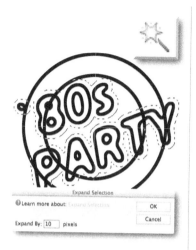

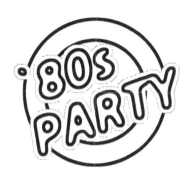

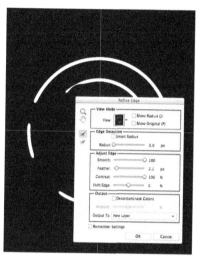

13 Grab the Magic Wand **A**. Make sure Contiguous is checked. Click outside of the text. Inverse the selection *ctrl* *Shift* *I* ⌘ *Shift* *I*. Go to Select > Modify > Expand. Set a value of 10 pixels. Click OK.

14 Click the circles layer thumbnail to make it active. Press *Backspace*. We now have a gap between the words and the circles. Hold *ctrl* ⌘. Click the circle layer's thumbnail to load its selection.

15 Open Refine Edge. This time set Smooth and Contrast to maximum. Set Feather to 2 pixels. Change the Output to New Layer. Click OK. This gives us a layer with the modified circles. The original layer is hidden.

16 Now to add the neon. Go to the Effects Panel. Select Layer Styles > Cheat. Double-click the Neon Blue preset. Click the text layer's thumbnail to make it active. Apply the Neon Pink preset.

17 Our neon doesn't look very impressive at the moment. When we turn off the white layer to reveal the bricks below, however, we get the full effect of the glowing edge around the tubing.

18 We can enhance the effect by creating a new layer above the bricks and using a soft black brush set to a low opacity to paint a border around the edge. All that remains is to add the rest of the flyer's text.

HOT TIP

There are often pieces of the outline left where the expanded selection didn't go right across. This can detract from the effect slightly; here we had a narrow strip just above the 0 in '80s. It was easily removed using the Eraser tool **E** with a very small brush tip.

9 Art & design
You spin me round

IMAGE: **GUITARIST - ABSOLUTVISION.COM**

NOSTALGIA ISN'T WHAT IT USED TO BE. The current generation may well look at the image above with indifference; it's something only their parents and enthusiasts can speak of with adoration. The vinyl record is still an iconic object, though; depicting days of listening to warm tones and soft crackles.

In this project we'll 'go retro' and create a design based on a 7-inch single. We'll be creating the from scratch (if you'll pardon the pun) using layers, selections and filters. We'll follow on by adding some label artwork; we'll see how to place text on a circular shape, as well as creating a graphic object and using masks to place objects in front and behind of one another.

We've also put together two actions; the first creates the record in the tutorial, the second is a variation that makes a 12-inch LP, complete with multiple tracks. Instructions on installing and using actions can be found at the back of the book.

DOWNLOADS

Rockin Rick.jpg

Vinyl record 7″

WHAT YOU'LL LEARN

- Combining filters to create circular grooves (page 273)
- Adding radiating highlights (page 274)
- Creating text on a circle (page 275)
- Creating a stylized graphic effect (page 276)
- Selectively hiding areas to create dimension (page 277)

1 Begin by creating a new image file. Go to File > New > Blank Document. The dimensions used here are 755 for the width and 540 for the height. The resolution can be left at its default setting. Make sure the Background is white. Click OK to create the new document.

2 Create a new layer. Grab the Elliptical Marquee tool *M*. Hold *Shift* to constrain the proportions. Draw out a large circular selection in the center of the image. Press *D* to select the default palette. Now press *alt* *Backspace* *⌐* *Backspace* to fill it with black.

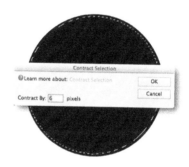

3 Go to Select > Transform Selection. Hold *alt* *⌐* to force the scaling from the center. Reduce the selection down to roughly the size of the record's spindle hole. Press *Enter* to commit, then press *Backspace* to delete the pixels. Press *ctrl* *D* *⌘* *D* to deselect.

4 Before we add the texture we need to leave space for the lead-in. Duplicate the base layer *ctrl* *J* *⌘* *J*. Hold *ctrl* *⌘*. Click new layer's thumbnail to load its selection. Now go to Select > Modify > Contract. A value of around 6 pixels works well on this size of image.

5 Go to Filter > Noise > Add Noise. Set an Amount of 400%, the Distribution to Uniform and check Monochromatic. Click OK. Now go to Filter > Blur > Radial Blur. Set the Amount to 100. Set the Method to Spin. Set the Quality to Best. Click OK to apply.

6 The result is is too light. Open the Levels dialog *ctrl* *L* *⌘* *L*. Drag the Shadows slider to the left edge of the histogram. Drag the Highlights slider to the right edge of the histogram. Lower the opacity of the layer to around 20%. Leave the selection active.

9 Art & design

7 Next we'll create the lead-out area. Go to Select > Transform Selection. Hold `alt` `⌥`. Now scale the selection down. Reduce it to around 65%. Press `Enter` to commit the changes. Fill the selection with black. Press `ctrl` `D` `⌘` `D` to deselect.

8 Create a new layer. Grab the Brush tool `B`. Select a medium-sized soft tip; around 70px here. Set the foreground to white. Now create three vertical stripes by holding `Shift` as you paint downward. Release `Shift` after each one, otherwise they will be joined together.

HOT TIP

When we scaled down the selection to create the label, the hole in the center was also scaled, making it a little too small. To fix this, click on the base layer's thumbnail. Now grab the Magic Wand `A`. Click in the center of the record to select the original hole. Click back onto the label's thumbnail and hit `Backspace` to make the hole the same size.

9 Go to Filter > Distort > Polar Coordinates. Select Rectangular to Polar and click OK. Press `ctrl` `alt` `T` `⌘` `⌥` `T`. This duplicates the layer as it enters Free Transform. Rotate the copy 180°. Now position it at the top of the record. Press `Enter` to commit the changes.

10 Press `ctrl` `E` `⌘` `E` to merge the two layers. Lower the opacity to around 30%. Now hold `ctrl` `⌘` and click the base layer's thumbnail. Press `ctrl` `Shift` `I` `⌘` `Shift` `I` to inverse the selection. Press `Backspace` to delete the excess area outside.

11 Press `ctrl` `Shift` `I` `⌘` `Shift` `I` again to reverse the selection to normal. Go to Select > Transform Selection. Hold `alt` `⌥` and scale the selection down just inside the lead-out area. Create a new layer. Fill the layer with 50% gray. Press `ctrl` `D` `⌘` `D` to deselect.

12 The gray label is a bit dull. Before we move on to the artwork we'll add some color. Create a Gradient Fill layer above the label. We'll use a linear Violet, Orange preset. Click OK. Now press `ctrl` `G` `⌘` `G` to create a clipping group with the label.

274

13 Begin by selecting the Text on Shape tool . Go to the Tool Options panel and choose Ellipse from the Presets menu. Holding *Shift* to constrain the dimensions, draw out a circle to match the whole area of the label.

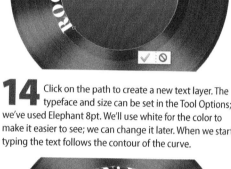

14 Click on the path to create a new text layer. The typeface and size can be set in the Tool Options; we've used Elephant 8pt. We'll use white for the color to make it easier to see; we can change it later. When we start typing the text follows the contour of the curve.

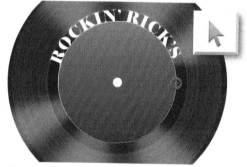

15 Grab the Shape Selection tool *U*. Hover the cursor over the text; it changes to the one shown in the inset. Click on the text. Drag it clockwise to move it on the path. If the text starts to disappear, we can click and drag the End Point (circle) further clockwise.

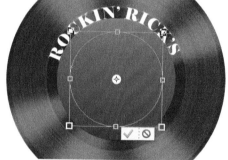

16 We now need our text on the label. Press *ctrl T* *⌘ T* to enter Free Transform. Now hold *alt* *⌥* to constrain the proportions and drag a corner handle in to scale the path down. It may be necessary to adjust the text's position again afterward.

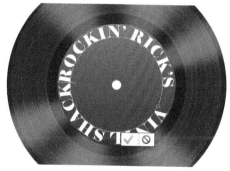

17 We'll add some text at the bottom of the label. Grab the Text on Shape tool again. Position the cursor at the bottom of the path Click and start typing. Although we haven't created a new path, our new text is created on a separate layer.

18 The text is upside down. Grab the Shape Selection tool again. Click and drag the cursor inside the circle. The text will flip over to display the correct way up. We just need to center it and scale it up to fit the label. Next we'll add the graphic and the remaining text.

HOT TIP

It can be fiddly trying to align the text using the start and end points. It's often easier to adjust them to make sure we can see the whole of the text, then use Free Transform to rotate the path around. There's some guesswork involved as the adjustments are only visible when we commit the changes but we have better control over the positioning.

275

19 Make sure the top layer is active in the Layers panel. Go to File > Place. Select Rockin Rick.jpg. Click Place to import into the document. Press *Enter* to set the layer down at its current dimensions. We'll be scaling it down later.

20 Grab the Quick Selection tool *A*. Select the background by clicking and dragging around the guitarist. Make sure the section between his arm and the guitar is selected and that any stray areas are tidied. Press *ctrl Shift I* *⌘ Shift I* to invert the selection.

21 Open Refine Edge. We're going to be making a graphic image so we need a crisp outline. Set a small amount of Feather; around 0.9px. Increase the contrast to around 30. Shift the edge in to around -13%. Select New Layer as the output. Click OK to apply.

22 Press *ctrl T* *⌘ T* to enter Free Transform. Drag the corner handles in to scale the guitarist so he fits inside the label. We want to keep him overlapping the text but leave some space between him and the label. Press *Enter* to commit the changes.

23 Next we'll create the graphic effect. Go to Filter > Adjustments > Threshold. This converts the image to pure black and white. We don't need to make much of an adjustment; drag the slider to the right a little to add more black. Around 135 is good. Click OK.

24 Let's place him behind the text. Click and drag his layer below the two text layers. The white of the image is a little overpowering. Open the Levels command *ctrl L* *⌘ L*. Drag the right-hand output slider a fraction to the left to tone it down a little.

25 We need to tidy the bottom of the guitarist graphic. Create a layer mask. Click on the Rockin' Rick text layer's thumbnail. Press *ctrl Enter* ⌘ *Enter*. This converts its path to a selection. We'll use this as a template to erase the excess part of the layer.

26 Click the guitarist's mask thumbnail. Press *ctrl Shift I* ⌘ *Shift I* to invert the selection. Grab the brush tool *B*. Now paint over the bottom part of the guitarist in black. The selection shapes the layer to fit the curve of the text. Now deselect.

HOT TIP

It's often easier to create parts of your artwork away from the area you want to put it. Here we had extra space around the record that we could use as an uncluttered scratch area. If the image we're working on is tight on space, we could temporarily extend it using the Canvas Size dialog. Alternatively we could create the the component parts in a new document and import them afterward; this is often the best way to work if we're creating a very large montage with dozens of separate layers.

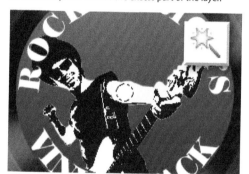

27 The graphic is also covering up the hole in the record. Click the record layer's thumbnail. Grab the Magic Wand *A*. Click the center of the record to select the area of the hole. Go back to the guitarist's mask. Fill the selection with black. We can deselect again.

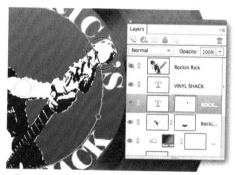

28 Let's add some dimension. Click the Rockin' Rick text layer. Create a layer mask. Hold *ctrl* ⌘. Click the guitarist's image thumbnail. Grab the Brush again. Paint over the K in black. This has the effect of bringing the guitar's head in front of the text. Deselect.

29 While we are on the text layer, let's change its color. Grab the Horizontal Type tool *T*. Click the color chip in the Tool Options. We'll pick the Pastel Green Cyan preset from the default presets list. Do the same with the text at the bottom.

30 We'll create the central text away from the record and reposition it afterward. Drag out a paragraph box. Set the alignment to center. The font we'll use here is Nueva Std. Set a size of around 4pt. The color is Pure Yellow Orange.

Saving files for the Internet

WE ALL WANT TO SHARE our photographs and montages with others, and the internet provides a simple, easy way to do just that. But rather than just taking your Elements file and uploading it to a website, you first need to save it in a format that web browsers will understand.

JPEG, GIF and PNG are the three most common file types. Elements provides a useful way to save images for web delivery: it's called Save for Web and you'll find it under the File menu.

Here, we'll look at what each of the three formats has to offer and see how to use the Save for Web dialog to get the best possible results from your digital images.

DOWNLOADS

Grandparents.psd

WHAT YOU'LL LEARN

- Using different file formats to alter file size and quality
- Changing settings to allow for tranparency

1 Here's a detail of our original photograph, enlarged so we can see the detail – but at 313K, it's far too big for internet delivery.

2 As a 256-color GIF image, we can see a little blockiness appearing in the white of the teeth: this image is a hefty 264K in size.

3 Reducing the number of colors in this GIF file to 64 reduces the file size to 168K, but we can clearly see the 'dither pattern' in the skin tones.

4 As an 8-color GIF, the file size comes down to 72K: it's now acquired the appearance of a poorly photocopied sepia print.

5 As a JPEG file with a quality of 50, this is very close to the original, but its size has been reduced to just 73K – fine for the internet.

6 Taking the JPEG quality down to 20 produces some marked 'blockiness' and reduces the file size to 38K.

7 For the sake of comparison, here's the file at a JPEG setting of 0. The image is just about unusable, but takes up just 19K of space.

8 A 24-bit PNG file produces the best results, but at a cost: this file is a massive 604K – nearly twice the size of the original.

The first step in Save for Web is to choose the file type. JPEG is best for photographs and GIF is best for areas with a lot of flat color, such as buttons and badges. PNG supports transparency, unlike JPEGs, and produces good quality – but at the cost of increased file size.

Unless you're creating page furniture for web pages, it's best to stick to JPEG format, as this will give you the best results. There's a trade-off between file size and quality: the better the quality, the larger the file will be, so the longer it will take people to download.

A JPEG setting of 50 or more will produce an image that's almost indistinguishable from the original file. The more complex an image, the larger the file will be: so a shot of a cloudy sky will produce a much larger file if there's an intricate fence in front of it.

As you drag the Quality slider, you can see the results of the JPEG compression in the right-hand pane (the left one always shows the original image). If it's not showing an area you want to concentrate on, drag within the window to move it and both images will pan together. You can also zoom in using the Magnifying Glass tool at the top left to see an area of interest in detail.

JPEG files can be set to 'progressive', which means that they will load in stages, each pass producing a more detailed version of the image. This was an issue when most people had slow modems, but is now rarely used.

Beneath each image is a readout showing the file type, the size the resulting file will be, and the time taken to download it. Click the tiny arrow at the top right of the images to change the speed of download: the default 28K applies to old-fashioned modems, which are hardly relevant in the era of high speed broadband.

You can also choose to reduce the physical image size as well, using the New Size section (center right). This will, of course, reduce the file size as well, but you need to be sure of the dimensions you want to end up with before playing with these numbers.

If you have a favorite combination that works well for your images, you can save it as a preset and then apply it to each image that passes through the Save for Web dialog. You can also choose to include ICC profiles, which aim to maintain consistent color: unless your computer has been calibrated to do this, it's best avoided.

The Matte box is used for saving GIF and PNG images with transparency: if you want to place images on a colored background in a web page, specify that color here and the transparent pixels will be blended with it. This is necessary because GIFs and 8-bit PNG files only support one level of transparency – on or off.

When you've chosen your settings, press OK and the standard file Save dialog will open. Be sure to specify a different name for your file to avoid overwriting the existing image; although a dialog will warn you if you're about to do so.

9 Art & design
Making things move

IMAGE: **PHOTOS.COM**

MOVEMENT IS ONE of the characteristics that most distinguishes the internet from printed books. We can create short animations right inside Elements, using the Save for Web feature.

In this example, we've made a simple montage containing just five layers: the background, with the road and sky; the clouds; the car; the crate on the back of the car; and the shadow beneath it.

By moving each of these layers around and making a new composite copy as a separate layer, we can create our animation as a series of separate Elements layers. It's then an easy matter to string these together to make a moving image.

We can't show our finished animation in this book, of course, but it is available to download from the website if you want to see how it looks when it's moving. Details on this can be found at the end of the book.

DOWNLOADS

Truck.psd

Truck moving.gif

WHAT YOU'LL LEARN

- Making a frame-by-frame animation
- Creating merged copies from multiple layers
- Using opacity to apply an 'onion skin' overlay
- Making a seamless scrolling background
- Using Save for Web to combine and save the animation

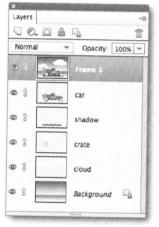

1 Begin by selecting the whole canvas *ctrl A* ⌘ *A*. Then make a Merged Copy *ctrl Shift C* ⌘ *Shift C*. This makes a copy of everything in the artwork. Now choose Paste *ctrl V* ⌘ *V* and move that copy to the top of the layer stack (shown above).

2 To make frame 2, first hide the first merged copy. Grab the Move tool *V*. Move the clouds layer to the left a little way (see Hot Tip). Raise the car up a fraction, then rotate the crate using Free Transform *ctrl T* ⌘ *T* to give the impression of them jiggling around.

3 Repeat the Select All, Merged Copy, Paste procedure as before, Move the clouds to the left some more, lift the truck a little and move and rotate the crate. All these new composite layers will become a single frame as part of our final animation sequence.

4 A good trick whilst making the animation is to leave the last frame we made visible but lower its opacity to 50%. This creates an 'onion skin' effect, letting us see the previous of the objects so we can gauge where to place them next. Remember to turn the last frame off again before making the merged copy.

5 When the big cloud starts to disappear off the left edge (frame 4 in our animation), we need to make a copy of this cloud layer and move it over to the right, so the small cloud is just creeping in from that side. This is where our cursor tap count comes in handy, we can measure the distance we need to move it across.

HOT TIP

With a short animation with only a few frames, we can hold *Shift* and tap the cursor keys to nudge the objects 10 pixels at a time. This makes it a lot easier to judge where the first and last frames will meet; particularly for the clouds in our example; we moved them in multiples of 16 taps (160 pixels) here.

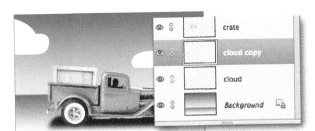

6 For frame 5 and the subsequent frames, we need to move both cloud layers at the same time. This makes sure that the animation runs smoothly. To do this we'll link the layers together by click the chain icon next to the orignal cloud layer.

7 You can make as many frames as you like in your animation: we're using just seven. In this frame, the small cloud, which has been sliding in from the right, is now approaching its original position. We can stop here, as the next iteration will be the same as the first frame.

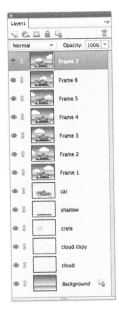

8 Here's how your Layers panel will look after all seven frames have been completed, along with the frames themselves on right – the faded image representing the loop back to the first frame. Before we continue on to make the animation, we'll need to delete the original layers, otherwise they will also be included as well. At this point you would want to save the document as a new file so you don't lose either the frames or the individual components.

HOT TIP

As the only constant element of the animation is the clouds, we could create their movement on separate layers first, then animate the truck's more erratic behaviour over the top of each frame of the clouds using the same merge and paste technique to create the full animation frames.

9 Choose File > Save for Web to open the dialog, which will look exactly as it did on (page 278). Make sure that GIF is selected as the file type; this is the only format that allows animation.

We don't need Transparency enabled on this occasion as our animation is one solid image. We could, of course, create an animated image on a solid background, using the background color as the transprency in order for the web page or email background to show through.

Next we'll check the Animation box to tell Elements we want this to be an animation, otherwise it will only save the currently displayed layer. A progress bar will go across the bottom of the window; this is the dialog loading up all the layers in the document as frames. Elements does not take layer visibility into account, which is why we had to delete the originals, rather than simply hiding them.

Once the frames are loaded, the displayed image will default to the first frame; corresponding to the first layer in the Layers panel. We can see the number of frames in the Animation section at the bottom of the

settings panel. Here we can also specify the time each frame is displayed before moving to the next; the default is 0.2 seconds; we want the animation to be as smooth as possible, so we'll set this to 0.

The looping options determine if the animation will play once, forever or we can specify the precise number of times; this is useful for website graphics where we want something to happen when a button is pushed, for example. We'll use Forever; that's why we wrapped the clouds around in that way.

Adjust the Dither and number of colors, if you like, to reduce the size of the file; our example weighs in at over 600K, larger than a standard web animation would normally be.

Click the Preview button at the bottom to see how your animation will look in a browser: this is the first time you'll be able to see it moving. When you're happy with the timing, press OK to save the animation as a GIF file.

HOT TIP

We would only want to produce smaller animations in GIF format, as they can produce very large file sizes. For larger, high quality animations, there are numerous utilities available that can convert a series of JPEG images into a single movie file. We can always use Save for web to test them first, of course.

Glossary

Actual size

Displaying the image on screen so that one pixel in the image exactly matches one pixel on the monitor. This is not the same as print size, which is determined by the resolution of the image.

Adjustment Layer

Special layers that perform non-destructive tonal and color adjustments to all or part of the artwork; they can be turned on or off and altered as required.

Aliasing

The opposite of anti-aliasing: no attempt is made at blending elements of the artwork to avoid jagged edges. This does have its uses: it can be used with very small fonts to avoid them becoming unreadable.

Alpha channel

An area used to store a layer's selection information. This can be loaded and saved whilst the document is open; some file types can store alpha channels permanently with the image information.

Anti-aliasing

The method of creating a smooth transition between contrasting colors to avoid harsh, jagged lines.

Background layer

By default, this is the base layer upon which all others are added. Most operations can be performed on this apart from moving and applying styles.

Bitmap

The method of creating an image by adding individual pixels of a specific color in a two-dimensional grid. Most images produced in Elements use this process.

Blend mode

Used to combine the content of two or more layers by blending the upper layer with the layer beneath in different ways to produce a variety of effects.

Brightness/Contrast

An adjustment method used for enhancing the strength of layers and images.

Channel

The area that holds the color information of an image. In Elements there are three channels – red, green, and blue – that are mixed together in varying amounts to define all the colors.

Clipping group

Hiding areas of the artwork by grouping two or more layers: the base layer acts as a mask template, its pixels defining what is visible on the layers above.

CMYK

Abbreviation for cyan, magenta, yellow, and black – the colors used for reproducing images in printed materials.

Color settings

A section of Elements' Preferences that set whether images are displayed for on-screen viewing or optimized for printing.

Compression

The method of reducing image file sizes using complex algorithms. There are two types: lossless, which does not affect the quality of the image, and lossy, which sacrifices some quality in favor of smaller files.

Constrain

Forcing the direction of movement when using a particular tool, usually adhering to 45° angles. This is often used to ensure layers remain aligned when they are moved around the artwork.

Constrain Proportions

When enabled this function maintains the dimensions when resizing an image, shape, or bounding box. When used with the Marquee tools it ensures a perfectly circular or square selection.

Contiguous

This is an option for tools such as the Magic Wand. When enabled only the local area around the cursor will be affected; otherwise instances will be selected from the entire document.

Cropping

Reducing the frame around an image to focus on an area of interest.

Depth of field

This is the area of the image that remains in sharp focus whilst the rest is left softer. The technique is often used to draw attention to a point of interest in the picture.

Desaturate

Removing the color information of an image leaving only grayscale tones describing the shadows, midtones, and highlights.

Displacement

A method of distorting an image according to the brightness values in an associated grayscale image file.

Distribute

A method of arranging layers to produce equal spacing between their centers or edges.

Dithering

The method of making an image appear to have more colors than it actually has by creating a patterned transition with a mixture of the available colors.

Dots per inch (DPI)

A measure of the output resolution of an image. On-screen images are typically displayed at 72 or 96 dpi whilst professional-quality prints are 300 dpi or sometimes more.

Feathering

The method of smoothing and blending a selection to avoid jagged edges. This differs from anti-aliasing as the edge is blurred against the destination rather than bridging using a gradient.

Filter Gallery

The dialog that lets you browse and apply individual filters or stack several filters together as layers to achieve different effects. These can be previewed prior to committing them to the image.

Gaussian Blur

A filter that uses a bell-shaped curve to give the impression of soft focus.

Gaussian Noise

A filter that adds random pixels in black and white (or in color) to create the effect of tight texture.

GIF

A lossy file format used in the early days of the internet. Today, GIF images are used for creating animations, a feature not possible with most other file formats.

Graphics tablet

A device connected to the computer that allows you to control the cursor with a pen-shaped stylus instead of a mouse. Many are pressure-sensitive, allowing much more accurate control of the tools.

Grayscale

An image composed of black, white and shades of gray, with no color component.

Interpolation

This is the method of resizing up or down by adding or removing pixels. When upsizing, an algorithm works out the average between adjacent pixels and places new ones in between.

JPEG

A method of compressing images to take up less space on disk. JPEG files can have a variety of settings, offering smaller file sizes at the expense of some quality.

Layer

All images in Elements consist of at least one layer: they are equivalent to laying sheets of acetate on top of each other to build up areas of the artwork.

Layer linking

Layers can be linked together, allowing them to be moved and transformed as a single item. This is useful if you need to uniformly reposition or scale multiple sections of the artwork.

Layer mask

Masks are used to selectively hide parts of the artwork by painting in shades of gray: black hides the area, white reveals it, and anything in between makes it transparent.

Glossary

Layer style

These add effects to a layer without permanently affecting the artwork. Examples include: drop shadows, bevels and glows. These can be combined and their attributes adjusted to suit the image.

Leading

The adjustable spacing between lines of text. The term originates from the early days of printing when lead blocks were placed to keep the type separated.

Levels

An adjustment dialog for correcting and enhancing the shadows, midtones and highlights of a photo. They can be applied to the image as a whole or to the individual color channels for finer control.

Marquee

This is the outline that defines a selection. It's often called the 'marching ants' because of its continuously moving dotted line.

Merge

The Merge Down command will combine one layer with the layer directly beneath it. Merge Visible will produce a single layer from all visible layers in the artwork.

Modifier keys

The keys ctrl, shift and alt that provide additional functions when held down in conjunction with certain tools, usually serving as shortcuts for switching between the tool's modes.

Non-destructive

A term used to describe an effect which does not permanently alter the image and remains editable, even after the image is saved and reopened.

Opacity

Determines how transparent the content of a layer appears: 0% is completely invisible, 100% is solid. Adjusting this value can be used for blending components of the artwork or for creating special effects.

Out-of-bounds

A framing technique where parts of the image extend outside of the frame's boundaries; often used to emphasize the action of a photo.

Painting tools

Any tool such as the Brush, Clone tool, Smudge tool, and so on, that affects the area of an image over which it is dragged.

Panel

An area in the workspace containing sets of items such as styles, brushes or layers. These can be collapsed or hidden away when not in use.

Photoshop CS6

The 'big brother' of Elements, which offers superior controls and a range of additional features.

Pixel

A loose abbreviation of 'picture element'. The individual dots which make up a digital image; each can be one of the millions of colors available.

Pixelation

Visible degradation often caused by scaling the image larger than its original size. This is also used to describe the stepping effect when anti-aliasing is disabled.

Preset Manager

A dialog with which you can load, save and organize any brushes, gradients, color swatches and patterns you may have downloaded or created, along with the program's built-in presets.

Print size

A viewing mode in which an image is displayed at approximately the size it will print, using the current resolution settings.

RAM

Random Access Memory: the part of the computer that holds running programs and their data; for Elements this would be open images and the undo history.

Raster image

An image that is formed of individually colored dots (pixels). This is the most commonly used format for digital painting and photo editing.

Resolution

The method of describing the quality of a digital image by the number of individual pixels it contains. The higher the resolution, the more defined the areas of the picture can be.

RGB

Abbreviation for red, green, blue – the colors used by a computer monitor for displaying images.

Saturation

The depth and intensity of the colors in an image.

Scratch disk

A special area of the computer's hard drive reserved for temporary data storage when system RAM is running low.

Scrubby slider

An alternative method of increasing and decreasing the value of a particular attribute in some dialogs by positioning the cursor over the value and dragging right or left.

Shadows/Highlights

An adjustment method for recovering image data from the darkest and brightest parts of an image without affecting the midtones.

Simplify

Also referred to as rasterizing. The method of converting a shape or text layer to a regular bitmap layer; this can also be applied to layer styles to make them permanent.

Smart Fix

A simple method of automatically enhancing images that requires minimal technical knowledge on the part of the user.

sRGB

A color space devised to make graphic elements look better on computer screens. sRGB is a limited space that's best avoided for printing purposes.

Swatches

A collection of favorite colors and gradients stored in an easily selectable panel.

TIFF

A lossless image file format (see JPEG). Some digital cameras have the option of saving images in TIFF format.

Tolerance

This setting determines the precision of the associated tool. The higher the value, the larger the area of similar tones affected and vice versa.

Tool Options panel

The contextual toolbar that sits across the bottom of the Elements window. This provides specific options and controls for the currently selected tool.

Unsharp Mask

An adjustment that attempts to make the image appear crisper by enhancing the contrasting edges. The 'mask' element allows the area of the effect to be fine-tuned by means of a tolerance-like setting.

Vector graphics

A way of creating images using interconnected points, lines and curves generated by mathematical formulae. Unlike pixel-based artwork they can be scaled to any size without losing definition.

Visibility (layer styles)

Similar to changing a layer's opacity except it only affects the pixels of the layer, leaving the style itself untouched. The three modes, Show, Hide and Ghosted, turn the pixels on and off or render them semi-transparent.

Downloadable content

Accessing the online content

All the necessary files for following the projects in the book are available to download from the book's dedicated resources section on the website. Simply type the address below into your favorite browser's address box. You can also follow the links from the main website.

howtocheatinphotoshopelements.com/resources or tinyurl.com/htcie11

Project files

This symbol indicates that you'll find an Elements file on the website to accompany the tutorial. They're available to download in batches based on each chapter. Each one includes the starting point for each workthrough.

Some images contain all the necessary components as layers in a single file. Projects that use several images are held in folders; this is denoted on the project page.

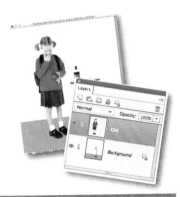

Movie files

Sometimes it's easier to understand a concept when you see it acted out live, rather than just by reading about it. There is a selection of Quicktime movies available that show the tutorial played out in real time. You can choose to watch the movies on the website or download them to watch straight from your computer. To view them on the computer you'll need the free QuickTime player from www.apple.com/quicktime, if you don't already have it installed.

Smart brushes

Although we haven't used Smart Brush presets in the book, we've included some useful ones to download. Refer to the information on the website for details on how to install them.

Gold paint

Silver paint

Metallic paint

Diamond paint

Custom shapes

The custom jigsaw pattern shapes, as described on page 167 are also available to download. We've also included a small selection of stars so you can make your own starbursts to place behind text announcements.

To use them, download them from the Goodies section of the website; there are instructions on where to place the files on the hard drive depending on which operating system you are using (Windows and Mac OS X).

Fonts

Elements comes with a number of useful fonts to complement those already installed on your computer. We've used a couple of additional fonts in the projects. These can be downloaded from the Goodies section, along with installation instructions for your OS.

Layer styles

We've included a range of useful layer styles to complement those already present. As well as the neon text effects used in the book, we've added a range of inner shadows, some metallic styles and two new types of inner and outer glow, the difference being their blend mode is set to Multiply; this can be useful for creating shadows which are centrally placed, rather than offset to one side. The files can be found in the Goodies section of the website.

To install the styles, go to Edit > Preset Manager. Select the Styles preset type from the drop-down menu. Click the Add button on the right of the dialog. Browse to where you downloaded the Cheat Styles.asl file. Click Open. The new styles will appear in the dialog window.

Once installed, the styles can be accessed from the drop-down menu in the Styles section of the Effects Panel.

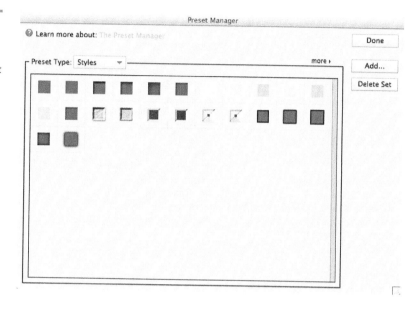

Actions

The Actions panel is new to Elements. Three of the projects in the book have actions that can be used to create part of the effect; although it's worthwhile going through the steps manually to begin with, of course. The file containing these actions, along with some bonus extras can be downloaded from the Goodies section.

To install the actions, go to the Actions panel. Click the fly-out menu on the right of the panel. Choose Load Actions. Browse to the place where you dowloaded the Cheat Actions.atn file. A new entry called Cheat Actions will appear in the panel beneath the default actions that come with Elements.

To begin with, you'll see the action names beneath the main folder set. To run them simply highlight the action you want and click the Play button. The shorter actions will run without interaction; the project actions have information windows that pop up to tell you to perform certain tasks; the action stops while you do so. To resume, simply press play again.

Actions can also be started at any point in the command list. This is useful if there's a particular effect you want to use that's part of a longer sequence. To see the command list click the blue disclosure arrow next to the action's name. Highlight the start point and click the play button.

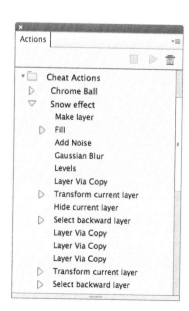

Index

Index

Printed and bound by CPI Group (UK) Ltd, Croydon, CR0 4YY

21/10/2024

01777101-0012